My Brother, Grant Wood

MY BROTHER, GRANT WOOD

BY

NAN WOOD GRAHAM
WITH JOHN ZUG AND JULIE JENSEN MᶜDONALD

STATE HISTORICAL SOCIETY OF IOWA
1993

Photo credits: Title page and folio blocks, pp. 1, 12, 18, 20, 27, 30, 36, 40, 43, 48 (mortuary sketches), 55, 57, 61, 67, 70, 74, 81, 86, 84, 90, 95, 104, 120, 127, 128, 134, 140, 141, 143, 145, 147, 149, 154, 157, 163, 168, 171, 178 all by Chuck Greiner, Front Porch Studios; pp. xiv, 11 by Joan Liffring-Zug, Joan Liffring-Zug Collection; pp. 3, 6, 10, 19, 22, 24, 35, 39, 45, 47, 50, 51, 121, 129 all Nan Wood Graham photos, Joan Liffring-Zug Collection; p. 48 (top), 49, 53 from John B. Turner, Joan Liffring-Zug Collection; pp. 60, 133, 183 all by George Henry, Cedar Rapids; p. 98 courtesy Mrs. Harry Chadima, Joan Liffring-Zug Collection; pp. 29, 102, 123, 161, 164, 185 Joan Liffring-Zug Collection; p. 103 by John Barry, Joan Liffring-Zug Collection; pp. 105, 173, 175 Edwin B. Green photos, Joan Liffring-Zug Collection.

Front cover: American Gothic, 1930, oil on beaverboard, 29 $^7/_8$ x 24 $^7/_8$ in., Art Institute of Chicago.
Back cover: Portrait of Nan, 1933, oil on masonite, 40 x 30 in., Elvehjem Museum of Art, University of Wisconsin-Madison. Anonymous loan.

Library of Congress Cataloging-in-Publication Data

Graham, Nan Wood.
 My brother, Grant Wood/ Nan Wood Graham with John Zug and Julie Jensen McDonald
 p. cm.
 Includes index.
 ISBN 0-89033-012-3 : $16.95
 1. Wood, Grant, 1891-1942. 2. Painters—United States—Biography.
I. Zug, John. II. McDonald, Julie. III. Title.
ND237.W795G73 1993
759.13—dc20
 [B] 93-28241

CONTENTS

CHRONOLOGY

1891 Born on a farm near Anamosa, Iowa, on February 13.
Son of Francis Maryville Wood and Hattie D. Weaver Wood.

1901 Letter published in the *Anamosa Eureka* tells of Master Grant
Wood recognizing 55 different kinds of birds.
In March his father dies.
In September, Hattie Wood and four children move from
farm to Cedar Rapids, Iowa, 25 miles away.

1905 Wins prize in national Crayola contest for colored drawing of
an oak leaf.

1910 Graduates from Washington High School, Cedar Rapids.

1910-11 Attends Handicraft Guild in Minneapolis, Minnesota. Studies
design under Ernest Batchelder.

1911 Teaches at Rosedale Country School.

1912 Attends evening art classes at University of Iowa for 3 months.

1914-16 In Chicago and Cedar Rapids. Works at Kalo Silversmiths
Shop in Chicago and attends evening classes at the Art Institute
of Chicago.

1918 Inducted into United States Army. Paints camouflage.

1919 Teaches art at Jackson Junior High School in Cedar Rapids.

1920-28 Travels four times to Europe, painting in France, Italy, and
Germany. Studies at Academie Julien in Paris. Several exhibits
in Cedar Rapids and sells scores of paintings done abroad.
Teaches briefly at McKinley High School in Cedar Rapids.

1927-28 Commissioned to design large stained glass window for
Cedar Rapids Memorial Coliseum. Travels to Munich,
Germany, to execute design.

1929 *Woman With Plants*, a portrait of his mother and his first
painting in a new direction, exhibited in American show at
Art Institute of Chicago.

1929-30 Paints *Stone City* and *American Gothic*.

1930 *American Gothic* wins Harris bronze medal and $300 pur-
chase prize in the Annual Exhibition of American Paintings at
the Art Institute of Chicago.

1932-33 Founder and moving spirit of the Stone City Art Colony.

1934 Directs Public Works of Art Projects in Iowa. Becomes
Associate Professor of Fine Arts at University of Iowa.

1935	Marries Sara Sherman Maxon. Solo shows at Lakeside Press Galleries, Chicago, and Ferargil Galleries, New York. Purchases home in Iowa City.
1939	Divorces Sara Maxon Wood.
1940	Leave of absence from university teaching.
1941	Summer at Clear Lake painting.
1942	Dies of cancer on February 12 in Iowa City.

UNLABELED ILLUSTRATIONS

ACKNOWLEDGEMENTS

Publication of this book was made possible for the State Historical Society of Iowa only through the close cooperation of John Zug and Joan Liffring-Zug of Penfield Press. John's careful work with Nan's manuscript knit her memories into book form. Joan's energy and enthusiasm fired the project and her extensive collection of Grant Wood photos has enriched this memoir. The Zugs acted as Nan's agents, supporting her project from the time that she first showed them her collection of stories. This book owes much to their unswerving loyalty.

Others had a hand in shaping this final product: Julie Jensen McDonald worked with Nan's words and produced the true magic of enlivening the prose without losing Nan's unique voice. Carolyn Hardesty polished and sharpened that prose through her final edit. Wanda Corn provided a foreword with a deft combination of academic perspective and warm affection. Claudia Callahan's vision and design helped incorporate Nan's words and Grant's artwork into a coherent whole. Society Intern Mary Frances Trafton assisted in pulling together many of the innumerable details of publishing . Chuck Greiner's copy photography reproduces some of Grant's more private works.

Much of this material is in the Grant Wood collection of the Davenport Museum of Art, which generously allowed the Society to reproduce numerous works from that collection. The scrapbooks that Nan deposited there are a treasure trove of images and information. Registrar Patrick Sweeney's assistance made access to the collections possible. In addition, Curator Brady Roberts, Director William Steven Bradley, and the acquisitions committee of the museum's board cooperated with the Society in every possible way.

Many institutions made their materials available for this publication and their staffs across the country were unfailingly cheerful and helpful, including Cindy Schwab and Kenneth Farmer, Abbott Laboratories; Edith Golub, Charles Scribner's Sons; Larry Mensching, Joslyn Art Museum, Omaha, Nebraska; Nicky Stanke, Carnegie-Stout Public Library, Dubuque, Iowa; Peter Stevenson, University of Iowa Museum of Art; Joy Payton, Cincinnati Art Museum; Carolyn Schmidt, Coe College; George Henry, photographer, Cedar Rapids, Iowa; Melissa Thompson, Amon Carter Museum, Fort Worth, Texas; Tom Delaney, Sheldon Swope Art Museum, Terre Haute, Indiana; Elizabeth Burke-Dain, Art Institute of Chicago; Lucille Steiger, Elvehjem Art Museum, Madison, Wisconsin; and Deanna K. Clemens, Cedar Rapids Museum of Art.

Many of those acknowledged above knew Nan and their cooperation was fueled by their fondness for her. She would have appreciated their interest and support.

Christie Dailey
State Historical Society of Iowa

FOREWORD

My palms were a bit damp when I met Nan Wood Graham for the first time. I was a young art historian intent upon organizing a major museum exhibition of her brother's work, and I had come to her home asking for her cooperation and help. From others, I had learned that she was a fund of information about Grant Wood, and that she had meticulously assembled a large number of scrapbooks tracing the artist's career from its very beginnings. I had also read that she was suing a national magazine for printing a parody of *American Gothic* that she found offensive. Both bits of information had me worried. What if she would not share her invaluable scrapbooks with me, and what if she discovered that I not only collected take-offs of *American Gothic* but had even created one with my husband for a Christmas card? What if she were so protective of her brother's fame or annoyed by art historians that my dream of a retrospective exhibition could never be realized?

I will never forget the way the day went. It turned out to be the start of a long and wonderful friendship. Nan answered the door in a long, black-and-white-checked gingham dress with lace trim, which, if memory serves me right, she wore with short white boots. (This was the mid 1970s and Nan was then in her seventies.) The dress was of her own design and making, a wonderful creation that spoke both to her Iowa roots and to Southern California, her home in late life. It was the first of many highly personalized outfits that I would see her in, for she loved to sew and to dress up. She always looked particularly fine in hats, which she wore upon a full head of silvery white hair provided by one of many wigs she enjoyed wearing in her late years.

My worry about Nan's being offended by my collection of *American Gothic* parodies immediately disappeared when she took me into her bedroom, where I found two walls papered from floor to ceiling with cartoons, greeting cards, and parodies of the painting. Nan had a twinkling sense of humor, much as she describes her brother as having, and she loved reworkings of *American Gothic*, as long as they were in good taste. She said Grant would have loved them too, had he lived to see any of them. (Grant Wood died in 1942, and the parodies did not begin in earnest until the 1960s.) The pleasure she took in them, in addition to my own interest in them, led me to include a selection of great *American Gothic* knock-offs in the retrospective exhibition that traveled around the country in 1983 and 1984. Not all of the museum professionals on the tour liked the idea — pop culture in an art museum? — and it helped to have Nan's convictions at hand when I was called to defend that part of the exhibition.

As the female model for *American Gothic*, she lived in the limelight of the picture's fame. This suited her just fine. She would disarm reporters when they asked her what it felt like to be a stern and decidedly non-glamorous legend. Her

brother, she always responded, had given her the best gift of all, a rich and eventful life. Never refusing an invitation to be photographed in front of the painting or a reproduction of it, she would strike the old chestnut pose so quickly and so completely that it turned everyone present upside down in glee.

If Grant gave Nan a full life, she gave him and his memory the most dedicated service. Until she went totally blind in 1984, she continued to compile scrapbooks, respond to a steady stream of mail, help people wanting to exhibit the artist's work, and answer the many telephone callers who had tracked her down as the woman in *American Gothic*. She also wrote this memoir because she felt burdened by stories and recollections about her brother that no one else knew. She was the last surviving member of her family —neither she nor her siblings had children — and the only person alive who had been a part of Grant's life from boyhood until his early death from cancer. She felt protective of his reputation and hated it when people got the facts wrong concerning his life or gave them an interpretation she felt unfair. Nothing made her angrier than to read or hear something said about her brother which she felt was inaccurate. Were you *there*, she would ask? She wrote this book to set the record straight and to tell it from the heart.

A couple of things probably should be said about Nan's recollections. First, she had the good fortune of a wonderful piece of equipment: a steel-trap memory that never wore down, even in her ninety-first year, when she died. She wrote the bulk of these memoirs in the 1960s and 1970s, looking back to the early years of her family's life. She consciously made this a story of the artist's life, not hers, so the book ends at his death in 1942 with a small addendum about the new appreciation Wood's work began to enjoy in the early 1980s.

Second, she was a wonderful storyteller. She was very gentle and soft-spoken, and she had a certain way of telling family tales that I always enjoyed. Folklorists could probably give it a name. For me, I felt her raconteur style had something to do with growing up in farm country. She liked to let a story evolve and drag out a bit for dramatic effect; listening to the unchanging pitch of her voice, I was never sure when the punch line would arrive. When it did, it was often at her own expense. As she told stories about her family and her past, I would think of her brother's paintings; he had the same kind of flair for the colorful and well-observed detail, the sustained narrative, and the touches of down-home humor. In both of them, what seemed on the surface to be too folksy and down-to-earth to be labeled a "style" was a manner of speaking honed by regional ways. If humorist Garrison Keillor calls his kind of talk "Minnesotan," the Woods spoke in "Iowan."

Third, Nan loved Grant very much. In the pages which follow, she speaks with abiding affection and appreciation, often adoration, for him and what he did for her. If we read between the lines we also learn something of

the many ways she helped him; theirs was a mutually supportive relationship. Along with her mother, Nan was Grant Wood's only close family. And she gave him what family members are best at: unconditional love and fidelity no matter what his foibles or failures.

That Nan could see no blemishes on her brother's life except a few easily excused slip-ups was characteristic of her. She was a very tolerant and generous person. The one thing she could not endure, however, was criticism of Grant, whether of his career or his art. There was no surer way to get on her wrong side than to raise questions about the meaning or value of her brother's work. The only defense she knew was the instinctive one of a blood relation: attack the intelligence of the critic. To her dying day, she never understood the way artistic fame works in our culture: that the art world prides itself on an open marketplace of opinions and that artists who attract large audiences are magnets for controversy and debate. Nor could she separate adverse opinion about art in the public domain from slander against personal character. She confused the two, feeling that an attack on her brother's art impugned his integrity and goodness as a person. And that she would not tolerate.

To be sure, the controversy Grant Wood aroused in the late 1930s was fueled by passion and vehemence that only a rough-and-tumble street fighter could counter. And neither of the gentle Woods fit that description. The kind of art Wood made —figurative, story-telling, dealing with rural themes —had been in perfect stride with national sentiments during the Depression years. But by World War II, what he did suddenly came under attack for its alleged folksiness, narrow vision, illustrative quality, and regional celebration. As Nan says at the end of her memoirs, he was called just about everything: "satirist, liberal socialist, fascist, communist, isolationist and ... flagwaver." But now the tide has turned again, and Grant Wood, along with other figurative artists of the 1930s, has found a place in the history books as one of this country's most inventive Regionalist artists. Nan lived long enough to relish this change though not long enough to see her book in print. When she died in 1990, she knew that the State Historical Society of Iowa was going to take on the project and that pleased her very much. She very much wanted to add her words to the record of a man whom we know as an artist but whom she knew intimately as a brother. Since it takes many perspectives to understand the workings of an artist, Nan's memories are invaluable to all of us. They certainly have been to me in my research and writing. So one last time, thanks, Nan. We now can all enjoy and learn from the fruits of your hard work and generous spirit.

Wanda M. Corn
Stanford University

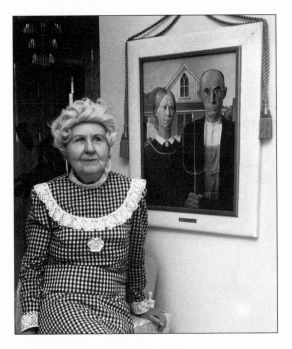

Nan Wood Graham poses in her California home in 1975.

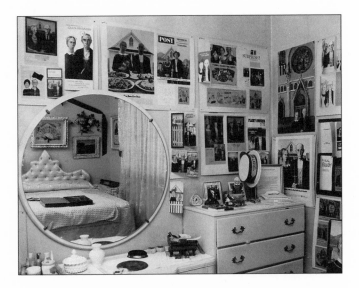

Nan's bedroom displayed her collection of *American Gothic* parodies.

BROUGHT UP ON LOVE,
AN INTRODUCTION

Mother used to say, "It's better to be born lucky than to be born rich." I was born lucky, for I was the sister of Grant Wood, who became America's most famous artist, the Artist Laureate of the nation.

I was nine years younger than Grant, so the stories of his boyhood that I will relate were told to me by him and by my mother.

Grant's remarkable talent was noted by teachers when he was very young, but no one in our family dreamed that someday he would occupy a unique niche in American art. As a child, I posed for Grant many times, and no thoughts of great fame overlaid those pleasant moments. As an adult, I posed for *American Gothic*, Grant's conception of a small-town Midwesterner and his daughter, with Dr. Byron McKeeby, our family dentist. Although artist and models sensed that it was a serious undertaking, not even Grant had an inkling of the tempest this painting would cause.

Grant was ten when Father died, so he had to assume manly responsibilities immediately—the gardening, milking the neighbors' cow, and doing all kinds of odd jobs. I was still a school girl when my brothers Frank and John left home. The family unit became we three: Mother, Grant, and me. We were close, sharing the good times and the bad. Sometimes we were cold and sometimes we would have welcomed more food, but mostly, we shared good times, happiness, and high hopes.

We were brought up on love as our mother transmitted her own character and taught us the precepts of our father. I never heard my mother say a mean or belittling word about anyone. She was a gentle person, filling our lives with peace, tranquility, and companionship. She laid the foundation for Grant's soft and gentle character, which was noted by all who knew him.

Mother read to us from the Bible. She taught us to turn the other cheek. She worked hard. She showered us with love. Small, shy, and frail but durable, Mother was a lifelong inspiration to Grant and me. She also inspired William L. Shirer, who wrote about her in his book *20th Century Journey* and in a letter to me. The Shirers were our neighbors in Cedar Rapids, and Grant and the famous journalist and historian were long-time friends.

Easy to get along with and easy to live with, Grant never forced his opinions on anyone. In our home, we all did our own thing. Grant had a wonderful sense of humor, and we had our own family jokes.

Nicknames abounded in our family. To her nieces, Mother was "Aunt Do," for she was always doing something. To his uncle, Grant was "The General"—for General Ulysses S. Grant. Among just the three of us, Mother was

"Mom," Grant was "Gus," and I was "Nicky." Our brother Frank once heard Grant say that he thought "Gus" was the ugliest name in the book, and he promptly started to call him that. Frank soon forgot all about it, but I persisted. Grant said I was full of the Old Nick for calling him a name he hated and started calling me "Nicky." I loved it; Grant is the only one who ever called me that. I'm sure he enjoyed my calling him "Gus," too, because he always smiled.

Throughout his life, Grant assumed responsibility for Mother's welfare and mine. The three of us were a family until my marriage in 1924, and we were reunited thereafter during the times when my husband was a patient in a veterans hospital. When we were separated, as we were during Grant's European trips, we corresponded, and I have always treasured the cards and letters.

Besides his messages to me, I have kept Grant's first letter, written to his Aunt Sarah when he was eight and found in her effects after her death; two yellowed newspaper clippings concerning the number of birds Grant had observed on the farm, written when he was ten and I was one; and the myriad clippings sent by friends and well-wishing strangers through the years.

Some memories are not documented in scrapbooks, however. I am still charmed by what Grant did for my high school graduation. We were a class of two —Vesta Jones and me. The ceremony was in a church, which Grant decorated with tall ferns, daisies, and wild asters gathered in the woods. His artistry was an expression of a loving spirit, and everyone said the church never looked so beautiful.

I was living in California when Grant sent for me during his final illness. His last letter to me was written before he entered the hospital, to be handed to me after his death.

Grant had something for everyone —the intellectuals, the powerful, the factory workers, and the farmers who were his friends.

His legacy survives through more than talent. Grant's stark honesty and simple greatness come through in his works, giving them a universal quality and character. They have stood the test of time.

Adolescence, 1940
Oil on masonite, 20 $^{3}/_{8}$ x 11 $^{3}/_{4}$ in.
Abbott Laboratories

CHAPTER 1
THE BOYHOOD YEARS

We were at breakfast one morning in 1930 when Grant made a quick sketch on the back of an envelope of his idea for the painting he would name *American Gothic*.

"This is what I plan to paint," he said, "a Gothic house with two people standing in front of it. They will be people with long faces—the type who would live in a Gothic house."

When the painting was finished, he entered it in the 43rd Annual Exhibition of American Paintings and Sculpture at the Art Institute of Chicago.

"It probably won't even get in the show," he said, but the painting that would be synonymous with his name won the Norman Wait Harris Medal and the $300 purchase prize to become one of the Art Institute's most famous acquisitions.

American Gothic made headlines all over the world. In Paris, Gertrude Stein said, "Grant Wood is the all-time menace. He is America's first artist."

A distillation of Grant's thirty-nine years of life went into that painting (and others), and here's how it began.

Grant Wood was born February 13, 1891, in our parents' farm home four miles east of Anamosa, Iowa. My brother spent his first ten years on that Iowa farm, long before the revolution brought about by the automobile, the tractor, and the electric motor. Although Grant began drawing at a very early age, everyone assumed that he would grow up to be a farmer like his father.

In these, the years of imprinting, he learned all the farm chores that a boy could perform. Grant had his own animals—a goat and chickens. They belonged to the entire family, but they were known as Grant's, and he took care of them. He also had ducks and turkeys. Beginning as Mother's helper in the garden, he later did most of the work, and everything grew for him. He learned to drive the cows in and out for milking, taught calves to drink, and eventually

did some of the milking. He gathered wood and cobs for the stoves. In time, he did some field work, and at threshing time, he was the water boy.

We had one huge, round bald spot in the middle of a fertile green pasture where nothing would grow. Everyone believed that it had been a stamping ground and wallow of the buffaloes that roamed the prairie. The hard ground made a hollow sound when the boys stomped on it and ran in circles on this favorite play spot.

Farm work in that era provided a profound inner satisfaction that seems to have been lost in the transition to urban, motorized living. But Grant as a boy experienced the sounds and smells and sights that became a reference file for the future artist. His impressionable mind recorded the lowing of the cattle, the grunts of the pigs, the neighs of the horses, the crowing of the roosters before dawn, the delighted cackle of the hen's announcement that she had laid an egg. He never forgot the sheet lightning at the end of a hot summer day, the heavy rumbling of thunder, the katy-dids, the crickets, the tree frogs, the little kittens, and the sound of corn growing during hot summer nights. He recalled the smells of the barnyard, the new-mown hay, the first violets of spring, the lilacs, and the pine trees Grandpa Wood had planted so many years before.

How well he knew the glittering silence that came with the first heavy snow and the squeaking sound when you walked on it, the sound of sleighbells, and the slow drip from the eaves of the barn during the first thaws of spring.

The human voices stored in his memory were Father's—calm as it taught the second of his three sons the farm chores, directed, counseled, and offered thanks before each meal, and Mother's—kind and loving through the day from the breakfast call to the evening reading of the Bible story.

The house had its own distinctive speech: the creaky-squeaky hand pump, the snap of the glowing fire in the cook stove, the clinking of dishes being washed, the walls "cracking" in the middle of the coldest nights. No water could be more cold and pure than that which came from our well in winter. No radio or television offering could equal the exquisite tenderness of the hymns Mother played on the parlor organ on Sunday afternoons.

Frank, the oldest boy, was business-like—a real help to Father in the farm work. John, the youngest boy, was mischievous and into everything. Who could forget the time he hammered on the bee hive to see what would happen?

Grant was a moody child. Some days he would be a perfect angel, but on his off days, he could be a small devil. On one such day, Father sent Grant to the cellar for punishment. This wasn't much of a punishment, because the cellar was always full of goodies—nuts, barrels of apples, jars of home-canned pickles, jams and jellies, and a big tin box of crackers. Seating was provided in case the family had to use it as a storm cellar. It was here that Grant did his first

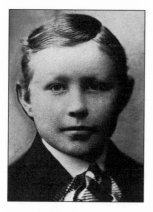
Grant, age 10

drawing, a hen setting on many eggs sketched on a piece of cardboard from the cracker box.

On another occasion, he scratched in pencil on the cellar wall, "Grant Wood was Bon Here Feb." More than forty years later, on February 12, 1939, a photograph of this inscription with the missing "r" appeared in the *Des Moines Sunday Register* rotogravure section on February 12, 1939, and Grant had forgotten all about it. A year or two later, the owners of the house enlarged the cellar and tore out the wall.

Mother knew how to be a disciplinarian. She was especially concerned that the boys should learn manners from their parents rather than from the hired men on the farm. Most of the hired men wore mustaches and drank from large cups with a bar to keep the mustache out of the coffee. Our table setting included cup plates similar to butter dishes. The hired men considered it fashionable to pour their coffee into the saucers to cool, placing their coffee cups on the small cup plates while they drank from the saucers. For them, the height of elegance was eating peas with a knife without spilling a single one. When Mother caught the boys trying to copy this feat, she threatened to banish them from the table.

Grant attended Antioch rural school four miles east of Anamosa from 1898 to 1901. It was a good mile and a half walk, and Frank led the way. The schoolhouse consisted of an entry hall where coats were hung on nails and a large room with a pot-bellied stove in the center and rows of desks on both sides.

The winter term was the best attended. In the fall and spring, some of the older boys dropped out to help their fathers with farm work. Winter was severe in those days. The teacher arrived early to start the fire with wood and cobs. When the pupils came, they huddled close to the stove until the room was warm. All drank from the same long-handled dipper in the water bucket.

Although eight grades were taught in the same room, everyone learned the three R's, and many would test out well against today's eighth graders.

Antioch had a succession of teachers, and Grant's favorite was Katherine Hines, a daughter of a farm family in the neighborhood. He told Mother, "When I grow up, I'm going to marry Kate Hines."

Families were large in those days. Attendance records showed twenty pupils named Byerly, seventeen named Hayes, and thirteen named Nielson but only three Woods—Frank, Grant, and John.

As Grant meandered to and from school each day, he observed the world around him—the plowed fields, the growing corn, the seasons, the

animals, the people, and the little country school. In later years, he immortalized these scenes in paintings titled *Young Corn*, *Fall Plowing*, *Spring Turning*, and *Arbor Day*.

In his boyhood, Grant never dreamed that one day this little school would be dedicated to his memory. Last used as a school in 1959, Antioch School is now kept up by the Paint 'n Pallette Club of Anamosa, which also built a large, lovely building for area artists and their exhibits. The school is a busy place during Anamosa's annual "Grant Wood Festival Days" in June, a pleasant event I have enjoyed several times.

Once during his rural school days Grant borrowed a book of fairy tales from a neighbor. Father took Grant and the book back to the neighbors, handed them the book and explained, "We Quakers read only true stories." Without question, this incident helped shape my brother's lifelong interest in legends and myths, expressed in paintings like *Midnight Ride of Paul Revere* and *Parson Weems' Fable*.

That first letter of Grant's, written to our aunt in Ohio, included some creative spelling, but it's not bad for an eight-year-old:

Dear Aunt Sallie:

I hope this letter will find you in Ohio and having a good time John and I have sutch a cough that we have not went to school this week I have found 9 doz. eggs we are all lonesome here even ma without you John said O don't say that Aunt Sallie will think we are holy heds mrs. Cheshire Died and wos buried monday and it rained all day I have no more time to right so good bye to you.

Your lonesome little Grant

In his first decade of life, Grant came to know all the Woods and the Weavers. Grandpa [Joseph] and Grandma [Rebecca] Wood were Virginia farmers who headed west with their children and former slaves in a covered wagon after the Civil War. Grandpa Wood died two years before our parents were married, so Grant didn't know him, but he knew Grandma well.

Grandpa and Grandma Wood bought rich farmland near Anamosa for three dollars an acre, built a home, and planted crops. They had seven children altogether, three of whom died in infancy; our father, Francis Maryville, was the oldest. He was born in Virginia in 1855 and known by his middle name, pronounced "Merville."

The nearest Quaker church was at Whittier, almost half-way to Cedar Rapids and too far to go by horse and buggy on Sundays. Grandpa and Grandma Wood maintained their Quaker birthright by attending the Whittier church once a year. On all other Sundays, they attended the Presbyterian church in Anamosa, and it was here that our parents met. Mother was the organist and father was superintendent of the Sunday School.

Grant was linked to the Weaver side by a namesake. John Smith, Grandma Weaver's brother, and his wife Martha lived in Waterloo with their son, Grant, for whom my brother was named. I was named for my grandmothers, Nancy Weaver and Rebecca Wood.

Mother's parents, De Volson and Nancy Weaver, never were farmers. They came to Iowa from New York State in the late 1850s, and Grandpa Weaver bought an inn at Fairview on the outskirts of Anamosa. The stage coach trip from Dubuque to Iowa City took two days, and the stage stopped overnight at Grandpa's hotel, the half-way point.

Mother had vivid memories of the night the hotel was destroyed by fire. She was carried from the flaming building, and somehow her treasured hoop skirt was among the possessions saved. Every time she told about it, I imagined it so strongly that I felt I had been there. After the fire, Grandpa ran a sorghum mill for a number of years, but it also burned. After struggling with his financial losses for a time, he was elected sheriff of Jones County.

Mother was the oldest of the four Weaver children. Born in 1858 at Fairview, she was christened Hattie De Ette. Then came Frank, Minnie, and Fred. Both girls took dancing lessons and attended Miss Springer's School for Young Ladies near Anamosa. Mother took organ lessons and Aunt Minnie studied painting. Grandma Weaver saw to it that her daughters wore the best silks, satins, and ribbons, and she curled their hair around a hot stove poker. With their big blue eyes, rosy cheeks, dainty figures, and grace in the dance, they became the belles of the ball. Mother was a tiny Dresden doll. She weighed ninety-eight pounds and was possessed of flawless skin, dimples when she smiled, and light brown hair that she tried to darken with strong tea.

Tiny Hattie Weaver barely came to the shoulder of "Merville" Wood, a lean and lanky six-footer with a stern and serious face and straight blond hair. They had a great deal in common, including educational background. Father attended Hazel Knoll Boarding School, and in a day when few went beyond high school, he attended Lenox College at Hopkinton about forty miles north. Father had a fine mind and polished manners. Both of them were quiet, calm people, and shyness was another quality they shared. When they began dating, they

would sit at opposite ends of the sofa, not saying a word. Mother told me how her little sister, Minnie, delighted in poking her head into the parlor and making fun of them, much to Mother's embarrassment.

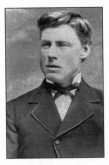 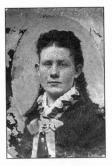

Francis M. Wood Hattie Weaver Wood

Their large wedding took place on a cold sixth day in January 1886. Guests came to the Weaver home at Strawberry Hill, Iowa, in a caravan of sleighs. Mother's dress was bottle green taffeta, Victorian style with high neck, tight basque waist, leg-of-mutton sleeves, and a row of small buttons down the front. The hemline was at her ankles, and she wore a bustle. Her hair was swept up in a formal style with curls on the top and long curls down her back. Father was formally attired in a black suit with white kid gloves.

I did not learn the postscript to the wedding story until years later, when a distant relative told me the rest of the story.

After the minister pronounced Maryville and Hattie man and wife, Father fainted. His brothers tossed cold water on him, and off they went to the Wood farm for a big reception and banquet in his honor. Not their honor, but his. Other sleighs filled with guests followed, but the bride and her family were not invited. When I asked Mother about this story, she admitted that it was true, but she said she never meant to tell her children.

"How would you feel if you were the bride and were not invited to the wedding reception?" she asked.

Hurt as she was, she dearly loved Maryville and tried to understand his family's action. Father's two brothers and sister did not want him to marry. They planned that all the Wood children should stay on the farm, work hard, acquire more land, pool their money, and eventually become extremely rich. None of Father's siblings ever married, and his marriage was a great disappointment to them. Grandpa Wood had died in 1884, and now the thirty-year-old Maryville was abandoning them. This left Uncle Clarence, who was twenty-nine; Aunt Sallie, who was twenty-one; and Uncle Eugene, fifteen.

The separation after the wedding went on for a while as Father went into debt for the construction of their new home. The newlyweds lived apart

until it was completed in the spring. They were well-prepared for the life that awaited them. They were not children. Father had learned the myriad duties and skills of farming, and Mother, graduated at sixteen, had taught country school for eleven years and saved her money.

Grandpa and Grandma Weaver gave them their land, which adjoined the Wood farm. The Weavers also presented them with an elegant set of parlor furniture. The framework was golden oak, and each piece was upholstered in two tones of plush—gold and amber, amber and green, and red and yellow. Mother's savings bought a luxuriant Wilton velvet rug, cream-colored and bordered with a golden-brown scroll. It was decorated with a scattering of pink cabbage roses, a motif repeated in the gilt wallpaper, creating the most elegant parlor for miles around. The weekly *Anamosa Eureka,* which had carried a lengthy wedding story including a reference to the beauty of the bride, now called this new farm home "a place of taste, culture and plenty."

Into this house the Wood children were born: Frank, Grant De Volson, John, and Nancy Rebecca. Frank was four when Grant was born, and John was born when Grant was two.

My arrival seven years after John's was a welcome surprise, both to my parents and to Grant. After the birth of three boys, my parents had given up all hope for a girl. Grant was delighted with me because I was blonde. Our two brothers had brown hair and were on the slender side, while Grant was blond and inclined to be chubby. He had wondered why he didn't look like his brothers, but then I came along. I looked so much like him that he was convinced that he was a member of the family.

At nine, Grant was interested in bird watching. He wrote a letter to the newspaper, touching on that subject while offering considerable personal information: the names and ages of his brothers and sister ("Nancy Rebecca has two teeth as sharp as splinters."), his pets (two calves and ten ducks), and Father's promise to get him some white turkeys. With a "rousing big Turkey" in his future, Grant invited "Mrs. Editor" to Frank's birthday dinner.

He also told her, "We boys have studied birds all summer. I like to study birds and insects, but when I take toads or crawfish to our teacher she says it makes her sick."

The following year, Grant wrote another letter to the paper, naming fifty-five varieties of birds he and Frank had spotted in Grandma Wood's yard. They recorded the date of the first appearance of each bird. The editor commented, "His communication on this subject is very interesting and shows that he is an observing, thoughtful, wide-awake boy."

The near future held little birdsong. Life on the farm was to come to a sudden and tragic ending. Father had been ailing about a year when he woke

Mother one night with the words, "Hattie, I feel very strange. I believe I am going to die."

"For pity's sake, Maryville," she said, "let me have Frank hitch up and go for a doctor."

"There's no use sending for a doctor," Father replied. "I am beyond human aid."

He dropped into a fitful sleep, and when he awoke in the morning, he said, "Hattie, I'm sorry I frightened you last night. I don't know what got into me. I feel fine today."

Much relieved, Mother started breakfast. Father ate a hearty meal of ham and eggs, and after reading the mail, said he thought he would drive into town. He stepped to the window to view the weather.

Mother heard a crash. Father was lying on the floor. His summons from beyond had come, and he died before the doctor arrived.

It was Monday, March 17, 1901. Father was forty-six when he died. Frank was fourteen, Grant was ten, John was eight, and I was sixteen months old.

The coffin was in the parlor of our home—the room with the gold wallpaper and the roses. Mother told me that she held me up to the coffin and said, "Look, baby, look. Please, please try to remember him. He won't be here to bring you up, but I want you always to remember him. He loved you so!"

I looked, but I have no memory of my father. Frank and Grant ran the farm as best they could, but Mother sold it that spring. Life on the farm was at an end, but for Grant, it would never end. Much of his art, including *Spring in the Country*, painted in the final year of his life, reflects his early experiences on the farm.

On moving day Frank saddled up the old horse and rode to Cedar Rapids. He was stopped by another horseman who shouted, "President McKinley has been shot!"

The people who bought our farm took Mother, Grant, John, and me by buggy to Anamosa, where we caught the train. The furniture went by farm wagon. It was September 5, 1901. Teddy Roosevelt was about to become president.

In Cedar Rapids, we moved into a rented house. Later, Mother purchased a home at 318 14th St. NE, a well-built box house with three bedrooms in a district known as Central Park. Neighbor boys who would become Grant's lifelong friends included David Turner and William L. Shirer.

Our move to the city brought entirely new sights and sounds. After dark, kids screamed joyfully as they played games, caught lightning bugs, or chased the June bugs attracted to the gas lights on the corners. Horses pulling fringe-topped buggies clomped along the brick paving until they reached our unpaved street. There, the sound was muffled, and a big cloud of dust rose

behind them. Coal rumbled down the coal chutes into cellars. A piano tinkled out the notes of "Redwing" or "On the Trail of the Lonesome Pine." Our own Victrola played "I Picked a Lemon in the Garden of Love," "They Handed Me a Letter Edged in Black," and "The Merry Widow Waltz."

Grant enrolled in the fourth grade at near-by Polk School. This country boy was extremely shy. He found it hard to talk to people, and he blushed easily. Grant often had attended Antioch School barefoot and clad in overalls. Now he was surrounded by city kids in tight-legged knee pants and turtle-neck sweaters. His own "city clothes," selected and paid for by Uncle Clarence, were long pants, a vest, a white shirt, and a big bow tie. Grant's chubby frame, round face, and curly blond hair accentuated the different look of his attire. The boys razzed him and made him the butt of their jokes, but Grant laughed with them and soon won them over. His incisive yet kindly sense of humor and his ability to enjoy jokes on himself would stand him in good stead all his life.

Grant and John built a gym in the former hayloft of the big, white barn in our back yard. They installed rings to swing by and a chinning bar, and Mother gave them an old mattress for a wrestling mat. The boys put a railing around one corner of the loft and installed "box seats" for spectators, who were invited to watch them chin themselves and turn somersaults.

Our property had lots of space for a garden—from the alley to the corner. Grant turned the soil with a hand plow, which was hard work for a boy of ten. He picked up arrowheads and bits of Indian pottery which he used for making watch fobs in later years.

Each year, Grant and Mother did the planting together. Grant knew and followed the rules observed by country people. Potatoes and other root vegetables were planted in the dark of the moon. Vegetables that grow atop the earth were planted in the light of the moon. Corn was expected to be "knee high by the Fourth of July." Grant sold produce from the garden, and still there was enough to feed us all summer and enough to can to last all winter. The basement shelves were filled with jars of tomatoes, string beans, beets, and pickles.

Grant earned money by milking Dr. and Mrs. Richard Lord's cow. Grant and two friends, Bart and Zim (Lawrence Bartlett and Harland Zimmerman), went to hear Billy Sunday, the dynamic evangelist, and found seats in the front row. As the afternoon wore on and the evangelist showed no signs of winding down, Grant grew uneasy. It was time to milk the cow. Finally, he got up and walked out. Billy Sunday took this as a personal affront. He pointed at the retreating Grant and shouted, "There goes a boy straight to Hell!" Grant kept on going.

When he told Mother of the incident, she said, "You should have told him where you were going."

"Oh, Mom," he said, "how would it have sounded if I had said, I'm on my way to milk the Lords' cow?"

Grant also took care of the Woitesheeks' horse. The two Woitesheek sisters lived across the alley from us with their aging father. They didn't get along with their next-door neighbors, the Von Martinitz family, and the Von Martinitz boys built an ugly spite fence. The Woitesheek sisters paid Grant five dollars to knock it down, which he did with a mighty heave on a windy night in the dark of the moon. He said it was the most money he had ever made at one time.

Another of Grant's enterprises came about because of the bad drinking water in Cedar Rapids in those days. At times during the summer, the water had to be boiled for drinking. Buying a small wagon and some jugs, Grant drew artesian well water from a pump downtown and established a water route with door-to-door delivery.

Mother tried to carry out Father's stern beliefs and to make good Christians of us. Each night she read Bible stories to me. By the time I was too old for that, she had read them to me many times. About ten years after Grant had heard our father intone the words, "We Quakers read only true stories," my turn came. Innocently and enthusiastically, I brought home from the library either a book of fairy tales or *The Wizard of Oz*, I forget which. Mother made me take it back unread, saying, "Your father would not approve."

I was taught to say my prayers at bedtime and did so nightly. Mother always said grace, as Father had done. One Thanksgiving I burst out with, "Frank didn't bow his head! He sat up straight!" Mother said nothing, and Frank looked daggers at me. If my own head had been properly bowed, I couldn't have spied on Frank, but no one thought to point that out to me.

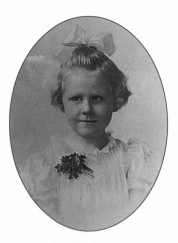

Nan Wood, age 4

Occasionally, Mother took us to see Clairbel Weaver, her first cousin, who lived on a farm just west of Cedar Rapids. Clairbel, who never married, milked all the cows and ran the farm herself, still finding time to join literary societies and other clubs in Cedar Rapids. Grant always thought Clairbel "put on airs." Years later when she expressed her disapproval of his *Daughters of Revolution* (1931), Grant concluded that his childhood impression of Clairbel had been correct.

I was brought up with the smell of turpentine. When Grant wasn't using it in his painting, Mother was using it to doctor us. If we had a cut, she put turpentine on the

wound, and it hurt! When we had colds, Mother made a poultice of turpentine and lard and placed it on our chests. Once when Grant stepped on a nail, Mother saturated a woollen rag with turpentine and lard and made a smudge by lighting it. She had Grant hold his leg over the smudge, saying it would draw out the poison. Grant called his injured limb "smoked ham."

Banana oil was another common odor at our house. Grant used a lot of it. One day he was using it when Mother was baking a custard pie. The pie took on the banana flavor, and we were afraid to eat it. Mother was so upset she called it "pustard kie." From then on, custard pies always were called "pustard kies" in our house.

We usually ate in the kitchen because Grant laid his projects out on the dining room table. When he found India ink as a medium, he began to do drawings and cartoons. For a spatter effect, he would ink an old toothbrush and draw a pin across the bristles. One cartoon I recall was of a fat man lying on a beach clad in an old-fashioned striped bathing suit. A huge mosquito was biting him, and Grant captioned it "Living on the Fat of the Land." Another cartoon was of a boy named Lorrey, who was eating. Grant's caption was "Lorrey Ate," and none of us dreamed that decades later in 1940, Grant would be named Artist Laureate of America.

One of Grant's boyhood hobbies was collecting bugs, salamanders, tadpoles (we called them "pollywogs"), toads, caterpillars, and garter snakes. He carefully studied their markings and noted how each was perfect in its own way. He watched, fascinated, as butterflies emerged from their cocoons.

Early in his Polk School days (1902), Grant wrote letters to his former classmates at Antioch School on tablet paper. In one, he commiserated with his friend over the death of a pony, talked about the Belgian hares he was caring for, and wrote, "We have painting and drawing, and if I get time, I will send you one of my paintings." The second letter described Bird Day at school, reported that he had learned to ride a bicycle and planned to buy one, and mentioned that he had sent the painting the recipient had requested with what sounded like a request to borrow it back.

Grant never fought, but John did. When Grant was about twelve, he came home bloody and with a black eye. He said three boys jumped him, thinking he was John. Grant didn't cry. He simply said, "I'm mad."

Emma Grattan, a woman of powerful personality and strong likes and dislikes who never hesitated to speak her mind, was the art supervisor for all Cedar Rapids schools. She constantly prodded the superintendent of schools for more time to teach art, and people were saying, "Are we trying to turn out a generation of artists?"

Miss Grattan went from school to school, checking on art instruction, and she spotted Grant very early. Recognizing his unusual talent, she encour-

aged him. Frequently, she asked that he be excused from his regular classes to come to her office and work.

Grant loved those days. Miss Grattan provided him with paints and brushes and let him paint whatever he wished. Once, as he was leaving, she handed him a half-can of sardines. She said she couldn't eat them all and hated to have them go to waste because they were so choice. Grant brought them home. Mother shared the general view that food that had stood in an open can should be shunned, and she urged Grant not to eat the sardines. Grant told her that Miss Grattan said it was perfectly all right, and he believed her. He ate the sardines with no ill effects, and Miss Grattan eventually became a close, life-long friend of us all.

A family for whom Grant did odd jobs gave him two tickets to a lecture by the famed sculptor Lorado Taft, and he took me. I was too young to appreciate it, but Grant was so inspired that he decided to try his hand at making plaster casts. His first attempt, his own fist, turned out perfectly. He kept it for many years, and then it was missing. We believe it was stolen. I would give almost anything to have that cast today.

Grant's next attempt was to make masks of his two friends, Bart and Zim. Mother wrung her hands. She told Grant that masks were made only of dead people. She said the boys might smother, but Grant was determined and the boys were willing. One of them breathed through a tube in his mouth, and

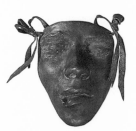

the other had a tube in one nostril. The complete masks were perfect, showing every line and pore on the boys' faces. The boy who breathed through a tube in the mouth appeared to be smoking a cigarette. Years later, when Grant completed his studio on Turner Alley, he gave these masks a coat of toned-down gold paint and hung them, one on each side of the door. Today they are in the collection of the Davenport Museum of Art.

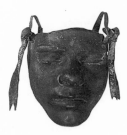

The year 1905, when Grant was 14, was a year of decision for him. He won third prize in a national contest for a crayon drawing of oak leaves, and the *Cedar Rapids Gazette* commented, "The award of third prize in such a contest shows excellent art ability." Grant always told me that the prize inspired his decision to be an artist, and a good one. Nothing ever deterred him from that resolution.

When Grant was in the eighth grade, the teacher asked all pupils to write a theme on places they would like to visit in Europe. Grant invited some of the boys in his class to come over one evening to talk about

it. Mother baked cookies, and Grant made a paper cook's hat and apron for me to wear while I served. Mother opened a jug of homemade grape juice, and at the last minute, Grant put a pinch of soda in it to make it fizz.

"Fellows," Grant said, "why don't we really go to Europe this summer? We could bicycle to New York and earn our way on a cattle boat."

The voices were shrill with excitement as they all said, "Let's do it!"

The only dissenter was Mother, who thought fourteen-year-olds were too young for such a trip. To her surprise and consternation, all of the parents gave permission, but she stood her ground and refused.

Grant bore his disappointment quietly. He, who had the idea, was the only one of the group who did not go to Europe. All summer long, when he received a card from Asel Moore or one of the others, he had a sick look on his face. So did Mother. She was sorry she had not let him go.

At this point, Grant had known about automobiles for four years— through our brother Frank, whose passion was cars. When Frank was fourteen, he was offered a ride home from Washington High School in the first horseless carriage in Cedar Rapids. The driver and owner of the Locomobile Steamer was W.G. Haskell, prominent coal man and state senator. Mr. Haskell drove Frank right up to the front door, and Frank was never the same again. He was wild about automobiles. He read everything he could find about them. He sent a letter of inquiry to Davenport, and a representative came to Cedar Rapids to offer Grandpa Weaver the Oldsmobile agency, saying cars were the coming thing and were here to stay. Frank added his passionate agreement, and Grandpa Weaver was convinced that he was right. He started business with Frank as a full partner at the rear of Grandpa's home at 1640 A Avenue NE. The overflow was stored in our barn. This was the first automobile dealership in Cedar Rapids, and it expanded almost immediately to handle the Reo and Oakland makes. When Grandfather's brother died in Texas, his uncrated new car was routed to Cedar Rapids, and now the partners had a Mobile Steamer for sale, a competitor of the Locomobile Steamer that had won Frank's heart.

The business prospered and was moved to larger quarters downtown. Grandpa Weaver didn't live to enjoy it for long. One Sunday, he took Grandma, Mother, Aunt Minnie, and me (I was five) for a ride. The automobile was bright red and had a steering rod, as steering wheels were still rare. The car had two rows of seats and a buck board, looking much like a buggy, but there was no place for a whip.

All the roads were unpaved and full of ruts. We dressed for the occasion. Grandpa wore a long duster and tin glasses with vision slits. The rest of us wore dusters, tin glasses, and hats tied on with long veils. Our faces were well-greased to protect them from sun and wind.

The automobile's narrow buggy wheels and tires sank deeply into the sand. We were halfway between Cedar Rapids and Marion when we got stuck. Grandpa had us get out, and he pushed and pushed. It was a hot day for September. Finally, Grandpa got the auto out of the sand, but his face was red, and he was short of breath. We had to wait a while before he could drive us home.

The next morning, I found Mother sobbing. She said Grandpa had died of a heart attack. He was seventy-three on the day of his death, September 2, 1905. Grandma Weaver lived with Aunt Minnie for a time and in 1906 came to live with us, remaining until her death in 1912. Mother's brother Fred became Frank's partner, but Frank moved to Waterloo while he was still in his teens. There he built a small battery business into a chain of five stores—the Standard Battery and Auto Parts Company—a business he continued until his retirement.

Grant finished the eighth grade in 1906. At fifteen, he entered Washington High School, where he met another entering student, Marvin Cone. They shared a strong interest in art, became close friends immediately, and continued that relationship for the rest of their lives.

One of Grant's earliest recognitions came when he was a freshman. Passing over its own art students, Coe College asked Grant to make the scenery for two operas, one of which was Giacomo Puccini's *Madame Butterfly*.

Frank said, "You don't know how to make scenery. You'll make an awful mess of it."

Mother was worried, but Grant was confident. He accepted, and everyone at Coe College was delighted with the results. Large photographs of the sets were in our home for years. This was the start of a secondary career. Grant and Marvin Cone created countless stage settings for plays over the years, sometimes individually, but usually by working together. Although Grant was paid $18 for the Coe College sets (the most he had received for a single effort at that time) plus passes to the opera for Mother and me, the subsequent work was done without charge.

When Grant was a sophomore, he did most of the drawings for the high school yearbook and contributed drawings to the school magazine, *The Pulse*. A *Pulse* cover drawing was reproduced in the *Cedar Rapids Gazette*, which commented, "The artistic ability of this young man is splendidly proven in this instance, as it frequently has been before . . . the future development of this artistic talent will be watched with interest."

Grant was a student, but he was getting his first teaching experience as well. I was the pupil, and I learned what many were to learn later—his enthusiasm was catching. Always patient, he would show me what to do, but he would never touch the work of a student. "If I did, it wouldn't be your work," he would explain, drawing on the back of an envelope to show me what to do. When he finished, he would say, "Now draw it yourself."

Once I entered a contest sponsored by a furniture company, hoping to win a miniature wood-burning cook stove. The company furnished the crayons and gave us a picture of a room interior. I took it home and tried to get Grant to color it for me so I could win. I coaxed and I cried and I carried on, all to no avail. "You've got to be honest about this," he insisted. When I won the contest, his lesson was not lost on me. I was delighted to have done it on my own. Grant was pleased. He got the pipes and hooked up the little stove for me. He hammered out of copper a little teakettle that worked perfectly and is now in the Davenport Museum of Art.

Grant made a "cozy corner," a popular fad at the time, covering two wooden boxes with cretonne and putting them in a corner. Then he made drapes above them and hung a lantern he'd made from a Quaker Oats box. My little stove was in the kitchen, and all the little girls in the neighborhood would come to play with it. We used the teakettle for heating water and making what we called coffee. It was terrible stuff! Mother would save the tiny potatoes out of the garden, and we would boil them and cook up awful messes.

From their earliest high school days, Grant and Marvin were members of the Cedar Rapids Art Association, serving as volunteers for all sorts of duty. Their free services meant the success of many projects. They unpacked every painting that came for exhibition, and this was a a big job. Each incoming painting had paper pasted all over the glass to keep it from shattering and damaging the art. The paper had to be scraped off with a razor blade, and then the glass had to be cleaned. When the exhibit closed, Grant and Marvin took the paintings down, pasted paper on all the glass, and repacked the art. When an exhibit was especially valuable, Grant took a folding cot to the gallery and spent the night guarding the works. Sometimes Marvin would get up at 5 a.m. and throw pebbles against the second floor windows to wake Grant. Then they'd spend the early dawn hours copying the Old Masters together. When Grant went sketching, I was his companion if there wasn't anyone else, but when Marvin Cone went with him, I had to stay behind. I was terribly jealous of Marvin.

Grant loved to dance. Every noon when he came home from school, he would practice with me as his partner. I finally rebelled, having no ear for music and no rhythm, but Grant became one of the best dancers in high school. He and Paul Hanson worked up an act in which they slapped their legs and the soles of their feet. It was well received. In our family, Mother was the only one with musical talent. When the rest of us tried to sing, it was like dogs howling, and our speaking voices were equally unreliable. In moments of stress or excitement, Grant's voice went way down in the cellar. Mine would go way up in the air. Poor John stuttered when he was embarrassed; only Frank escaped the curse of poor speech.

One day Grant's friend Bart, who had a motorcycle, invited Grant to take it for a ride. "Get on," he said. Grant did, and away went the motorcycle. Grant thought his only task was to steer. After nearly five miles—half-way to Marion—Grant said, "When you want me to turn around, just say so." Hearing no reply, he looked around and discovered he was alone on the cycle. He had no idea how to stop it. The cycle ran out of gas in Marion, where Grant got some instruction from the service station attendant and drove home. Grant tried to explain why he was gone so long, but his friend could not believe he had never driven a motorcycle and refused to lend it to him again.

Grant was still in high school when he began his interior decorating business, which he continued intermittently for more than twenty years. He went on with it until well after *American Gothic* (1930). I was his first "employee." When we showed up for a job, Grant would introduce barefoot me with my hair in pigtails as his assistant, and people would burst out laughing. Yet we worked so cheaply, I supposed they figured they couldn't lose. Grant took the upper part of the room, and I took the lower. He showed me how to hold the brush and how not to leave brush marks. He designed and made his own stencils for borders. In all his work, he was a perfectionist, and we worked up a good reputation as decorators, plying our trade in some fine homes.

No job was too big for Grant. When the Central Park Church wanted bids on painting the interior of the chapel, Grant won against professional painters with an $18 bid. He was in the red on this job before he started, paying more than $18 to buy lumber for scaffolding and calcimine to put on the walls. Grant didn't mind at all. He told me that painting the church would be good advertising, and he was proud of a job well done.

The ladies of the same church combined their favorite recipes into little cookbooks. A pompous elder with long, white "goat" whiskers asked Grant to paint a flower on the cover of each of the one hundred books. He said he would give Grant a dollar for the lot when they were finished. Grant spent hours and hours painting flowers and little scenes on the one hundred books. Months went by, and there was no dollar. When Grant asked the elder to pay, the man said in an enraged tone, "What dollar, young man? I don't owe you a dollar for painting those cookbooks. The effrontery of you asking me!" Grant was never paid, but the covers were so nice that some are still cherished by their owners.

Years later, this same man came to Grant's studio and asked him to do some illustrating. Grant said, "I do not care to do any more free work for you." The old man turned and glared at me. "Are you the maid?" he asked. Then he pounded his cane on the floor and said, "Tut, tut, young man. You'll come off your high horse someday."

Grant completed high school in 1910. He was already nineteen years old by a few months. He left high school with memories of the only stage

appearance of his life—amateur or otherwise. Grant played the hind end of a horse, and a girl rode the horse. Slated for no speaking role, Grant whispered one sentence, "Please don't put all your weight on me."

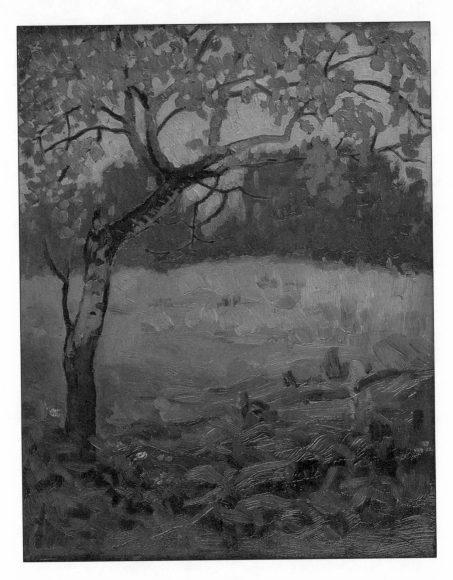

Quivering Aspen, 1917
Oil on composition board, 11x 14 in.
Davenport Museum of Art

CHAPTER 2
A WIDER WORLD

With high school behind him, Grant was determined to be an artist. Even at nineteen, however, he was well aware that a young artist could not expect to support himself by his art, let alone take care of a mother and younger sister. Grant also was determined to further his education, and he knew it would cost money, which he didn't have. He settled on a mixture of working, saving, attending art schools, reading, and painting.

The very day of his graduation, Grant left for Minneapolis to accept a scholarship from the Arts and Crafts Guild operated by the highly respected Ernest Batchelder. Grant studied copper work and handmade jewelry, two areas in which he had experimented previously. He proved to be such an apt pupil that when Batchelder was ill for a few days, Grant was asked to take the class.

To put an end to sleeping in the park, Grant and a new friend, Harold Kelly, answered an ad for a mortuary night watchman. That job lasted until the night the undertaker couldn't get a toupee to lie down and calmly tacked it to the forehead of the corpse. That was enough for Grant and Harold, who promptly decided that sleeping in the park wasn't so bad after all.

After a full summer of apprenticeship, Grant became a professional craftsman in the Guild's shop under Batchelder. Eventually, he left because he found no time or place for painting. He missed his dining room studio.

Years later, a writer who knew neither teacher nor pupil wrote that Batchelder had a great influence on Grant's painting. Batchelder, then elderly and living in California, was delighted to read the story, but it was not true. Copper work and jewelry making were part of the curriculum, but painting was not. Even so, Grant always said Batchelder was an excellent teacher.

Back at home, Grant quickly filled the dining room with studio projects again, and home life seemed more normal. He brought Harold home with him, and the girls were crazy about this handsome, dark-haired fellow. He and Grant double-dated a number of times. Once they went on a triple date with our cousins, Stella and Maxine Pope. The girls brought a friend for Grant, and he brought Ralph Conybeare, who dated Stella. Ralph and Stella later married. This was the first of three occasions on which Grant played Cupid.

Grant wore rimless glasses that perched on his nose—the pince-nez popular at the time. Fragile, they were attached by a cord to clothing to keep them from falling and breaking in case they came off. The skin on each side of Grant's nose looked dented and red, and he often removed the glasses to give his poor nose a rest. The glasses gave him a studious, intellectual look. Grant's hair had darkened a little but still was wavy. The cleft in his chin (he always said his chin was parted in the middle) was more pronounced. Navy blue suits were the order of the day, and they tended to get shiny in the seat, knees, and elbows. Grant would swab the area with water that had a bit of vinegar in it or rub it with an art gum eraser.

Grant took one job over Mother's protests. The work was at the roundhouse, the big building where they turned locomotives around while making repairs.

Mother said the work was too heavy and added, "For pity's sake, get a job where you can use your talents."

One day at work Grant got a sudden pain in his back and couldn't straighten up. He quit, deciding Mother knew best.

Grant and Harold both worked all the summer of 1911 on the farm of the Woitesheck sisters about thirty miles away. They enjoyed the farm work, but neither was happy with the sleeping quarters—blankets spread on the hay. Grant told us their sleep often was disturbed by rats running over them, some almost as big as cats.

Grant obtained a license to teach and took a country school at Rosedale, six miles away, for the 1911-12 school year. He took the interurban train as far as possible and walked the rest of the way through rain, sleet, or snow—except for a short time when he boarded with a farm family and came home weekends. The pay of $40 a month was not the only lure. In lieu of a college education, he could qualify to teach in city schools by teaching a full year in a rural school.

Grant proved to be a qualified and innovative teacher. To raise money for books and other school needs, he put on all-school parties, creating carnival booths all the way around the school room. In a typical booth, the visitor paid

for a fish pole and dangled it over a screen. When there was a "bite," it meant the pupil behind the screen had tied to the string a "fortune" written by Grant. His friends came from Cedar Rapids by bobsled for these parties, and although it increased the profits, it ended when some of the farm families objected to having "city folks" at their school parties.

In 1912, Grant established a jewelry and copper workshop in the basement of Kate Loomis of Cedar Rapids, and his creations were both original and beautiful. One of his clients was a wealthy family that had just built a mansion on B Avenue. They consulted Grant about their problem, a smoking fireplace. He corrected the difficulty with a beautiful copper fireplace hood of his own design.

Grant commuted by interurban railway to the State University of Iowa School of Art in Iowa City in 1912-13. He dropped in on a life drawing class for which he was not registered and so impressed the teacher that he was allowed to stay on without charge. That teacher later founded the Cumming School of Art in Des Moines.

We said good-bye to Grant in 1913, when he enrolled at the Art Institute of Chicago, where he would study for more than a year. To pay his way, he got a job as a master craftsman at the Kalo Shop, exclusive makers of handmade jewelry. He worked days, attending classes at night. Grant and several other men who worked at the Kalo Shop rented an old farmhouse on the outskirts of Chicago. They took turns doing the cooking. Grant's housemates were Norwegians, and he came to like their cooking. Sourdough bread that was several days in the making was a particular favorite.

Grant and one of the men, Christopher Haga, decided to go into business for themselves. They rented a room in Chicago, found shop space nearby, and began making jewelry. At first, business was encouraging, but this was 1914, and with a war beginning in Europe, they noticed that soon no one was buying jewelry. Grant walked the streets looking for work, found none, and returned to Cedar Rapids.

Coming home, Grant learned the news that Mother had withheld from him. She had lost the house, and she and I were living with Aunt Minnie. When Father died, the farm was paid for and he had carried life insurance, but Mother's funds were now exhausted.

With Frank and John married and Grant in Chicago, Mother had tried renting rooms, but she was entirely too soft to be a landlady. The renters got away without paying their rent and they stopped up the plumbing. One young man, a Coe College student, got sick. Mother was so sorry for him that she took care of him all winter and gave him room and board free.

At Aunt Minnie's request, we moved in with her, and Mother rented our house furnished. This was an equal disaster with the rent unpaid and Mother without money for mortgage payments. The mortgage was foreclosed.

Mother's organ was long gone. The beautiful plush carpeting with the roses bought with her teaching money went to a neighbor, Mrs. Main, for $15. All the rest of our furniture went to a second-hand man who loaded it on a large truck before informing Mother he had no money with him but would pay the next day. Neither he nor the furniture ever were seen again. His neighbors reported that he packed his belongings and left in the middle of the night.

Grant walked the streets of Cedar Rapids applying for work with no better luck than he had in Chicago. He resumed his interior decorating and did odd jobs to pay Aunt Minnie our share of the grocery bills. Grant also painted her living room.

Grant slept in the attic. His dining room studio was gone, but so was his time for painting. He was determined to build a house, but first, there was to be a reunion with the Woods.

Father's life insurance policy named Mother as the beneficiary, but after his death, his two brothers and his sister sued to collect the life insurance. The case went to trial, and Mother won. We had not seen or heard from them since. I was a baby when Father died, but now, nearly fourteen, I was the one to break the ice. I saw a magazine article about the Wood farm, and on impulse, I sent a valentine to Aunt Sallie in February 1914. It got no response, but some time later, Aunt Sallie telephoned to tell us that Uncle Eugene had died. She asked that Grant and I attend the funeral the next day.

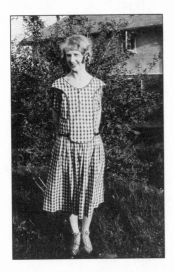

Nan, age 18

A man met us at the depot in Anamosa. After a long drive by horse and buggy, we arrived at the farm, where the funeral service was already underway. We were ushered into the parlor, where the family was seated near the coffin. This was the first time in my memory that I had seen Aunt Sallie and Uncle Clarence. Grant, now twenty-three, had not seen them since he was ten.

The parlor was a copy of our own farm parlor which Mother had described to me so often: golden wallpaper, cabbage roses, and matching carpet of cream and amber.

Aunt Sallie took my hand and led me to the coffin. Tears streamed down her face as she said, "This is your Uncle Eugene. Take

a good look, for you will never see him again."—Mother's words as my infant eyes regarded my dead father.

I looked. Uncle Eugene had bright red hair. Aunt Sallie had black eyes and coal-black hair with a ghostly, dead-white complexion. She also was haughty in manner. It seemed impossible that these people could be blood relatives. With our blue eyes, light hair, fair skins, and stubby noses, Grant and I had the looks of the Weavers.

After the service, Aunt Sallie lit the kerosene lamp, and we sat and talked, mostly about Uncle Eugene and his last illness. Grant's coming was a great comfort to Aunt Sallie. He was her favorite nephew, and she said she always had told herself that someday Grant would come back to her. She had many plans for his future and had decided she was going to make a florist of him because it was such clean work.

Grant went home the day after the funeral, but I stayed two weeks. From my window I could see a large grove of towering pine trees planted years before by Grandpa Wood. This grove was half a city block in length and equally as wide, hiding the house from the road. All around the house were giant elm trees, and in back was an apple orchard with huge, overgrown trees. On later visits I discovered that the foliage from all these trees was so dense that the rooms were dark in broad summer daylight. At night, the only sounds were the swishing of the wind through the pine trees and the throaty hoots and calls of the owls. It was a mighty lonely place, and it is just as well that Mother never came to the Wood home. The only times she ever saw the Woods were on their rare visits to Cedar Rapids. She always treated them cordially, and this spirit was mutual—with one exception. Aunt Sallie blamed my bad points on my mother while crediting Father with my good attributes.

I attended high school in Waterloo in 1914-15, living with my brother Frank and his wife. When school was out, I returned to Aunt Minnie's and some wonderful news. Grant had purchased a lot for $50, payable a dollar down and a dollar a month, and he was going to build a home for us. It was a large lot— an acre or so—about a mile from the little town of Kenwood Park, now a part of southeast Cedar Rapids. It was simply beautiful, including a hill and a high bluff above Indian Creek. Wildflowers and ferns were everywhere, and giant oak and elm trees grew on both sides of the swift-running creek.

Frank sent enough lumber from Waterloo for a ten-by-sixteen-foot cabin. Starting his first building project, Grant was free to use his imagination. He said, "Nicky, it doesn't cost a cent more to build something decent than it does to junk up a place. Even if it is small, there's no excuse for it not being nice."

Grant gave the cabin a Dutch door and roof, stained it light brown, and set out flowers and vines. We called it our "shack," but actually, we had many conveniences. Grant was building a new life for us all.

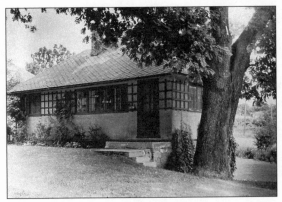

The Kenwood Home built by Grant.
Grant, Nan, and their mother lived here from 1917 to 1924.

His ingenious innovations were many. For instance, Mother and I slept on a cot. In the daytime, we placed pillows across the back and used it as a couch. Grant cut half the legs off his small cot, and we could slip it under ours during the day.

A low partition divided the living area and the kitchen where Mother cooked on an oil stove. Corner cupboards with scalloped edges held dishes and groceries. Grant cut a hole in the floor at the end of the kitchen and fitted it with a trap door for rubbish disposal. When the rubbish box was full, he had a bonfire. A spigot on a rain barrel extended into the kitchen to give us running water. For a sink, Grant used an old phonograph horn and drilled a hole in the floor to let the water run out. Our wash pan fitted nicely into the horn, and the waste water flowed to the vines and flowers.

Outside, Grant built a table and benches under a crabapple tree. This was a beautiful place to eat, especially when the tree was in bloom. Grant said that someday he would hollow out places in the table to use instead of plates. Mother could clean them with a swipe of the dishcloth, the crumbs would feed the birds, and there would be no dishes to do.

Cousin Clairbel Weaver gave Grant a dozen baby chicks to raise, and he planted a large garden. We enjoyed wild strawberries, gooseberries, walnuts, butternuts, and mushrooms from our own land. Grant bought a motherless calf for three dollars and named her Lucy. I helped Grant drag the reluctant Lucy six miles to her new home, and it took us from 8 o'clock to midnight. Our hands were blistered, and we were covered with dust and dirt. We all came to love Lucy, but she remained frisky, even when full-grown. Mother and I were wary of her, but Grant always handled her with ease. He lifted Lucy every day until she became too heavy.

Most of the people who flocked to our place were Grant's friends. First, they came to see how the project was progressing, but later, they came just to

be with us. We had loads of fun, enjoying corn roasts and mulligan stews provisioned by Grant's garden and cooked over an open fire. Mother baked rhubarb and gooseberry pies.

New sounds on hot summer evenings included faint music from the open-air dance hall a mile or so away on the road to Marion. Bullfrogs croaked all night, but we never could find them in the daytime.

Cold weather was a problem because the cabin was not winterized. We spent the cold months next door in a cabin built by Paul Hanson, Grant's high school friend. Paul and his family lived with his parents in Cedar Rapids during the winter. The pot-bellied stove produced more heat than our cook stove, but the Hanson cabin was not insulated either. I never knew it could get so cold inside any structure. We suffered, but we survived.

Then Grant and Leonidis (Lon) Dennis built three "real" houses, two for Paul Hanson and one for Grant. Ours would later have the address of 3178 Grove Court, and it was our home until 1924. Grant paid Lon $150 a month, combining cash, paintings, and a note. When Grant finally paid Lon off, Lon returned the note. On the back, he had drawn a picture of our house and printed "Free at Last." Grant said he had a notion to frame it.

The houses Grant and Lon built were strong, sturdy, and fully insulated. They mixed and poured concrete floors and laid tile foundations. Grant designed hip roofs. Our home was on two levels with outside entrances on each. On the upper level were two bedrooms and a living room with windows on three sides. Grant laid the hardwood floors. A dining room, kitchen, and furnace room/bathroom were on the lower level. We did not have running water, but Grant built a chemical toilet. We bathed in a galvanized tub in the kitchen.

Frank sent us dining room furniture, which Grant refinished. He dyed an old carpet a soft green for the dining room and painted the walls a mellow orange. He stained the ceiling beams light brown and stenciled a design of seed pods between them, picking up the colors in the room.

About two miles away was Cook's pond, which Grant called "Corot's pond." On hot summer evenings, he and Paul Hanson would swim there. As a hoax, Grant made molds and cast some giant footprints, pressing them into the sand to make tracks leading to the pond. Then he dove in and came up with his head covered with decaying leaves and dripping mud. Paul took a picture of this horrible creature. Grant made more of the giant footprints in concrete and used them as stepping stones from our house to a rustic bridge he built over a tiny stream in our back yard. Years later, a new owner raised the level of the back yard with fill dirt. After Grant's death, David Turner had the fill dirt dug up in an effort to find the footprint stepping stones. None were found, but news of the "dig" got into the papers, and a Los Angeles concrete company began to

make and sell Grant Wood Stepping Stones. A newspaper ran an article with instructions for making the stones and sold patterns. For a long time, it was not uncommon to find giant-footprint stepping stones for sale in lumber yards.

Grant found time to resume his art work, working both in the cabin and in our new home. He did some commercial illustrating, including a design for a corn oil can label. He submitted three designs, and a Cedar Rapids company selected one and told him to send his bill. Grant, who never charged enough, billed for $6. Fortunately, a good friend of Grant's worked in the office of the company. He changed the bill to $60 and told Grant, "They won't think your work is any good if you charge so little. You don't know the value of your own work. Actually, that design is worth $600 if it's worth a cent." The company officials were pleased, both with the work and the price, and the design appeared on labels for many years.

Grant moved into another art form by writing a story titled "No Trespassing." He sold it to Country Gentleman for $50.

One year in those times when the city directory came out, we discovered that Grant had listed his occupation as "painter." The only calls resulting from that listing were from people wanting their houses painted, and Grant decided that was no way for an artist to describe his profession.

Most of Grant's paintings of this era were given away, and those that were sold went for nominal sums. Some families still have Grant Wood paintings from the days before World War I, but others sold them.

In the summer of 1915, I visited Aunt Sallie and Uncle Clarence again. It was threshing time, and Aunt Sallie's dinner table made a lasting impression. It was laden with fried chicken, home-cured hams and sausages, and mashed potatoes and gravy, with many choices of vegetables and pies—enough to feed the entire threshing crew.

I also have vivid memories of Aunt Sallie taking me to Quaker church at Whittier and later visiting with some Quakers who she said were distant relatives.

The three-piece bathroom installed on the first floor of the Wood home was their pride and joy, the only one in the countryside. This bathroom was seldom used, its principal purpose being to impress people. All visitors were taken to see it, and all were favorably impressed. The bathtub did have one practical use. It held the big cheese Uncle Clarence ordered each winter from Montgomery Ward & Company of Chicago.

Aunt Sallie Wood died in 1927 at the age of sixty-two. Uncle Clarence was now seventy. Grant was Aunt Sallie's favorite nephew, and I had been with her summers from the time I was fifteen until I was twenty. Aunt Sallie left about $40,000 in trust for Grant and me, giving Uncle Clarence the power to invest and re-invest, serving without bond. He met some confidence men in Mexico City, converted the entire trust to cash, and handed it over to them. Uncle Clarence cried when he told me about it, saying he would make up every penny of it to us some day. Instead, he died in 1937, leaving his entire estate to one Etta Lee. My brother Frank helped me bring suit, and we won.

When the first Liberty Bonds of World War I were issued, Grant offered to make a booth for their sale next to the post office in downtown Cedar Rapids. His offer was accepted, and he decided to make the booth in the form of a giant Liberty Bell. Using geometry and algebra, he figured the exact size for the frame and the canvas.

He cut the canvas in bell-shaped pieces like segments of an umbrella, and while he was making the wood frame out in the yard, I was stitching the canvas pieces together for him. They were a perfect fit for the frame.

People were curious about the frame taking shape. When they asked Grant what he was doing, he told them he was making a "flying bell." The word went around that Grant Wood must be balmy, that he might get killed, and that he should stick to building hip roofs—opinions that made him chuckle as he worked.

The bell was the same size as the Liberty Bell, and Grant bronzed it, painted a crack on it, and painted the letters exactly as they appeared on the real thing in Philadelphia. It was loaded on a truck for the three-mile trip to the Post Office, and it created a sensation on First Avenue. People thought it was the real Liberty Bell, calling friends and relatives to say, "They're moving the Liberty Bell into Cedar Rapids. Come out and look at it!"

Once situated, it still was mistaken for the real thing. After a rainy day when a number of people whacked it with their umbrellas, trying to make it ring, a policeman was assigned to Grant's bell to keep people from punching holes in the canvas.

In April 1917, Grant began work on a mural for Harrison School titled *Democracy Leading the World on to Victory*.

It covered the west wall of the corridor of a new annex. Democracy's four-fold support was represented by a khaki-clad soldier, a sailor in blue, an

engineer with his transit compass, and a figure representing Labor. Overhead was the figure of Democracy pointing the way with outstretched arm, and all looked toward the printed text of President Woodrow Wilson's speech. A door threatened to cut the painting in two, but Grant placed the figures to the right and the speech to the left of it.

For my eighteenth birthday, July 19, 1917, Grant made me a painting called *Quivering Aspen*. I had never heard of aspen trees, and when Grant gave me the painting and told me its title, I exclaimed in great joy, "An aspirin tree!" Grant patiently explained. Although the painting often was exhibited by its right title, our household referred to it as "Quivering Aspirin." The painting is now in the collection of the Davenport Museum of Art. On that memorable birthday, Grant also built me a dressing table and bought cretonne to skirt it and make matching drapes. He helped Mother choose colors that would go with "Quivering Aspirin" to make a braided rug.

Aunt Sallie's graduation present to me was a course at the Cedar Rapids Business College. Miss Grattan told Aunt Sallie that she should have sent me to art school, but Aunt Sallie said she had failed to make a florist of Grant, and "one artist in a family is enough." Grant advised me not to go to business school, but inasmuch as my aunt had spent all that money, I felt I had to go through with it. The results confirmed all of our misgivings. I became the world's worst stenographer.

On the home front for a time, Grant learned how to trick a chick. Our neighbors let their chickens run loose to peck holes in Mother's tomatoes and uproot things with their scratching. Mother kept a pile of pebbles handy to throw at them, becoming so expert that Grant said he would take her to a carnival and win some prizes. He took another approach. He dropped a trail of corn into our kitchen and put a string on the doorknob. When a chicken followed the trail inside, he pulled the door shut with the string, and we had the wandering fowl for Sunday dinner. Grant felt remorse over this and said he'd never kill a chicken again.

Because he had flat feet, Grant was excused from military service, but he waived the exemption to serve with the 97th Regiment, U.S. Army Engineers. The day he left us to go to war, we shook hands formally in farewell. Our family never had been demonstrative, as Father had not believed in a show of emotion. As close as we were, we would have found it embarrassing—even in this situation.

However, when Grant was out of sight, Mother could hold back no longer. Wiping the tears away, she said, "Like as not, we'll never see him again." This was one of the few times I ever saw her cry.

Grant departed for nearby Marion, where he was put in charge of a number of men going to Camp Dodge northwest of Des Moines. They all arrived safely.

Before this time, Grant was involved with a Chicago girl. They exchanged letters, and Grant made several trips to Chicago. He gave us glowing accounts of the girl's apartment and of a thick, syrupy, after-dinner drink they enjoyed but which was unfamiliar to him. Before Grant went into the service, the girl knitted him a khaki sweater, but we were to hear no more of her.

In his spare time at Camp Dodge, Grant made pencil sketches of his fellow soldiers. He charged a quarter for doughboys and a dollar for officers. After Grant became famous, he occasionally received letters from old buddies telling him how proud they were to have their own signed Grant Wood pencil portrait. Some asked him what he thought the portrait would be worth.

Grant sent home all his portrait money plus as much of his pay as he could spare. As Grant's dependents, we received $35 a month—$25 for Mother and $10 for me. Frank filled our cellar with coal, bought a hundred-pound bag of sugar, and helped in other ways, but with wartime prices soaring, times were hard.

The nationwide influenza epidemic hit while Grant was at Camp Dodge. Along with many other soldiers, Grant became sick and was sent to the hospital in a car so crowded that he had to stand on the running board and hang on. The hospital was so full that they couldn't find covers for all the patients. Grant was one of four men in a small room, and when one of them developed the chills, Grant took off his coat to cover him. By morning, Grant was the only man alive in that room.

As it turned out, Grant's illness was an appendicitis attack; the doctors decided against surgery.

Fredrick Newlin Price got that story all wrong in the 1930s when he wrote "The Making of an Artist" for the *New York Herald*. Talking long distance with Arnold Pyle, he misunderstood the word "appendix" and wrote that Grant Wood suffered "an attack of anthrax while in service." The error was repeated by other writers, one adding that Grant Wood "nearly died of anthrax." Grant parted with his appendix about a year after that first attack.

From Camp Dodge, Grant went to Washington, D.C., to serve in the American Expeditionary Force Camouflage Division with a group of artists. Their job was to make dummy cannons and to camouflage the real ones. Some of the dummy cannons were placed on display at the Smithsonian Institution.

In a repetition of his heart-breaking eighth grade experience, Grant saw his entire group leave for Europe without him. Why? No shoes could be found to fit his flat feet. Thwarted a second time in his desire to see Europe, he vowed to go as soon as he could save enough money for the trip.

Two weeks later, November 11, 1918, the Armistice was signed. Grant was mustered out, arriving home on Christmas Eve. This was the happiest Christmas we ever had. Grant regaled us with his experiences at camp, and Grant the non-singer convulsed us with his deep-voiced rendition of "Beautiful Katy," which every doughboy knew. Whatever he lacked in pitch and timing, he made for with his enthusiasm. He also knew "Over There," "Tipperary," and "How Are You Gonna Keep 'em Down on the Farm?" but "Beautiful Katy" was the only one he dared to sing.

Friends advised Grant to apply for his soldier's bonus and use it toward the price of a trip to Europe, but he declined. He said that he had not gone overseas, and that Uncle Sam didn't owe him anything.

The happiest times of Grant Wood's life followed his discharge from the armed forces: the years of teaching, four trips to Europe, convivial associations with those who shared his interest in all of the arts, and steady progress toward his own professional goals.

First, Grant applied for a job teaching art in the Cedar Rapids public schools. He was short on credentials, but the school officials were so delighted to have him that they gave him a special license. With no money to buy civilian clothes, he started his teaching at Jackson Junior High School in his Army uniform: wide-brimmed hat with four dents in the crown, snug-fitting coat, pants like riding breeches, and leggings of wool khaki wrapped from ankles to knees. He wore stubby high-topped shoes and sported a close-cropped military haircut. His army-issued glasses hooked behind his ears. He used his first paycheck to buy civvies.

While the pupils were delighted to be taught by a soldier, Principal Frances Prescott had her doubts. Hearing that Grant was assigned to her school, she called the superintendent and said, "What have I done to you that you have inflicted Grant Wood on me?" Later she said, "Grant Wood was the best teacher I ever had, bar none."

Grant had his own original and unorthodox ideas of how to teach art. He did not believe in regimenting his pupils, and his theory was, "Let 'em talk, let 'em move around, give 'em plenty to do, and keep 'em interested." Art was not a required course, and boys that age tended to avoid it, but they flocked to Grant's classroom.

Catching the streetcar was bothersome, and Grant soon bought a nearly new car through Frank, who gave him a half-hour driving lesson. Grant drove the sixty miles back to Cedar Rapids alone, getting along fine except for

one brush with a culvert which threw the car crosswise in the road. The car had low mileage and was a shiny robin's egg blue with white wire wheels. All of us were proud of it. Grant also used it to reward effort. At the end of a designated time span, the four or five boys who turned out the best work were taken on an overnight camping trip by Grant and our cousin George Keeler, an artist in wrought iron. The boys vied for this exciting reward for good work.

In seven years of teaching, Grant had trouble with only two boys. One troublemaker was cured by responsibility. School-owned rulers had been disappearing, and Grant appointed the difficult kid "custodian of the rulers." The boy's conduct improved immediately, but he was so zealous in his duties that Grant had trouble keeping him from wrenching privately owned rulers from their owners.

The second boy was a problem for all the teachers. Husky and a head taller than Grant, he created disturbances and ignored Grant's orders to stop. Grant took him by surprise, going to his seat and grabbing him by the back of the collar for a good shaking. The boy was meek and orderly thereafter, but his mother complained that her son's shirt had been torn. If Grant didn't buy him a new one, she said, she would have him fired. Grant didn't, and he wasn't.

Many of Grant's students at Jackson and at McKinley Junior High, to which both he and Miss Prescott were transferred, recall their art classes with affection.

"I was in the seventh or eighth grade at Jackson and had a terrific crush on Grant," said Jane Carey De Lay. "His class was fun because it was so very informal. It must have been painful to him to have to spend so many hours with so many ungifted youngsters, but you wouldn't have known it. In his very mild way, he was exciting."

Speaking at the dedication of Grant Wood School in Cedar Rapids on November 13, 1951, Miss Prescott said, "I was apprehensive because I didn't know him very well. I knew that he was shy and gentle, very quiet and timid, and I wasn't too sure just what he would be able to do in a classroom. He hadn't been with me very long before I realized that he had two things that are very important for a teacher. One, he had an entrancing sense of humor. The other was a capacity for hard work. The children were delighted with him and enjoyed him because he was so much fun. He always was two jumps ahead of them, making them laugh, and they used to run to meet him as though he were the Pied Piper. They were just thrilled the cold morning when he came to school, and to keep from putting his hand out the window in his car, he invented a wooden hand to show when he was going to turn. They were convulsed with laughter the morning he painted a mitten on the hand because it was so cold."

Grant designed a beautiful bench with big leather cushions for the school office. Miss Prescott told him she was delighted with it but considered it too comfortable for the naughty children who sat there awaiting discipline.

"I can take care of that," said Grant.

He designed another bench known as the mourners' bench. Like a church pew, it was stiff. At each end he carved the head of a crying child, and on a band across the back he carved in beautiful letters, "The Way of the Transgressor Is Hard." Built by manual training pupils, that bench is now on permanent loan to the Cedar Rapids Museum of Art from the school system.

Miss Prescott continued her description of Grant, saying, "He was immaculate and meticulous in his appearance, but he always wore overalls in the classroom. He never had any of the earmarks of an artist—long hair, soiled fingernails, and a flowing tie. He never could quite see why he should release his children at the end of an hour and let some other teacher have them. If he was interested in working with them, he wanted to keep them."

Grant loved a daily shower, but our facilities at home amounted to a tub next to the cookstove. One day he asked Miss Prescott if he could shower at the school. She said he could use the showers in the athletic department locker room, but the chief engineer had his own shower and might share.

Two days later, the chief engineer, Mr. Hood, asked Miss Prescott to accompany him to the boiler room. She found the half-door of the shower painted robin's egg blue with daisies and butterflies and topped with a sign that read, "Hood and Wood."

In all his years of teaching, Grant was late only once. Miss Prescott recalled, "One morning, he didn't come at all. I called and said, 'Grant, are you ill?' He said, 'Oh boy, what time is it?' His mother and sister were away, and he had overslept. Then he couldn't get his car started in the cold, and I went out and got him. We got to school about 10:30, but I always said he was much more valuable at that hour than many were at 7 a.m."

It took him a while to get the hang of academic requirements, however. One day he came into Miss Prescott's office disturbed by a notice that it was grade week.

She said, "Just take your class book—you have a class book, haven't you, Grant?"

He handed her the required object, and she said, "But Grant, you don't have any names in your class book."

"No," he said, "I don't know their names."

"Do you know their ability in your subject?"

"Oh yes, I can give every child a grade, but I don't know their names."

Miss Prescott identified the pupils, and Grant gave them a grade.

Their projects were linoleum block Christmas cards, scenery for school plays, and silhouettes for the school magazine.

Grant always said that an aspiring artist cannot make a living by selling paintings but must find employment. For him, teaching was the ideal solution. The classroom was fun for his pupils, and he found real enjoyment in teaching.

He had fun in other ways, too. Mother used to say he had so many irons in the fire that it was too bad he wasn't twins. He played as hard as he worked.

Parties were frequent in our home. Grant would invite his fellow teachers and Miss Prescott to our house for conversation, laughter, and dancing. In the winter they took a portable phonograph down to Indian Creek and ice-skated to music, pausing to warm themselves at a big fire. The guests would bring the ingredients for oyster stew, which Mother would have ready when they came in from the cold.

One day during this time, we were riding merrily along in Grant's car when we saw a car wheel rolling along in front of us. People were running beside us, waving and hollering. We smiled and waved back. Suddenly my side of the car dropped and dragged on the ground. We had been cruising along on three wheels.

Grant also took time for art projects like the eight-sided bas-relief plaque he designed for the Cedar Rapids Art Association to use as a fund-raiser. Lon Dennis was the model for the one hundred plaques Grant made. Anyone who paid $100 for a life membership received one, and Grant became a life member for his efforts.

He made more bas-reliefs about this time. One was of Sylvester Neville and another was of Bob Hanson, the baby son of Paul and Vida Hanson.

Grant and Marvin Cone exhibited together and with others. At the Killian Picture Galleries from October 9 to 22, 1919, Marvin showed eighteen paintings done at home and thirteen done in France.

Grant had still not been to Europe. His paintings in the show were *A Sheltered Spot, Looking for Wigglers, In Retrospect, Frugal Harvest, Indian Creek, A Modern Monolith, Quivering Aspen, The Sexton, The Horse Traders, Thirty One Seventy Eight, Reflection, The Old Stone Barn, Reluctant Sun, North Tenth Street, East, A Cubby in the Woods, Feeding Time, A Tree in June, Fresh Plowed Field, At Rest by the Road, Sunbath, Painted Rocks-McGregor, Mixing Mortar,* and *Summer Breeze.*

The following April he showed ten of those paintings at an Art Association exhibit plus *The Picture Painter, The Hermits, Spring, Moonrise, A Winter Eve, The Yellow Birch, Last Snow, Reflection, Dull Day, January Thaw, Cloud Shadows, The Cut Bank, The Kewpie Doll, The Scarlet Tanager, Overmantel Decoration,* and *Retaliation.*

A modernistic exhibition at the Art Association amused Grant. When he came home one evening, I was playing "Song of India" on the phonograph, and he said, "I've got an idea. I'm going to paint the colors of the sound of music in 'Song of India.' I'm going to do it in modernistic style and have a lot of fun with it."

I played the record over and over while Grant painted swirls of color onto the canvas whenever it came to certain notes. He called the painting *Music*, and when he and Marvin had an exhibition of their own at the Art Association, Grant hung *Music* with the other paintings. The others were priced at $25 and $35, and for a gag, Grant put a $1,000 price tag on *Music*. So much interest was shown in the painting that Grant took our phonograph and record to the exhibit. Using his paint brush as a baton, he demonstrated.

Within Grant's hearing, a wealthy man said to his wife, "Maybe we should buy this. Look at the price. It must be good."

Grant was so amused by this remark that he came home and woke Mother and me to tell us about it.

Arthur Collins, who became a noted radio and avionics inventor and manufacturer, recalls how the boys in Grant's class would try to get their teacher off the track.

When Grant was demonstrating painting to music, they asked if the same method could be applied to tennis. Grant said yes, noting that he had played tennis. The boys lost no time getting a willing art teacher to the court for a match with the best all-around athlete in the class. The boy said that to make the match even, he would not use a tennis racquet. The match, which lasted a game or two, featured one Maynard Shove, who served with a canoe paddle. In one startling play, he aced Grant, who enjoyed the incident immensely and often told the story on himself.

Marvin and Grant decided to paint portraits of each other. Marvin was the taller—thin and a bit pale. Grant was chubby and ruddy. Painting for the sheer fun of it, Grant made Marvin's face long and cadaverous, and Marvin made Grant's face perfectly round. They titled the portraits *Malnutrition* and *Overstimulation*.

Marvin's portrait of Grant burned in a studio fire at No. 5 Turner Alley in 1932, but, Marvin said in a radio interview in the 1940s, "I prize the one he did of me because it's the only oil painting of his that I have."

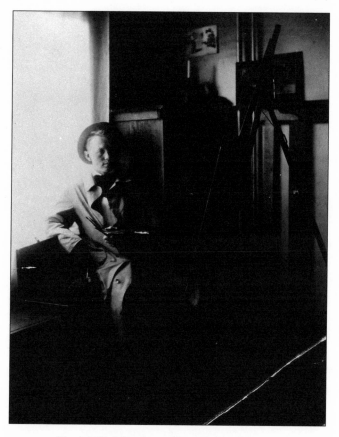

Wood disliked this photo of himself at age eighteen,
thinking that it made him look "arty."

CHAPTER 3
EUROPE AT LAST

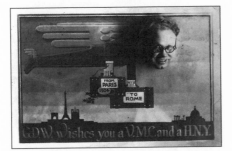

Grant's earnest desire to visit Europe had been thwarted twice, but in the summer of 1920, when he was twenty-nine and had saved money during a year and a half of teaching, he was all set to go to Europe with Marvin Cone.

His intentions were on a collision course with those of Emma Grattan, the formidable art supervisor of all the schools. She had engaged Ralf Johonnett of California to teach in Cedar Rapids that summer and wanted all her people to benefit from his expertise in color schemes. She ordered everyone to take his course, and that included me, for I was working in her office.

It included Grant, too, and when Miss Grattan learned that he was planning to go to Europe, she exploded. "I've a good notion to fire him" was one of her milder remarks. When Miss Grattan was angry, fire shot from her eyes. I saw her reduce a number of teachers to tears, but eventually I learned that her clipped and testy orders were a gruff cover for a soft and sentimental nature. She had a blind sister whom she adored and to whom she always sent support money, and she wore a diamond ring given to her by a fiancé who died.

Miss Grattan had coal-black hair, snappy black eyes, and a thin mouth. Her wardrobe was small but expensive, and her taste ran to browns, tans, soft oranges, and greens. She hated harsh colors and objected strongly to a purple hat of mine. Grant hated it too, and he gave me $10 for the privilege of burning it.

Once a year, Marvin Cone and Grant helped Miss Grattan with her "Living Pictures Festival." Such shows, with local people posing to depict famous paintings, were popular in Midwest cities and were thought to heighten interest in art. Grant and Marvin posed if needed and helped with arrangements.

Just when the show was scheduled in Cedar Rapids, Grant became ill and had surgery to remove his appendix. The day after the operation, Miss Grattan came calling and told him she was extremely provoked with him for timing his appendectomy right in the midst of her "Living Pictures Festival."

Grant's hospital room was filled with flowers and fruit from an orange shower given by the school children. He didn't stay there long though. Two days after his operation (May 22, 1919), the Douglas Starch Works blew up. Forty-three persons died and hundreds were injured. When people screaming with pain were brought to the hospital, Grant decided they needed his bed more than he did. With a tube still in his side, he loaded himself and his oranges into a wheel chair and was preparing to wheel himself the three miles home when Mary Fuller, one of his former teachers, happened along and brought him home in her car.

Grant's determination was just as strong when Miss Grattan called him to her office to discuss the conflict between the Johonnett course and his European trip.

I expected a showdown with raised voices, but Grant was as calm and gentle as ever. He simply told her she could not rule his life. Much to my surprise, Miss Grattan turned meek. She even looked frightened, I thought.

Later, when she told me, "I didn't know you Woods had such terrible tempers," I suppressed a laugh. Me, yes; Grant, never.

Grant borrowed $1,000, putting half of it in the bank for living expenses for Mother and me and using the other half for the trip. He was happy beyond measure.

"Nicky," he said, "the art critics and dealers want no part of American art. They think this country is too new for any culture and too crude and undeveloped to produce any artists. You have to be a Frenchman, take a French name, and paint like a Frenchman to gain recognition."

Grant traveled light, taking a single suitcase and a homemade canvas carry-all for his paints and equipment.

Marvin had served overseas in the war, so this was his second trip to Europe. In Paris, the two found an attic room in a rambling old house on the Left Bank that was convenient to town and to the Luxembourg Gardens, which they loved. It also was close to streetcar transportation to the Paris suburbs.

Determined to use every minute of their short three months to advantage, Grant put his excitement about the scenery and the people into paintings in the vague romanticism of the impressionistic style. One was titled *Misty Day in Paris*.

Grant wrote that it rained steadily the first week of July and said, "I have been going out alone, more or less, as Marv doesn't like painting in the rain and either writes or visits the galleries. I'm making a great collection of postcards—save 'em carefully." Two or three postcards arrived in every letter.

Those letters were full of enthusiasm, describing events like their pilgrimage to Ville d'Avray, the village Corot immortalized. Grant painted *At*

37

Ville d'Avray and *Corot's Pond*. The latter was purchased by Earl Carroll, the theatrical producer.

On Bastille Day, July 14, the streets were filled with jostling, hilarious crowds, and no easel was safe. Grant and Marvin went to the cemetery to sketch. Grant was stopped by the gendarmes as he started to leave, carrying the vase he had brought with him to sketch.

"Things looked rather bad for a few minutes," Grant wrote. "Pinched for robbing the dead and all that." Marvin spoke to the gendarme in French, and Grant was released, but the vase was impounded until he could prove possession. He never tried.

Grant's postcards were vicarious travel for Mother and me. One day we were with him in the Luxembourg Gardens painting the fountains, the next in Montmartre, where he sketched the cathedral in a "tough district" unsafe for Americans after dark—a horribly dirty area with eight-foot-wide streets and two-foot sidewalks. We were with him as he gazed up at the Eiffel Tower and took a ride on the Ferris Wheel because he couldn't afford to go to the tower restaurant, and we accompanied him to Versailles and the Paris Opera, where he experienced *La Boheme* and *Louise* with such marvelous scenery that "you could see out all over the city."

One card told us, "I got three dandy paintings yesterday. One of them I painted from a cafe table on a busy downtown sidewalk. The cafe owner seemed tickled to death to have me paint there and hustled around and made me comfortable, shooing the children away. It was a venture on my part, as Marv wasn't along to interpret, but I converse quite readily now with the waiters, who help me along when I stumble."

Actually, Grant never sought to become fluent in French. Instead, he communicated with quick sketches, saying, "I have a universal language at my fingertips."

Toward the end of the summer, Grant wrote, "I am feeling a bit blue about my work not making a better showing so far. It will look better when I get it home and framed, I hope. I have ten big panels and five or six small ones so far, but I will have to rush to get my thirty big ones that I had planned on. Don't quite see how I am to do it in the short time left."

He was sorry to leave Paris, saying, "My stay seems like a dream. I have the job of packing up my sketches so they won't stick together, and I suppose I will worry until I see them safe on board ship."

Grant and Marvin had four days at Antwerp, Belgium, before their ship sailed, and a favorable exchange rate made them some money. They celebrated by making a huge, tissue-paper balloon fitted with a lighted candle to make it ascend. The whole countryside turned out to watch and chase it across the fields.

"Great Scott!" Grant said, "What if it should land in a haystack and set it afire?" Fortunately, it didn't.

In a cafe, Grant admired the beautifully embroidered cap worn by a waitress and bought it from her. In the morning, a large group of girls appeared with bonnets to sell. He declined, but he did buy one girl's shoes with wooden soles and uppers made of braided corn husks. They were lined with rabbit fur, but they were uncomfortable and stiff.

Aboard the SS *Grampian*, Grant and Marvin had an exhibit of their Paris paintings in the lounge. The captain welcomed the show but told them they couldn't sell anything. That was fine with them, as they wanted to bring all the work home.

Grant and Marvin were in charge of a Raffles Hunt on the ship, and each morning they posted a clue in the lounge. Passengers then approached each other, asking, "Are you the mysterious Mr. or Miss Raffles?" The person who solved the mystery won a prize. A group of Canadian girls decided that Grant was the mysterious Mr. Raffles, and one of them, Winnifred Swift, asked him. She lost the game, but she won a friend who introduced her to her future husband, Marvin Cone.

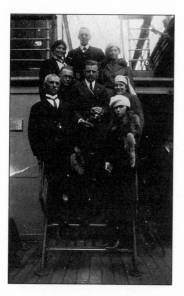

Grant (center left, in glasses) and Marvin Cone (center, with camera) on gangplank before embarking for Europe in 1920.

Winnifred later said, "We were on a tour of France and England and had been to the Olympic Games at Antwerp. That was the year Paavo Nurmi of Finland won the big distance race, and once aboard ship, we decided that Grant and Marvin looked like Finns. We tip-toed up behind them to hear what language they were speaking and were disappointed to discover it was plain, old American."

Marvin, Grant, and Winnifred arrived in Montreal by train, spent a day there and continued to London, Ontario, where the men met Winnifred's family. Marvin and Winnifred were married the following summer, when she was twenty-one.

The day Grant came home, excited kids ran ahead of him, pounding on our door to announce, "Mrs. Wood! Grant is home, and he has whiskers!"

Grant was a sight to behold. His hair was dishwater blond, but his beard was red—a sandy red which he called pink. He was wearing a suit of heavy, gray homespun fabric he bought in

Belgium. The high-waisted trousers almost reached his armpits, buttoning up the front like a vest and taking the place of one. Grant wore the suit only once or twice. It was too hot, and it itched.

The luxuriant beard was four or five inches long, parted in the middle and squared on the bottom like a neatly trimmed but upside-down hedge. Wearing new glasses with heavy bone frames, he looked like his own grandfather. As children, we had been afraid of Grandpa Weaver because his beard gave him such a severe look. Now, babies looked at Grant and cried. Still, he wore the beard to school with pride until the day it brushed across his palette and became smeared with paint. Then he cut it off. Friends who saw him clean-shaven pretended they had not recognized him before, shaking his hand and asking when he got back.

Grant and Marvin exhibited their work at the Library Art Gallery from November 10 to 20, 1920, pricing the paintings from $25 to $100. Grant's titles included *The Fountain of the Observatory, Place de La Concorde, The House of Mimi Pinson, Avenue of Chestnuts, Fountain of Voltaire, The Steps, Luxembourg Gardens, The Crucifix, Lion in the Luxembourg, The Lost Estate, From the Roman Amphitheatre, The Square, Chatenay, Pantheon at Sunset, Church of Val du Grace, By the Fountain of the Medicis, Pool at Versailles, Fountain of Carpeaux, Street in Chatenay,* and *Bridge at Moret.*

We discovered that we had become famous in the neighborhood. When Aunt Minnie came to live with us, she brought her cow which gave wonderful milk, her davenport for Grant to sleep on, and her piano. One night two men were walking past, and Grant heard one tell the other, "People with a lot of dough live there. They have a piano, and the boy has been to Europe."

Because Grant was in Europe, I took extensive notes during the Johonnett course. Upon his return, he read my notes and chuckled, saying, "I get what this Johonnett means. Now don't tell anyone, but the lady (Miss Grattan) is in for a surprise."

Was she ever surprised! I heard her say, "It's so strange. I don't understand it. The one person who didn't take the Johonnett course teaches his methods better than anyone else." I didn't say a word.

Grant's pupils used the Johonnett methods in making scenery for the school's Christmas program, and he became so engrossed in the project that he worked night and day to get it completed in time. Then he came home and collapsed in bed, sleeping all that night and the next day. On the second day, Mother called in the doctor, who said it was a case of complete exhaustion. We

managed to wake him long enough to get some food into him, and on the third day, he awoke fresh and eager to get back to work.

Grant's ninth grade pupils used the Johonnett method to paint a waterfall for a cantata, "Three Springs," given by the McKinley girls' glee club. Grant used two nail kegs, one about six feet in the air and the other near the floor of the stage. Turning a crank moved the canvas around in the manner of a roller towel, creating a realistic waterfall effect.

He used the method again as his pupils created a frieze on a hundred and fifty feet of canvas twenty inches wide. *Imagination Isle* was a landscape of castles and islands, and pupils painted about ten feet each, signing their names. Grant planned it for the walls of the school cafeteria, which he considered ugly—exposed heating and water pipes and dingy coloring. That's where it was placed eventually, even though Miss Prescott said, "Grant, it's a pity, as nice as that frieze is, to have it where only the people who eat in the cafeteria will ever see it."

"I've thought of that," Grant said, and he created a device to show it in the auditorium. Using the same nail keg method, he built a backboard in the center of the stage with a slit just large enough to allow the twenty-inch canvas to pass through. He brought the velour curtain down and divided it on either side. As a crank turned, the canvas moved from one side to the other until all hundred and fifty feet were seen by the audience.

"It was the first moving picture in Cedar Rapids," Miss Prescott said.

The children were brought in, the auditorium was darkened, and soft music played as *Imagination Isles* moved along to the words of a monologue written by Grant and recited by ninth-grader William Rozen.

It spoke of "brilliantly colored trees of shape unknown to science silhouetted against purple mountains," of a "sea bluer than the blue Mediterranean that frets itself into a snowy foam," of "glistening white castles."

No human body could visit these islands—only the spirit. And, Grant wrote, "Our hosts on this trip are forty-five ninth-grade boys who have produced the imagination isles in the art room of this school, using only the highest grade of oil paint and the very best imagination that can be found locally."

Artists are valuable, he said, "because they can lead others on short vacation trips into the delightful land where their spirits are trained to dwell."

Speaking of the placement of the frieze in the school cafeteria, he wrote, "As we sit there, we can visit in this tropical paradise, imagining that our everyday baked potatoes are the succulent seed-vessels of the magical mingo tree; that the boiled cabbage before us is the crisp and tender leaf of the Clishy-Clashy vine; that the creamed peas are the pellets of foam driven by playful waves upon a phantom beach."

In later years, Grant took a strong dislike to what he had written. He found it too sweet and syrupy, but I liked his sentiments.

Grant himself did several murals for the public schools. Although this was the era when much of his work was given away, Miss Prescott always saw to it that he was paid.

At the request of George L. Schoonover, Grant painted a triptych symbolizing the first three degrees of Free Masonry for the National Masonic Research Building at Anamosa. The triptych later was sold to Otto A. Schoitz of Waterloo, who presented it to the Grand Lodge of Iowa, headquartered across the alley from what later would be known as No. 5 Turner Alley, our home. The work remains on the walls of the Grand Lodge rooms.

Grant painted an eleven-by-three-foot mural for a real estate firm, and the models were our neighbors, Sylvester Neville, Vida and Bob Hanson, and a Mr. Charles; our cousin, Stella Pope Conybeare; and me. When the painting was finished, Grant hung it on one side of our house for the unveiling attended by the models and their families. We sat on blankets in the yard, eating macaroons and ice cream, while Grant trained a floodlight on the painting. It was quite a dramatic moment.

Grant titled the mural *Adoration of the Home*, and it was installed beside the real estate office (protected by glass) the next day. Eventually, Grant took it back on the pretext that it needed restoring, but he simply stored it for the rest of his life.

When we had a fire at No. 5 Turner Alley in 1932, Grant said he was sorry the mural didn't burn. He disliked it and said it wasn't a good piece of work, but it is now in the collection of the Cedar Rapids Museum of Art.

I remember many good times during this era. On the spur of the moment, Grant would bring home teachers and other friends, and we were prepared with popcorn, nuts, homemade doughnuts, and cider. Our Halloween parties always included bobbing for apples and eating lots of them plus homemade pumpkin pie with whipped cream.

Occasionally Grant dated one of the teachers. Once he arranged a date between a teacher and our cousin, George Keeler. George liked the tall redhead, who was just his height, and it wasn't long before they were married. Grant had played Cupid for the third time.

Taking a year's leave of absence from teaching, Grant left for his second visit to Europe in June 1923, where he would remain until August 1924. Except for time spent in Italy, he was a student at the Academie Julien in Paris. Art critic Thomas Craven, writing in the June 1937 *Scribner's* magazine, described that experience as "studying under that old montebank, Julien." Grant spent his spare time in France and Italy sketching and painting; a number of works were sold in Europe to help with expenses. Others were brought home.

Grant tasted the life of the art students of Paris or, as Craven put it, "had a fling at the Bohemian business." He wrote that he attended the Beaux Arts Ball, where he witnessed the wildest scenes of his life. Grant was part of those scenes, costumed as a savage. He painted his body red and wore a breech cloth, earrings, sandals, a bushy beard, and an overcoat. Champagne flowed freely, and it was traditional to bathe in the fountain in Luna Park, where Grant found himself the following morning alone with a headache. His overcoat, the money he had secured in his sandals, and one earring were missing. He was miles from his room; and he finally borrowed money from a street cleaner for an embarrassing subway trip home which involved three transfers.

Grant joined a group of painters who called themselves neo-meditationists and sat around drinking brandy at the Dôme or Rotonde, quietly waiting for inspiration that never seemed to come. He soon dropped out, saying he didn't believe in waiting for inspiration, that only hard work would get you anywhere.

Grant lived at a pension operated by Mme. Betat at 85 Boulevard Royal. As winter neared, he longed for central heating. Each morning Mme. Betat sent up a cup of thick chocolate—almost chocolate pudding—along with a pot of hot charcoal which would be the only heat in the room for the entire day. Grant wore his overcoat at all times, draping it over the charcoal pot to capture the warmth.

The weather grew still damper and colder. In December, Grant left with a group of artists to spend the winter in Italy. His Christmas cards that year were photographs of his smiling face thrust through a hole in a poster he painted—a stylized plane with arms and hands holding suitcases labeled "From Paris" and "To Rome."

When our card arrived, Mother was upset. "What will that boy do next?" she said. "He's flying around in a plane now. I hope he knows more about flying than he did about motorcycling."

He sent one of the cards to our cousin, Stella Pope. Remembering the many Christmases we had spent with Aunt Minnie Pope, he wrote, "I

am going to the Pope's for Christmas. That has a familiar sound."

En route to Italy, Grant's train was halted three days by a Swiss avalanche. Passengers and crew were hungry and cold; they used newspapers for blankets while they waited for the tracks to be cleared.

In Italy, the artists went to the old Hotel Coccumello, an ancient monastery in Sorrento. Their group included musicians who had a jazz band, and the Italians were enthralled by American jazz. Noting the crowds they drew in the off-season, the proprietor said all the students could have free lodging if the band would play every night. He also offered Grant the billiard room for an exhibition hall. A wealthy American named Bliss and her friends bought several paintings, and the Italians also bought some. A Sorrento woman asked Grant to donate a painting for her church raffle. After much deliberation, Grant chose *Pink House*, a painting of a woman leaning over the portico rail. He was bewildered when she turned it down in a cold and haughty manner, but he later learned that he had painted a house of ill repute.

Before leaving Sorrento, Grant gave the hotel proprietor and his family a triptych of Mount Vesuvius. They cherished the painting for many years before selling it in 1965 to John Hejinian, a vice-president of Chase Manhattan Bank in New York.

Paris was in the full bloom of spring when the artist group returned to resume studies and painting.

Among the techniques Grant studied at the Academie Julien was using spots of color on canvas to allow the eye of the viewer to do the mixing. He was not enthusiastic about this approach, but he did two or three such paintings. One was a rear view of a nude man holding a staff, *Spotted Man*. Grant never sold the painting, keeping it as a memento of his studies.

The mood of my brother at this time was well captured by Thomas Craven in his *Scribner's* article. Craven suggested that Grant had become "a victim of that old and snobbish superstition that a man cannot become an artist without submerging his personality in European ideas and conforming to the theories and practices prescribed by a colony of Bohemian esthetes." But, Craven noted, "By birth and training he was a workman; he had been schooled in the toughest of realities; and most important, he was at home among his own people." At home, at least, until "a great fear came over him . . . that he was a product of a new and raw environment, that he was not really an artist. . . . At home he was not regarded as an artist. . . thus he was moved to revolt against his people; not in externals, for his grievance was imaginary, and he was too sensible to put on airs; but inwardly to nurse his illusions of art."

Craven suggested that Grant was influenced by Mencken's drubbing of the yokels of the Bible Belt. "Wood revolted against the Babbittry of his people, their arrogance and their indifference to the refinements of the

spirit. . . . He would show his people that he was an artist in the European sense." He did this by painting the "remote and romantic."

In Paris, Grant bought an enormous, coffin-like box to bring his paintings home. All his luggage was marked WOOD with a curve above the Os to make them look like a pair of glasses. He got the idea from an artist friend who came to visit, found Grant not at home, and left his mark.

I had married while Grant was away. When he came home, he asked, "How much is left in the bank?" When I told him there was more than $100, he said, "That's my wedding present to you." He was giving me all the money he had, but it wasn't the first time he had started from zero.

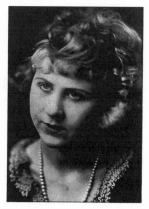

Grant also brought me a beautiful raincoat of oiled, chiffon silk from England. It was a shimmering, changeable peacock blue and green, and people would stop me on the street to ask where they could get one.

Ed, my husband, was a wonderful man, and we were very much in love. I was delighted that Grant liked Ed instantly. Seeing our love was hard on Grant, however. Before long, he confided to Mother and me that he had been very much in love with a girl he met in Paris but had broken off the romance.

Nan Wood, 1922

Her name was Margaret, and she was from Connecticut. She arrived in Paris late in 1923 and stayed seven months, taking lessons in voice and art. She did not consider herself either a musician or an artist but just wanted to spend some time in Paris.

As Grant described her, Margaret was dark and slender. She was thoughtful and quiet like him, and yet she adored having a good time in good company. He spoke of the wonderful times they had together—taking sketching trips, visiting the Louvre, going to the flea market, climbing the Eiffel tower, riding the giant Ferris wheel, boating on the Seine, and attending the opera. They visited a park where Grant had made a pet of the grand-daddy of all goldfish. He thought the fish recognized him when he fed it bread crumbs. When Grant and Margaret went walking in Paris, people on the street would look at Grant and say, "Baby Camay!" Why? Because billboards all over the city advertised Camay soap with the picture of a baby with a man's face. The man looked exactly like Grant.

After a conversation with Lee (Jeff) Jefferies, the American who had introduced him to Margaret, Grant stopped seeing her. He had told Jeff that he was in love, but he feared it would be a long engagement. He was in no position

45

to support a wife.

Jeff laughed and said, "Grant, you haven't a thing to worry about. The girl has a million in her own right and the prospect of inheriting more. Marry her and let her put you on the map."

Grant was stunned by this information and told Jeff, "It's best that we break off right now."

I learned later that Margaret became ill in Paris and came home to tell her parents she had had an unhappy love affair in France. She told them he had a cute, funny face, and she called him "Chubby."

Grant told Mother and me, "I had nothing to offer her. When I marry, I want to give my wife everything. I don't want her to have to struggle along as you have, Mom, and I won't live off a woman's money."

He never saw Margaret again, although they did correspond. Within a year, both Ed and I became ill and were patients at the Iowa State Tuberculosis Sanatorium at Oakdale. Today, tuberculosis can be managed with antibiotics, but in those days, it was a dread disease. My illness turned out to be slight, and I returned to live with Grant and Mother. Ed's illness was much more severe. He spent long periods at Fitzsimmons Hospital in Denver, and that's how I happened to be around to pose for Grant when he created the *Memorial Window*, *American Gothic*, *Portrait of Nan*, and other works. Sometimes Ed was in Cedar Rapids with us, but when he and I established our own home, we chose Albuquerque, New Mexico, for the sake of Ed's health.

About two years after Grant met Margaret, she was dead of tuberculosis, and I could not help wondering if a broken heart could have been a factor. Grant pursued his art, never speaking of Margaret, but without question, he thought of her often. After Grant's death in 1942, his secretary, Park Rinard, told me Grant had said he wondered what his life would have been like if he had married Margaret.

Park wrote to me in the late 1940s, saying, "I went over it again and again with him, knowing his reticence and sensitiveness about such things, in an effort to get it in the proper proportion. However, there was never a single line from her or a single reference about her in any of his correspondence. I believe that after she died, he destroyed whatever communications he may have had from her. It would certainly help if we had the last letter she wrote him— when she left for the sanatorium. Grant did say to me at one time that he would have married her had the sickness not developed, and that he had sometimes wondered if it would have worked out."

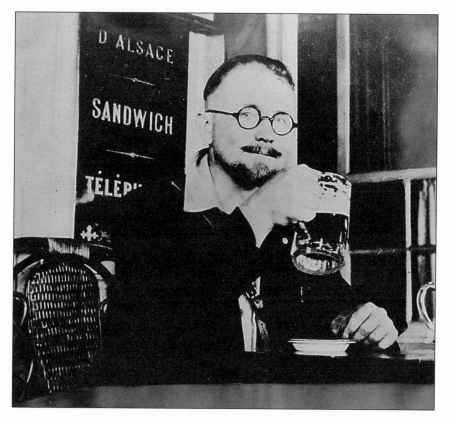

Grant Wood in France on his first trip to Europe, 1920.

CHAPTER 4
NO. 5 TURNER ALLEY

Coming home to Cedar Rapids from Europe in August 1924, Grant resumed his teaching career and his interior decorating business. He had sold his car to finance his stay in Europe and was without transportation. This was one factor that led him to the conveniently located No. 5 Turner Alley.

Grant accepted a decorating assignment from David Turner, who had just purchased a beautiful southern colonial mansion at Eighth Street and Second Avenue SE for his mortuary. This grand house had been the home of prominent citizens—the Douglas family and later the Sinclair family. Grant took complete charge, determining all color schemes and materials. David Turner was delighted with the results but horrified at Grant's lack of business acumen. When the job was finished, David expanded his interest in Grant, for Grant's own good.

I cannot remember when we did not know the Turners. We lived in a district called Central Park where everyone knew each other. On Fourteenth Street, we lived just two blocks from the Turners. When we lived at Aunt Minnie's, we were only two doors away. Grant associated with some of the people in David's crowd and vice versa, and Grant was an occasional dinner guest in the Turner home. They had always been friends. Now, when Grant was thirty-three and David ten years older, they were taking

a new look at each other. Through a tactful conversation, David determined that Grant was virtually giving away most of his interior decorating services and actually was giving away nearly all of his paintings. David always favored the underdog, and in Grant he found a prime example. Grant had no real business sense; he was afraid to charge for his own services.

Both David and his wife, Hilda, were kind and loving people. A mortician is popularly supposed to be on the mournful side, but David smiled a great deal. When he learned that Grant was intrigued by the fine brick colonial barn with a cupola at the rear of the property, he offered the hayloft as a studio. Grant could fix it up at his own expense, and he would pay no rent.

Grant accepted immediately with no contract, no termination date, and probably not even a handshake. Neither man could have known that this hayloft would become a National Historic Landmark. Neither did they think Grant would ever live there. After all, he had his own home, built with his own hands in a lovely, rural setting.

David Turner had no interest in artists as such, but he had a strong interest in Grant. David told me years later that before this time, he knew nothing about art and thought that artists were "a bunch of playboys and pimps." After getting to know Grant as an artist, David became interested in art and became a collector. It all began when David told Grant that the mortuary walls looked bare and cold. Grant loaned his own collection for the walls, but that didn't work out. Grant was forever borrowing the paintings back for an exhibit, and they would be gone for weeks. The solution was for David to buy all of the paintings then hanging in the mortuary; they became the start of his collection. At the time of David's death, he had the largest collection of Grant's early works in the world. They were given to the Cedar Rapids Museum of Art in 1972 by David's son John and his wife.

Grant refurbished the unused hayloft in the Turner
Mortuary's stable and lived in the studio known as
No. 5 Turner Alley from 1924 to 1934.

The hayloft of the Turner barn once had been filled with hay for the horses, and there was a tiny room for a coachman. With the mortuary's vehicles all motorized, this space was of no use to the Turner establishment. Grant tore out partitions, built in a fireplace, and covered walls with plasterboard. He

The studio at No. 5 Turner Alley featured curtains for privacy and theatricals.

chipped the heavy timbers to give them a hand-hewn look. He made saw marks on the softwood floor to create the illusion of tiles and painted alternate squares dark green and rust. He hired some of his pupils to paint, fill cracks in the plaster, and perform other labor. He removed the large wooden doors that once opened to receive hay, replacing them with large steel casement win-

dows. He installed the minimal wiring and plumbing necessary for studio use, as using the place for living quarters had not yet occurred to him. He covered the two cupboard doors with an old pair of overalls, wrinkling and antiquing them to create the illusion of an old copper door complete with wrought iron handles. The breast pocket of the overalls was intact—the perfect size

Grant carefully designed the interior furnishings of No. 5 Turner Alley.

for Grant's bottle opener—and the door was a conversation piece for years.

The only outside door had six square panels below the lock and a large window with a six-sided frame in the upper third. On the inside of the door, he crossed two wood pieces to center and support a clock hand. Around the curved top of the glass, he painted the hours from 7 to 12 and from 1 to 5. His name, painted in the center, led the eye to the message, "is returning to the studio at" with the clock hand pointing to the hour. The lower corners of the glass held more detailed messages: "is in," "is out o' Town," "is having a party" and "is taking a bath." The eloquent door is now at the Cedar Rapids Museum of Art.

An ancient bell bought in Rome hung above the door. Mounted on a spring, it was rung by pulling a knob. Also above the door were antiqued gold gargoyles—the two masks he had made of Zim and Bart.

Using algebra and geometry, Grant designed a galvanized iron lining for the cupola. The four men who lugged it up the stairs and into the studio said it was too big to fit. Grant assured them that it would, and they agreed to give

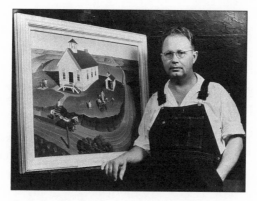

Grant posed with each completed painting to establish
copyright; he completed *Arbor Day* in 1932.

it a try, "but it won't be any use." They huffed and puffed and found it a perfect
fit. Grant just smiled and hung an antique lantern on a heavy chain from the
center of the cupola.

He designed and made a beautiful easel in keeping with the studio's
old-world atmosphere, and it was photographed frequently when Grant
decided to pose with each of his major paintings as it was completed.

Grant used a galvanized metal bushel basket for the hood of the
fireplace he designed and curved a row of bricks around it. The metal basket was
painted bronze and antiqued, and above it he recessed a nook to hold a pottery
Madonna and Child he had sent home from Italy. When the piece went through
customs, it was opened for inspection and not properly repacked. It arrived in
many pieces, which Grant told us to save. He patched them all together when
he got home and said he liked the statue better than ever because the accident
made it look older.

The completed studio boasted every nicety Grant could devise. It
combined suggestions of a Paris studio and touches (like the clock door)
that were uniquely Grant Wood. By sheer hard work, Grant had trans-
formed a dingy hayloft into what the *Cedar Rapids Gazette* called "One of the
showplaces of Cedar Rapids."

The place had no address until Grant received a letter from a French
friend addressed to "#5 Turner Alley." Grant got permission from the
postmaster to use that address, and it remains No. 5 Turner Alley to this day.

Grant belonged to a group that would later become the Community
Theatre, and he planned his studio to double as a playhouse. He had tracks for
curtains made to order so he could close off one end of the studio, and I made
enormous drapes out of heavy Baghdad curtain material he had brought from
Spain—hand-woven and hand-embroidered with wool. It came in strips about
fourteen inches wide that were used by the Arabs as camel covers. I sewed them

together at Grant's direction, creating a lovely, soft harmony of tan, rust, old blues, and browns. When a tassled chain was pulled, the curtains moved effortlessly, separating stage and audience. In later years, when we had company, Grant would sometimes chuckle and say, "I will call the servant." He'd pull the cord, and the beautiful curtain would open silently, properly surprising our guests.

The first play presented in the studio was *The Cardboard Moon*, and the cast included Ralph Leo, a well-known local singer, and a professional actor who was a nephew of Anna Eva Fay, a famed player on the national Orpheum circuit. Before the performance, Grant asked the city building commissioner to inspect the studio because he had removed some of the supporting beams. The building was pronounced safe, but Grant limited the invitations to forty, which he considered capacity.

He told Mother and me to come an hour early to claim special seats he had chosen for us. We arrived to find the place already filling up. Some invited guests brought guests of their own. Others said, "I know you intended to invite me but just forgot, so I came anyway." Grant responded politely, but inwardly he worried about the floor supporting the weight of the crowd. A few people simply crashed the party, thinking Grant would not notice—or not be angry if he did. The total was about sixty, and the building held up. The play was a huge success.

The studio was used two or three times, but the Community Players needed a larger space. Grant arranged for free use of the McKinley School auditorium in return for creating stage sets that could serve both the Players and the school. Grant and Marvin made all these stage settings, sometimes assisted by students. With a new play every three months, they would scarcely finish one when it was time to start another. Mother worried about Grant spending so much time on free work, but it was something both artists enjoyed immensely.

About this time, a friend gave Grant an artist's smock for Christmas. Not wanting to hurt the giver's feelings, Grant wore it for a time, but he said he felt silly in it and went back to his comfortable overalls.

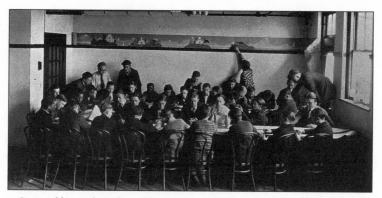

Grant and his ninth-grade students painted a freize they called *Imagination Isles* in the McKinley Junior High School cafeteria, 1924.

From Grant's new studio, it was an easy walk to McKinley Junior High School, but the studio was three miles from home. Without a car, Grant had to rely on streetcars, which made coming home for meals time-consuming. Even worse, the last streetcar for Kenwood Park ran at 1 a.m., and frequently Grant didn't make it. It was his long-time habit to paint well into the night, especially if he was enthusiastic about his work. Now, if he had school the next morning, he often spent the night at the studio. If not, he might walk home, arriving not much before sun-up. David Turner suggested that Grant and Mother move into the studio. Although I was not in Cedar Rapids just then, the offer included me. Grant welcomed the idea. Not only did he prefer living close to downtown, but he supposed the town gossips were talking about "what goes on in artists' studios" and liked the idea of Mother as a chaperone.

Mother balked. She said she already had a good home, and she definitely did not want to lose her garden. If she did move, it would be solely to please Grant, she said, but it took just one day to change her mind. In Kenwood Park, we hauled drinking water in a bucket from a well across the street; here, she turned on a faucet. We heated water for cooking and bathing on a wood-burning stove, but the studio had hot running water. Our home had a coal furnace that required much work and attention, but the studio had city heat, a by-product of generated electricity. Mother decided that she was indeed "a hot-house flower," and Grant found a renter for our Kenwood Park home.

Ingenuity enabled Grant to convert the tiny studio into living quarters for three. He built an outside stairway, using the space formerly taken by interior stairs for a kitchenette with a skylight. He installed a sink, electric refrigerator, electric plate, and built-in shelves. Under the eaves, he built cupboards, and our beds slipped under them in the daytime. Grant built a clothes closet with a half-circle rack that revolved the clothes out into the room or back out of sight. The bathroom had a sunken tub, and he installed concealed furnace pipes and

an electric fan to draw off summer heat before the advent of air-conditioning. Cupboard doors opened into the kitchen and concealed a disappearing shelf we used for a lunch counter. Mother handed the food across it from the kitchenette, and Grant called it "Mother's hot dog stand."

Dr. Bertrand R. Adams of Ames describes another of Grant's innovations: "One day as another artist and I were walking with Grant to his studio, he stopped to pick up his mail from an oversize mailbox—very ornate with just a narrow slot at the top. I wondered how he would ever fish those letters out of that narrow slot from such a deep box. Imagine my surprise when he pressed downward on the box platform and the letters fell into his hands. Two springs kept the box closed."

Our move to No. 5 Turner Alley brought another change of surrounding sounds, sights, and smells. We could hear the trains four blocks away, and on cold, clear nights we could hear the trainman call, "All Aboard!" The sirens of Turner's ambulances, the sounds of automobiles, and the footsteps of night people on their mysterious rounds in the alley below reached our ears. At Christmas, we heard chimes playing "Holy Night" and other carols. The smell of toasting oats came from the Quaker Oats Company, and the blackened oat hulls floated over the city and dirtied the snow. The unpleasant smell of gasoline exhaust seeped through the floor from the ambulances below, forcing Grant to cover his tile-like softwood flooring with an airtight hardwood floor. The sounds Grant enjoyed most were the bells that rang each day in the Immaculate Conception Catholic Church at Tenth Street and Third Avenue. The church bells reminded him of Paris. Best of all, Grant loved it when Mother sat at the piano to play and sing "Little Brown Church in the Vale."

Grant's fellow artists were wild about his studio and wished they had one like it. He said, "This alley is full of barns with unused haylofts. Why don't you rent them and fix them up the way I have?"

The idea was greeted with great enthusiasm, and some owners offered free use of the lofts to anyone willing to fix them up at their own expense. Unfortunately, the other buildings were not like ours—well-kept brick. They had wood rot from years of unrepaired roof leaks, and fixing them would have cost a fortune.

Then Grant had a better idea. Turner's former mortuary stood empty two blocks away. It was a strong, redstone mansion of mid-Victorian vintage with electricity and plumbing. David Turner was willing, and the artists were delighted. The upstairs occupants were Leon Zeman, who taught art; Edgar Brittan, an artist; Donald Horan, teacher of bass viol; and Jean Herrick, a *Cedar Rapids Republican* reporter. All four of these men worked with Grant in the repair and redecorating. Grant paid for all paints and materials used on the first floor

and hired some of his art pupils to help. The first floor became the gift shop of Hazel Brown and Mary Lackersteen and was called the Hobby House. The entire building was called the Studio House. It opened with a gala that attracted everybody who was anybody in Cedar Rapids and remained a lively place for several years. It never paid its way, however, and David Turner eventually had it razed to save taxes.

Confident that he could now earn a living by selling paintings and interior decorating jobs, Grant resigned from teaching after the 1924-25 school year. He now had much more time for sketching and painting, and he considered his decision to become as close to a full-time artist as economics would permit to be a turning point in his career.

His first commission came from the J.G. Cherry Company, manufacturers of dairy equipment. Grant took his easel to the factory, where he painted the plant and seven operations scenes. J.W. Barnett posed as *The Cover Maker*, Joe Horsky, Sr. as *The Painter*, and Jerry (Jack) Nejdl as *The Shop Inspector*. The other paintings were titled *Ten Tons of Accuracy*, *The Turret Lathe Operator*, *The Coil Welder*, and *The Coppersmith*. The paintings were first displayed in the windows of the Indianapolis Power and Light Company, a participant in a dairy show and machinery exhibit in Indiana. When the firm became the Cherry-Burrell Company in 1928, the paintings were hung in the board room; they were given to the Cedar Rapids Museum of Art in 1974. Grant had not reached his mature style when these paintings were made, but they were a forerunner of it. In later years, Grant, who was his own harshest critic, said these paintings were good.

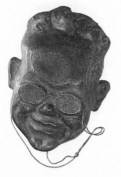

Late in 1925, Grant made a small clay model of his own smiling face, exaggerating his high forehead and cleft chin. The model wore pince-nez glasses attached to a heavy thread. He created a mold and cast a hundred plaster-of-Paris copies which he painted antique gold and gave as Christmas mementoes. I still have mine, and the Davenport Museum of Art and the Cedar Rapids Museum of Art have them, too.

Grant made his third trip to Europe in 1926, painting in Paris and southern France. On July 2, his one-man exhibit at the Galerie Carmine, 51 Rue de Seine, opened with a reception by invitation only. Thirty-seven paintings were in the exhibit, all but one renditions of French doorways. Bright posters all over Paris told of the exhibit, and Grant sent one home to us. He also sent notices from the Paris editions of the *New York Herald* and the *New York Tribune*. The *Tribune* article was illustrated by Grant's pen sketch of his own face signed "De Volson," his middle name, and it said, "The canvases of Grant Wood . . . have drawn a good deal

of favorable comment from the critics in mufti who inhabit the Left Bank." The *New York Herald* said, "Doorways and entrances invariably intrigue Mr. Wood, and nearly all of the paintings are constructed around that mysterious transition from indoors to outdoors which has played such a tremendous part in the civilization of man."

Grant had done some of the paintings in southern France in the company of the former Mary Safely of Cedar Rapids who was married to an Englishman, Michael Jeanes. Mary was an art student, and her husband arranged to take the two painters to cities in southern France on his business trips.

Back in Cedar Rapids, Grant was welcomed by friends who were artists, musicians, actors, and teachers. When a new cafe, the Travel Inn, opened downtown, Grant and his friends started dropping in for lunch. Soon it became a club, and then it was named the Garlic Club. A long table and a large wooden salad bowl were reserved for the members, and the charter Garlic Clubbers included James Farquhar, publisher of the *Republican*; Mrs. Farquhar; Gladys Arne; Betty Lowe; Ralph Leo; and Ted Sealy. Members who later achieved fame were author MacKinlay Kantor, Don DeFore of film and television fame, and Fran Allison, known for her performance with television puppets. When Fran Allison was honored on the television show "This is Your Life," Don DeFore said he first met her at the Garlic Club in Cedar Rapids. He went on to describe how Grant stood at the head of the table and ate a piece of garlic before breathing on the wooden bowl and mixing the salad. That tale is apocryphal. Grant sat at the head of the table and rubbed the salad bowl with a clove of garlic before adding greens and oil and vinegar and ceremoniously tossing the salad.

Grant constantly threw parties on the spur of the moment. He would come home with a load of steaks and buns and Brie and say, "Mom, a gang is coming. Put the coffee pot on." The conversation always was lively—about what everyone was doing and the latest plays they'd seen. I never knew any of Grant's parties to be a failure. He tossed pillows on the floor for seating and cooked the steaks over an open fire. He liked them rare and thick as a pot roast, and his steak sandwiches were something to write home about—more meat than bun.

Grant had a good appetite and was an enthusiastic eater. So was I. We often talked about this, not understanding why, eating the same food, Grant was inclined to be fat and I was inclined to be thin. One night at supper, Grant said, "It must be the way we fix our food after it comes to the table. I'll tell you what let's do. You fill your plate with the amount you want and fix it the way you want it. I'll do the same, and then we'll exchange plates. That way, you'll get fat, and I'll get thin."

That's what we did. Grant had sugar on his lettuce, sugar on his tomatoes, and sugar enough to fill half his coffee cup. He had butter on

everything, including radishes, celery, and cake. I didn't mind the butter, but the sugar was like medicine to me. I hadn't liked it since my days of turpentine and worms. Grant missed his sugar and butter very much, and after a week, he decided he would just as soon be fat. I would just as soon stay thin, so by mutual consent, we gave up the great experiment.

Another experiment Grant tried was to have Mother tie a string around one of his fingers to cure his forgetfulness. The string was used only for matters of importance, but when a forgetful Grant forgot what the string was for, he gave that up, too.

One day in 1926 Grant was out in the rain, and his shoes got soaking wet. He took them off, placed them on a table to dry and studied the still life they created. The painting that resulted was *Old Shoes*. At an exhibit, one man looked at the turned-up toes and said, "There's the reason Grant sways. It's his shoes. They're like rockers." His theory was wrong. When Grant was standing, he often put his weight on one foot and then the other, producing a side-to-side body movement, but he never swayed backward and forward. David Turner liked *Old Shoes* instantly and bought it. Later, a man wrote to him, saying he wanted the painting for his mother-in-law's birthday because her name was Oldshoes. He told David to name his price, but Dave said he'd never sell any of Grant's paintings. *Old Shoes* is part of his family's gift to the Cedar Rapids Museum of Art.

Shortly, Grant began a series of murals for the Eppley Hotels commissioned by the owner, Eugene Eppley of Omaha. The first was for Davey Jones' Locker, the dining room of the Russell Lamson Hotel in Waterloo, featuring scenes from the bottom of the sea.

He interrupted his work to come home for Christmas. At that time, he knew the Memorial Coliseum was being erected by the city of Cedar Rapids. On December 24, he wrote a letter to W.J. Brown, one of its architects. Grant said he very much wanted the contract for the stained glass window in the Memorial Coliseum and that Henry Hornbostal, an associate architect on the project, believed he was capable of doing it "to the credit of both the building and myself." He mentioned his Legion and local credentials but said that had little bearing on the matter. However, he wrote, "I feel very sure that no outside man could put into the window the work and devotion that I myself would." He pointed out that the window would take a great deal of research and detail work, "at the very least, a full year's time," described the painted glass process he would use, and expressed the hope of a favorable response from the architect and the commission.

After the holidays, Grant left for Council Bluffs, Iowa, where he painted murals that wrapped around two dining rooms of the new Chieftain Hotel. In the Corn Room, the walls were covered with harvest scenes: farm homes, barns, silos, windmills, corn shocks, golden pumpkins, winding highways, and, according to the *Council Bluffs Nonpareil*, "brilliant sunlight effects of which Mr. Wood is master." In the Pioneer Room, Grant worked with the assistance of Edgar Brittan on five murals depicting early Council Bluffs. The first four were scenes from Kanesville, the city's first name during the 1846 to 1852 Mormon period, chosen to honor Col. Thomas C. Kane, a friend of Brigham Young. Included was the home of Amelia Folsom, Brigham Young's favorite wife.

In 1959, restoration work on the Hotel Chieftain murals was done by Byron L. Burford, a friend and former student of Grant's who became an associate professor of art at the University of Iowa. Burford said the murals as restored should last indefinitely, but the same could not be said for the building. Within a few years, the Chieftain, which opened in February 1927, was torn down in an urban renewal project. Citizens who had given money toward the restoration failed in a delaying action. Experts estimated the cost of saving the murals at $100,000 and said they weren't worth removing. A California neurosurgeon read about the situation in the paper, and one day before the wrecker's ball was to crush the hotel's walls, Dr. Milton Heifitz flew to Council Bluffs and worked all night with his scalpel to remove the murals. He began by street light, and later someone brought a lantern. By morning, he had saved the murals at a total cost of $2.50 for tools—$99,997.50 below the estimates. Dr. Heifitz shipped the murals by air freight to his home in Beverly Hills to be restored at his own expense. The story made the European newspapers and even the medical magazines.

Grant was working on murals in Omaha's Hotel Fontanelle when we read in the paper that he had received the commission for the stained glass window in Cedar Rapids. The contract was to be awarded to Grant provided the project should cost no more than $9,000 and the commission approved his sketches. Grant wrote from Omaha, saying, "Isn't it wonderful about the memorial window?" and telling us that climbing up and down ladders eight hours a day was hard work. He was being treated very well at the Fontanelle, however, and said, "We have a wonderful room, and the hotel cook is making us a special dinner of bear meat."

He soon returned to Cedar Rapids to begin his research for the Memorial Window and plunge into many other projects. He and Marvin Cone designed a thatched-roof entrance for an authentic English garden patterned after William Shakespeare's garden in Stratford-upon-Avon for the Wednesday Shakespeare Club. The garden was and is located on an acre of ground in Ellis

Park on the banks of the Cedar River, but the Wood-Cone entrance eventually was replaced by English stone pillars.

The Eppley Hotels commissioned murals for the Montrose Hotel in Cedar Rapids, and Grant called the group *Fruits of Iowa*. Individual scenes were *Girl with String Beans, Boy with Watermelon, Man Feeding Hogs, Woman Feeding Poultry,* and *Hired Man Milking Cow*. He also did two small paintings, *Fruits* and *Vegetables*. The murals in the dining room were on canvas, and when the hotel people changed the decor, they peeled them from the walls and let them gather dust in a store room. When Grant heard that, he tried to buy them back for what the hotel had paid him—a very small amount. He pointed out that if they sold them back to him, they would have had the use of the murals free. They refused, asking $5,000, and then framed and hung the murals on the mezzanine floor. After Grant's death in 1942, they invited the public to come and see the hotel's "$50,000 collection of Grant Wood paintings." Later, when the hotel changed hands, the Eppleys were ready to move the murals from Cedar Rapids but were persuaded by many letters and telegrams to leave them in the city where Grant lived and worked. They are now displayed in the Grant Wood Wing of Stewart Library at Coe College, on permanent loan. Some of the preliminary charcoal drawings for the murals were part of the Vincent Price Sears Collection. *Man Milking Cow* was purchased by John Deere & Company, and *Man Feeding Hogs* was bought by the Waterloo Savings Bank.

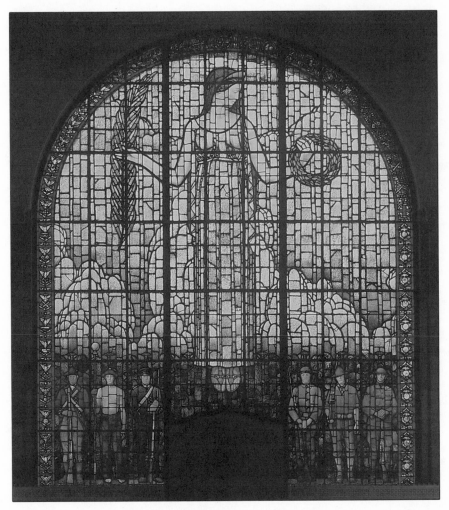

Memorial Window, 1927 -1929
Stained glass, 24 x 20 ft.
Cedar Rapids Veterans Memorial Building

CHAPTER 5
THE MEMORIAL WINDOW

Grant knew that the Memorial Window would take "at the very least, a full year's time," and the creation of the largest stained glass window in the United States actually took two full years.

He considered several ideas for the window before fixing upon the one he would use. At the base would be the life-size figures of soldiers of every American war: the Revolutionary War, the War of 1812, the Mexican War, the Civil War, the Spanish-American War, and World War I, known at that time simply as "the World War." Above the soldiers would be the central figure, a woman representing the Republic. Naomi Doebel, later reviewing the finished window for the *Cedar Rapids Gazette*, described that figure as "a woman in Grecian robes of lavender with pale rose cast, standing 16 feet tall with toes pointing down as she floats in the clouds, giving the spiritual effect achieved in many of the Renaissance paintings. On her head is a mourning veil of blue. In her right hand she holds the palm branch of peace and in her left the laurel of victory."

Grant put a lot of himself into this project. After traveling east to research the costumes in April 1927, he returned to work on the preliminary drawings. Although he said my features were all wrong, he decided to use me for the woman model. He would paint a classical face rather than mine. My costume was a problem, too. He wanted graceful draperies and tried an old sheet, but it was too stiff. After more experimentation, he tried cotton jersey and learned that putting it on me wet would do the trick. The weather was chilly, and he worried that I would catch cold, so he turned up the heat. Grant really sweated over that drawing. The wreath I held was heavy, so he made a prop I could use to rest my arm while posing.

The window was to be twenty-four feet tall, and Grant's drawing was full size—too tall for the studio. His solution was to draw it in sections and lay it on the floor. One day Arthur Poe, manager of the Quaker Oats Company plant,

dropped in. Noting the cumbersome problems of the project, he offered Grant the use of the large recreation room at the mill, and the rest of the work on the drawing was done there.

Perspective proved to be the greatest problem. Grant found that he had to make the lines and spaces wider at the top than at the bottom to keep them in proportion.

Harry Robinson, a former pupil, was one of the models, and he had five others. Arnold Pyle, a young Cedar Rapids artist, was Grant's assistant.

When the drawing was finished, Grant took it to Emil Frei, owner of the Frei Art Glass Company of St. Louis. Frei said the window should be made at his associated factory in Munich, where the "best workmen in the world" were available. Grant obtained the approval of the Memorial Commission to have the work done there, not expecting the later criticism from "patriotic" groups who saw it as most inappropriate that a window honoring American veterans should be executed in a country that had been the enemy just ten years earlier. Grant always was naive about political matters.

Frei went to Munich with Grant and stayed on to help with the creation of the big art piece. From mid-September 1928 to mid-December, a dozen skilled workmen labored to make fifty-eight sections for a window twenty feet wide and twenty-four feet high. Excitement ran high in the factory.

The finest of the workmen undertook the six life-size soldier figures against a rich oak leaf background. But something was terribly wrong. The American military men had been transformed into uniformed saints with the pinched noses and small nostrils seen in Gothic art. They wore the right uniforms, but they lacked the independent carriage, the forcefulness, the alert appearance, and the typical bone structure of the American face. The Civil War soldier looked like Christ. But what could one expect from men who had spent their lives painting Saint Peter, the Madonna, and the Savior? Grant was heartsick, but he couldn't speak German fluently, and rather than hurt their feelings when they were trying so hard, he said nothing. Again and again they tried to make the figures. Again and again they failed.

Finally, they bowed to the inevitable and told Grant, "We'll have to teach you to paint the glass so you can make these soldiers real Americans."

Grant began the most discouraging task he ever undertook. In painting stained glass windows, the artist works directly on bits of antique glass that are to be part of the finished window. The bits are fastened with wax to a plate glass through which light shines while the detail is applied to their tinted surfaces with a brownish iron oxide paint. Later, it is fired. The first few faces Grant painted looked fair before they were fired, but the high heat faded the features. He tried and failed over and over again. When he applied heavy layers of paint, they blistered. When he lightened the paint, it faded. Finally, he achieved the

right balance and painted all the faces except that of the World War I veteran, which Emil Frei painted. (Frei also did the heroic "Republic" for which I had modeled). It was necessary to remake two sets of uniforms, replacing a purple-toned glass used for contrast with a softer blue.

Then came the creation of the big border of Army, Navy, and Marine Corps insignia, and when it was completed, Grant was horrified to realize his drawings were too small in detail and too weak for such a big window. The proportions had seemed right in the drawing, but in glass of strong colors, the effect was different.

Grant said, "I was terribly dissatisfied, but I hated to say anthing to Mr. Frei, who had already been so wonderful. He was almost as miserable as I over the result but hesitated to speak for fear of hurting me. At last he understood my feeling and said, 'If you redesign the border, we will make it over.' It meant a tremendous amount of work and expense for him, but when it was finished on a larger scale, it was beautiful."

When the border was right, Grant's mind was at rest, but the men at the plant were in an uproar. To keep the Roman numerals for the war years in the spaces under their figures, the artist had taken numerical liberties. For instance, for 1898, he had written MCCMIIC instead of MDCCCLXXXXVIII. Grant, who had been confident that he was right originally, began to have his doubts. One faction maintained he was right and another said he was wrong. They argued and worried until the foreman suggested settling the matter by consulting an expert at the University of Munich. The verdict was, "The American's numeral is unusual but technically justified."

Working with German artisans who spoke no English, Grant made himself understood with just two German words, hell (light) and dunkel (dark). He learned the word for light in a cafe when he asked for a stein of beer. "Hell?" said the waitress. Grant was shocked, but he said nothing, and she brought light beer. When he left a tip, she said "Donkey!" (or so he thought). Grant told Emil Frei that "hell" and "donkey" were the only two English words he heard all night, and neither was complimentary. When Frei stopped laughing, he explained that the waitress had asked if he wanted light beer and had said Danke schoen (thank you) for the tip.

The ten thousand individual pieces in the window were made into fifty-eight sections, which were numbered and brought to Cedar Rapids to be installed.

Before he left Germany, Grant was honored at a farewell dinner given by the twelve artisans who worked on the window. Grant didn't understand a word that was said, but it was all very jolly, and a picture was taken. When the framed photograph, which was not very clear, arrived in Cedar Rapids, Mother examined it closely and said, "Aren't those Germans funny-looking people?

Especially the one in the middle." Grant burst out laughing. He was the "funny-looking German" in the middle. He loved to tell that story and often teased Mother about it.

Grant retained warm feelings for the German people. Men he met in German cafes had been soldiers, and they told of the times when doughboys sent to kill had saved their lives. They raised their steins and shouted toasts to the United States.

The placement of the window in the Memorial Building facade dissatisfied Grant in several ways. He wrote to Colonel C.B. Robbins, chairman of the Memorial Commission on May 11, 1929.

"You must not blame me for seeming impatient about this," he wrote, "as I have done my very best to create a fine piece of work, and I have felt bad that it has been exposed to the public gaze for over two months under such unfortunate conditions."

He reminded Robbins of his recommendations to the commission when the window was accepted and said, "All that I have tried to express in the window is centered in the expression of the woman's face." Unfortunately, when a viewer stood back far enough to see the whole window, the lanterns in the hall hung down and covered her entire head. Grant suggested spotlights for night lighting and the removal of the top lanterns.

He complained about the improper caulking between steel frame and stone which allowed a leakage of light giving "an unfinished effect to the window."

He further asked that an inscription be carved on a stone in the center of the window, because "A stone such as this coming up into the space of a window is very unusual. It needs an inscription to justify it." He said he had figures on the cost of the carving "which I will show you when you are ready."

His fourth point was the necessity of window shades in the large transoms above the entrance doors that flanked the window. "The dazzling white light that comes in here hurts the window."

Grant further noted that he had created "at least a $12,000 window for $9,000" and said he had hoped the window would have a public unveiling on some appropriate occasion such as Memorial Day "with yourself or some other nationally known man as speaker."

Colonel Robbins himself caused the delay in the dedication of the window—a delay of twenty-seven years, as it turned out. Grant had prepared a simple, dignified inscription for the window, but Colonel Robbins loudly demanded a long, flowery text. Grant refused to give in, and the deadlock lasted until the matter was forgotten.

The question of the inscription was not revived until thirteen years after Grant's death. By then, everyone wanted Grant's choice, but no one knew what it was. Eventually, we found what we believed to be the wording he

wanted in a sketchbook. Abraham Pilicer, then chairman of the Memorial Commission, pressed the matter, and the window was dedicated November 15, 1955, twenty-seven years and two more wars after its completion.

I came from California and my brother Frank came from Waterloo for the public ceremony, and I unveiled the dedication plaque. With slight modification, the inscription reads: "This window, dedicated in 1955, honors the sacred memory of the men and women who unselfishly gave their lives in defense of our country. Designed by Grant Wood (1892-1942)—Cedar Rapids' noted artist—and executed under his personal supervision in Munich, Germany." Actually, Grant was born in 1891, but the error in his birth date can be traced to him. Most of his life he told people he was born in 1892, thinking he was correct.

In 1973, some of the drawings for the Memorial Window were found rolled and stored above steam pipes in the basement of the Memorial Building. Heat from the pipes had caused some of the paper to dry and crumble, but the drawings of the figures were intact. The Memorial Commission placed them on permanent loan to the Cedar Rapids Art Association, and Donn Young, then director of the Art Center, said, "These drawings are most important documents. They seem to be the first example of Wood's famous American Gothic style."

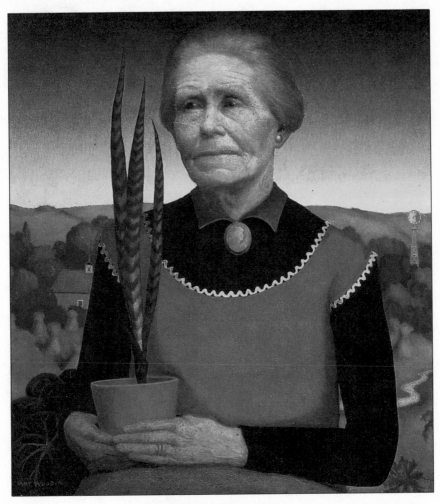

Woman With Plants, 1929
Oil on upsom board, 20 $\frac{1}{2}$ x 17 $\frac{7}{8}$ in.
Cedar Rapids Museum of Art

CHAPTER 6
A NEW STYLE

Currants, (1907)
Watercolor on paper
Davenport Museum of Art

The most important development of Grant's 1928 trip to Europe was a decided change in his own interpretation of his role as an artist. At the time, I knew nothing of the great ferment that changed him from Grant Wood, the French Impressionist, to the Grant Wood of his mature and meticulous style, but it happened with the decisions made on his Munich trip.

In a 1932 interview that appeared in the *Christian Science Monitor*, he said he was strongly influenced by the Impressionist school because he was taught to paint "after their manner." However, his natural tendencies were toward the extremely detailed, and as a boy, he painted a picture of a bunch of currants which no one, he said, "not even a Japanese—could have executed with a more meticulous finish."

In Munich, he attended the annual exhibition at the Glass Palace and, he said, "I found myself experiencing a reaction against so-called Modernism and felt myself strongly drawn toward rationalism. It appeared that the Modernists went to the Primitives for inspiration. I wondered if I could anticipate what was to follow, and it seemed to me the Gothic painters were the next step. I had always admired them, especially Memling, whom I had studied assiduously."

To Grant, the Gothic seemed the line of advancement, and he retained what he thought was lasting in the Modernistic movement, adding a story-telling quality as a logical opposition to abstraction.

"Here I was on dangerous ground, "he said, "because story-telling pictures can so easily become illustrative and depend on their titles."

For this reason, he leaned strongly to the decorative and tried to paint types rather than individuals. The lovely apparel and accessories of the Gothic period appealed to him so vitally that he longed to find the pictorial and decorative possibilities in contemporary clothes and art articles.

"Gradually, as I searched, I began to realize there was real decoration in the rickrack braid on the aprons of the farmers' wives, in calico patterns and in lace curtains. At present, my most useful reference book is a Sears, Roebuck catalog."

Grant joyously discovered that in the commonplace, in his native surroundings which he had taken for granted, were decorative adventures. He said, "I regret the years I spent searching for tumble-down houses that looked 'Europy.' I know now that our cardboardy frame houses on Iowa farms have a distinct American quality and are very paintable. To me, their hard edges are especially suggestive of the Middle West civilization. With this line of reasoning, I really found myself, and instantly my work became successful."

Grant's first painting after his return from Europe was of the person he and I knew best and loved most—Mother. She was sixty-nine at the time. Grant's first idea was to have her canning fruit, but he changed his mind and decided to have her holding one of her plants. In the painting she wears a black dress with a blue collar and an apron trimmed with rickrack. At her throat is the cameo brooch Grant bought for her in Europe. He bought one for me, too. Mine was ring size, and Mother's was larger. He said he bought hers because he thought the girl on the cameo looked like me, and he had it made into a brooch—the same one I wore later in *American Gothic*. In Mother's tired, seamed face in *Woman With Plants* is a look of ineffable serenity drawn from a full and rich life nearing its close. Behind her stretches Iowa in harvest time—a snug farmhouse, corn shocks in the fields, and a golden glow suffusing the scene.

Grant planned to send *Woman With Plants* to the annual exhibition of American painting and sculpture at the Art Institute of Chicago. He had exhibited at the Iowa State Fair and other local shows and won prizes, but this would be his first venture in the big shows. Even if a painting did not win a prize in Chicago, having it hung honored the artist.

He finished the painting on a dark and rainy afternoon, and the paint refused to dry. Grant waited as long as he could, knowing the deadline was near. "If this doesn't get off today, it won't get there in time," he fretted. He tried the electric fan to no avail. Then he held the painting over an electric hot plate. To our horror, the paint started to rise in blisters. Grant carefully pressed the blisters down with his fingers until he was satisfied with the results.

"Look, Mom," he said, "you may have a few more wrinkles, but the painting is better than ever and dry enough to send. Maybe I've discovered a new method of painting—hot plate a la mode."

Woman With Plants made the 1929 show and caused such favorable comment that my brother, highly elated, went to Chicago to see it hanging in its galleried glory. He came home feeling displeased. He said it "looked like a postage stamp" hanging there among the large paintings. To me, it was

beautiful—not only because it was of Mother, but also because it was and is a sensitive example of the artist at his best. The art critic Thomas Craven wrote that in this painting, Grant embodied all the craftsmanship and love of detail which he had admired in the Munich paintings and produced "a devotional painting of the purest type." We had watched the painting develop stroke by stroke, and to me, it was the most beautiful painting in the world.

Much has been written of Mother's worn, tired fingers holding the flower pot containing the speckled snake plant found in many Iowa homes. The slender-tipped fingers that once played the church organ and did exquisite embroidery were gnarled and roughened by the long labors of love. I remember her bending over the wash tub, scrubbing clothes on a tin washboard and hanging them out in weather so cold that the boys' long underwear froze stiff. She had to run inside every few minutes to warm her hands. I also remember those hands, cracked and bleeding from hot suds and cold winds, skimming a bit of cream off the milk and using it as lotion for an equally chafed face. To Grant and me, these were the most wonderful hands in the world.

And what of the face? If the Dresden doll who became our mother could have looked into her own future, could she have borne the losses and hardships to be seen there? They became part of the record etched in the face of the painting, along with the satisfactions and joys we three had experienced together. Mother took great pride in the steady progress of Grant's art career, even if she did grow weary of the parade of visitors to No. 5 Turner Alley and long for the privacy that once was ours.

Author William L. Shirer once wrote to me, "I'm sure she never knew it, but your mother was a life-long inspiration to me. She triumphed over all the terrible setbacks of life. And it must have been a triumph for her to have lived to see Grant become one of our greatest artists."

In his book, *Twentieth Century Journey*, Shirer wrote of Mother, "It was in her that I first grasped the wonder and beauty of human fortitude, of how a human being could survive degrading poverty and the numbing heartbreaks and hardships that went with it, with grace and dignity. Like her son, she refused to be defeated by what life at its worst had brought her. All this Wood has preserved for posterity in his painting of her—*Woman With Plants*—a copy of which hangs before me now in my study. It is one of the great portraits painted in our time. Wood thought it was his most enduring work."

A movement to keep *Woman With Plants* in Cedar Rapids was started by Arthur Poe, manager of the Quaker Oats plant. The painting was then known, incidentally, as *Woman With Plant*, Grant's title. He later made it plural. Poe wanted the Cedar Rapids Art Association to buy the painting, but Grant had no intention of selling it. He said he painted it for Mother, and it was to be hers. Mother had a different view. We needed money badly, and Grant could now command

$300 for a painting, a figure we'd never dreamed of in the past. She asked Grant to sell it. "For pity's sake," she said, "you can always do another painting of me." The painting was sold to the Art Association, which still owns it, but Grant, who fully intended to paint another portrait of Mother, never got it done.

The high point of a summer in Colorado for Grant turned out to be about 14,000 feet—the summit of Long's Peak. David Turner, who often vacationed at Estes Park, lined up a job for Grant teaching painting there. David, Grant, and other friends went for a climb. At the top, Grant felt the effects of high altitude; the others were amazed to learn he never had climbed a mountain before. They said the Long's Peak altitude was much too high for a first climb. The next day, Grant was so sunburned that they all called him "Red" Wood, but his sufferings were rewarded with honorary membership in the Amateur Mountain Climbing Club.

While in Colorado, Grant did several oil paintings of snow-capped mountains. One of these landscapes brought top money in a 1977 sale at the Richard A. Bourne Galleries in Hyannis, Massachusetts.

David Turner arranged for Grant to address the annual convention of the National Selected Morticians at Chicago, and the association presented a Grant Wood painting to its retiring president. When Grant came home, someone asked, "What in the world did you talk about to a group of morticians?" Grant cleared his throat twice and answered solemnly, "Burial as a Fine Art."

After his success with Mother's portrait, Grant painted *John B. Turner, Pioneer*, his second work in the new, meticulous style. John B. Turner was David's father, a fine old gentleman known to everyone as "Daddy Turner." Some of Grant's Amana friends had given him an old map which he used as background for this portrait, and Daddy Turner always smiled and called the painting "two old maps." He was not totally pleased with his portrait, thinking Grant made him look too old. Actually, the portrait was an excellent likeness and is one of Grant's finest paintings. Thomas Craven called it the best portrait ever painted by an American. The painting is at the Cedar Rapids Museum of Art.

Grant always enjoyed his visits to the Amana Colonies, seven villages about twenty miles southwest of Cedar Rapids. The people, farming about 26,000 acres and carrying on their own crafts and industries, were under a form of religious communal life until 1932, when they voted to separate their religious and secular entities. Grant met these people through Carl Flick of West Amana, a young painter who was having technical problems and came to Cedar

Rapids to see if Grant could help. Grant did help, and the two became friends, often painting together in the Amanas. All summer, we were showered with good things from Amana: yard-long sausages, mushrooms, and jugs of wine. Once Grant was given a raccoon, and we had it fried, stewed, in chops, as steaks, as ribs, and in burgers. It helped wonderfully with the meat bill, but we thought we'd never finish it. The climax came when a friend of Grant's showed up wearing a new raccoon coat, which was all the rage. Grant burst out, "For Pete's sake, Norm, please don't wear that coat when you come here. It's no reflection on the coat—I just can't stand to look at it!"

In those days, a photographer named Rembrant posted a big sign at his home on the highway to Marion that read, "Let me take your photograph. If you aren't good-looking, I'll make you that way." One day a *Cedar Rapids Gazette* story about Grant compared his work to that of the great Dutch painter, Rembrandt. The next day, a woman stopped me on the street and said, "Nan, I certainly don't see how the Gazette can compare Grant's work to that of Rembrant. The picture he took of me was terrible! He didn't make me good-looking at all!"

Grant was extremely careless with money. He would not carry a billfold—even when I made him a hand-tooled one that he liked. He jammed his money into his hip pocket with his handkerchief, and when he pulled out the handkerchief, money fluttered to the floor without his notice. Once while standing on a street corner in Chicago, Grant reached for his handkerchief and was shocked to find a hand other than his own in the pocket. This prompted him to buy a belt with a zippered money pocket, but after one trial, he never used it. He said it was too much bother.

John B. Turner, Pioneer won the portrait award at the 1929 Iowa State Fair. Grant returned from his trip to the fair with a chameleon. It had a little collar and chain so it could be worn on the lapel, and it would turn the color of the suit. Grant put it among Mother's house plants and told us it lived on flies. We had no flies, but Grant's friend, Chuck Clark, came to the rescue with dead ones. Grant put them on a broom straw and twirled it to fool the chameleon into thinking the insects were alive, and it ate. Fortunately, it lived well on two flies a week.

One day Grant brought home two fan-tail goldfish in a glass battery jar filled with water, sand, and seaweeds. Mother was delighted. The fish would follow her finger around the bowl, and when we came near, they wagged their tails as if they were glad to see us. Chuck was bemoaning the fact that he owned a rooming house with no roomers, and Grant suggested, "Maybe roomers are lonesome. Why don't you put a goldfish in every room?" Chuck advertised "Rooms for Rent—a Goldfish in Every Room," and the ad created a lot of interest. After seeing how glad the goldfish were to see him, a cab driver rented

a room, and soon every room was taken. However, the woman who managed the place moved out. Packing her bags, she told me, "Grant Wood and Charles Clark ought to be ashamed—running an undignified ad like that!"

A promising young artist named David McCosh who had won a scholarship and a $1,000 prize came to the studio one day, boiling mad. He said he had given a painting to a friend, who proceeded to pencil crude features on every face before hanging it. "There the thing hangs with my signature on it," Dave stormed. "Everyone will think I did it. I had a hard time to keep from yanking it off the wall, throwing it on the floor and jumping on it. What would you have done, Grant?"

"I would have yanked it off the wall, thrown it on the floor and jumped on it," Grant replied. I doubt that, because Grant hated emotional scenes. More likely, he would have borrowed it on some pretext and failed to return it.

In October 1929, the Community Players organized as the Cedar Rapids Theatre Guild and elected officers. Grant and Marvin were charged with decorating for a November 14 opening of *Meet the Wife*.

The sets were a lot of work for Grant and Marvin, but the theatrical life was so much fun that they didn't mind. One play opened on Friday the 13th. To show that they were not superstitious, the members voted to accept as an honorary member a cat named Beeswax that would be thirteen on its next birthday.

One bit of fun caused almost too much hilarity. The play was *The Queen's Husband*, and the setting was a library with a wall of books. Grant and Marvin titled the books with humorous digs at local people, but no one saw their handiwork in advance. On opening night, player after player would stroll toward the book shelves with great dignity, take a casual look at a book title and break into unscripted laughter. When the curtain fell, much of the audience came onstage to read the titles.

In a ship set for the play *Outward Bound*, Grant made the waves so realistic that a little old lady in the audience made a hasty exit. She declared that the waves were making her seasick.

When Little Theaters all over the country announced a contest to see who could write the best play, Grant and Jewell Bothwell Tull, wife of a professor at Cornell College, Mount Vernon, became co-authors. Their play, *They That Mourn*, was eliminated in local competition, but without their knowledge, Professor Tull entered it at the national headquarters, and it won the national first prize. When Grant received a $1.65 check from a play service for lease of the play, he was as pleased as if he had gotten a thousand dollars.

Grant and Marvin were deeply interested in a trial program for promoting general interest in art mounted by the American Federation of Arts with a $50,000 grant from the Carnegie Foundation. W.R. Boyd of Cedar

Rapids had been instrumental in securing the grant, and his city was chosen "because it is a community of less than 100,000 population, a typical American community sufficiently removed from any important art center which might otherwise be administering to its cultural life." The purpose was "to demonstrate the place of art in the daily lives of the people, to show other communities what can be done in the field of fine arts with limited financial means, and to encourage sales, because with possession comes added interest." The enthusiasm of people like Emma Grattan, Grant, and Marvin also helped attract the Carnegie grant to Cedar Rapids, where the Art Association was formed in 1905 by E.M. Sefton, an instructor in piano and music theory. Although they were high school boys at the time, Grant and Marvin were moving spirits in the group from the start.

Under the Carnegie grant program, many American painters came to Cedar Rapids to exhibit and lecture. They included Charles W. Hawthorne, Louis Kronberg, Paul Trebilcock, William W. Schwartz, Frederick Tellander, Frank Gardner Hale, and Francis Chapin. The grant also brought Mr. and Mrs. Edward B. Rowan to Cedar Rapids. Rowan directed the "Little Gallery" program of exhibits and classes. Numerous Iowans studied art with Grant at the Little Gallery, where as many as seven groups were studying simultaneously. Rowan took dance lessons from Edna Dieman while he was in Cedar Rapids, and when Ruth St. Denis danced at the Paramount Theatre, she visited the current art exhibit at the gallery.

Edward Rowan did make one mistake while he was in Cedar Rapids. He was from the East, and when two Cedar Rapids women wanted a portrait of their father, he persuaded them to bring an artist friend of his from New York to paint the likeness. This was a considerable investment for the women, and they were terribly disappointed with the result. They looked at the portrait of Daddy Turner by Grant, and then they looked at the portrait they had commissioned, and they were heartsick. Their imported artist explained that he had painted their father's soul—"what he really looked like inside." The daughters wept.

Grant had long been intrigued by the arched Gothic windows copied from the massive stone cathedrals of Europe and placed in frame houses in rural Iowa. While riding near Eldon in southern Iowa with a former student, John Sharp, Grant called out, "Stop! There's a house I want to use." He sketched the house that would become part of *American Gothic*.

As he put together his composition of the house and two people while he was at the breakfast table that morning in 1930, he said he had models in

mind—a man and a woman who would be just perfect. However, he was afraid to ask the woman, fearing she would be angry at the idea of being made something less than beautiful.

Clearly, he did not have me in mind, but I blurted out, "What's wrong with me?"

Grant looked at me for a moment and said, "I believe you will do. Your face is too fat, but I can slim it down, and you can get rid of the iron dog (marcel waves in my hair). Are you sure you won't mind posing?" I assured him I would not mind.

Grant never told me whose place I took as the model, but I'm sure it was a spinster who had hounded him to paint her portrait. Grant tolerated her because her nephew was his friend. She repeatedly told Grant she had no money, but the portrait would be "on commission." Mother and I agreed that she expected Grant to paint her looking young and beautiful, sell the painting, and take a commission from the artist. Dried up, dreary, and drab, she would have been ideal for *American Gothic*. I'm sure the idea of using her as the model secretly amused and tempted Grant, but he was correct in suspecting that this woman would have been furious about being painted any way other than beautiful.

The man Grant wanted to pose for him was our family dentist, Dr. Byron McKeeby. He and Grant were good friends and once had bartered a dental bridge for a painting of a bridge, a transaction they both described as "a bridge for a bridge."

Grant assured us both that when he finished the painting, no one would ever recognize us. He told me to slick down my hair and part it in the middle and asked me to make an apron trimmed with rickrack, a trim that was out of style and unavailable in the stores. I ripped some off Mother's old dresses, and after the painting made its debut, rickrack made a comeback. Grant was responsible for a rickrack revival.

He asked me to wear Mother's cameo at my throat, and as he was tearing up some paint rags from old clothes Aunt Hattie had given him for the purpose, he pulled out a shirt and said, "This is what I want the man in the painting to wear."

Grant spent three months working on the painting, often staying at it until two o'clock in the morning. Dr. McKeeby and I never posed together. Grant worked on Dr. McKeeby in the dental office in the evening, and I posed at home—No. 5 Turner Alley.

Winning the Norman Wait Harris Medal and the Art Institute of Chicago's $300 purchase prize, *American Gothic* skyrocketed Grant to fame and

stirred instant controversy of the type that would mark the reception of many of his later works. The painting was reproduced in newspapers throughout this country and in Europe, and those close to home were bombarded with letters protesting the "insult" to farm women. Letters to the editor called me "the missing link" and "an oddity," among other things. Mrs. Earl Robinson of Collins, Iowa, advised Grant to hang the painting in an Iowa cheese factory "because that woman's face would positively sour milk." Another woman dubbed the painting "The Return from the Funeral." Grant received a phone call from a woman who told him he was going to have his head bashed in.

People read all sorts of meanings into the painting. For instance, one "critic" said the three-tined fork represented the Trinity. No one seemed to take offense at the man in the painting. People seemed to find him kindly looking; a person they could trust.

All articles referred to "the farmer and his wife," which upset Grant. He said, "I simply invented some American Gothic people to stand in front of a house of this type. The people are not farmers but are small-town, as the shirt on the man indicates. They are American, however, and it is unfair to localize them in Iowa. My sister posed as the woman. She is supposed to be the man's daughter, not his wife. I hate to be misunderstood, as I am a loyal Iowan and love my state." Grant's words had little effect. References to "the farmer and his wife" have been made for more than half a century.

We received clippings about *American Gothic* from London, Berlin, and even Trinidad. American headlines read, "Iowa Painter Rises from Obscurity to the Top," "Iowan's Art the Vogue," "Grant Wood Hailed from the West to Berlin as an Art Discovery," "Critics Hail Grass Roots Portrait," "American Art in New Trend," and "Grant Wood's Painting the Talk of Chicago Art Circles."

An eastern art critic wrote, "Grant Wood's crassly meticulous Americana points a trend in painting that one regards with alarm," but favorable comment was more the order of the day. Christopher Morley, writing in the *Saturday Review of Literature* and *London Studio*, said, "In those sad and fanatical faces may be read much of both what is right and what is wrong with America. . . . It seemed to me one of the most thrilling American paintings I had ever seen."

Harry L. Engle, writing in *Palette and Chisel*, said, "It is a composite portrait of all the Uncle Johnathan Wesleys and Aunt Prudence Abigails of the Midwestern Bible Belt, and may good fortune grant them a glimmer of humor when they view the result."

Grant felt that Arthur Millier, art critic for the *Los Angeles Times*, had the best understanding of the painting. Millier wrote, "The authenticity of this social document (it is no less) comes from Wood's recognition of the long American story which made these firm Iowa people, and from his realization

that in the patterns of the farmwife's apron and the striping of the man's shirt, the batting of the house, the roof pitch, no less than in the facial lines and expressions, he was face to face with something real—with such material, in other words, as a good novelist would use. As in the case of a novel, the portrayed are probably the only people who resent it—it is too convincing!"

Despite Grant's efforts to disguise his models, I was recognized, even before the painting was completed. The studio visitor, William Allen White, the famous editor from Emporia, Kansas, looked at me and told Grant, "I don't have to look far for your model." I laughed and told him he was right.

Dr. McKeeby was not recognized until much later. His first reaction to the painting was that Grant had made him look too old—a common complaint among men. Grant felt bad about this. He went to Dr. McKeeby's office for a talk that made them both feel better. Later, Dr. McKeeby offered to go to the Art Institute of Chicago and pose beside the painting. In 1935, he told an interviewer that he was the man in the painting and proud of it. After Grant's death, Dr. McKeeby spoke on a national radio broadcast, saying, "Grant Wood was the kindest man I ever knew."

When Rousseau Voorhies visited Iowa in July 1934, he met Grant and Dr. McKeeby and reported that Gertrude Stein's admiration for Grant was genuine and enthusiastic. Voorhies represented Macmillan, the publisher of Sterling North's book, *Plowing on Sunday*, for which Grant had designed the jacket.

In a *Daily Iowan* interview in Iowa City, Voorhies said, "Miss Stein has said that Grant Wood is the first artist of America. She believes that he is first from the standpoint of time, because there was never really any other American artist before. The others were imitators of Europe. 'Grant Wood is not an imitator, but a creator,' she told me. 'He is not only a satirical artist, but one who has a wonderful detachment from life in general—a necessity for creating the best of art.'"

Voorhies, a descendant of Jean-Jacques Rousseau, said, "When I saw *American Gothic*, I made up my mind to meet two people—the painter and the model who posed as the farmer. When I did meet Mr. Wood, my reaction was that besides being a contributor to serious art, he has an exquisite sense of humor. At once he made me forget the Depression. Yesterday I met Dr. McKeeby, the model, and when I discovered that he could smile and say he was having the jolliest time of his life, I suggested to Mr. Wood that he get out a revised edition of *American Gothic* and show Dr. McKeeby making whoopee."

I missed meeting Voorhies because I was on the west coast at the time.

Grant was thirty-nine when he painted *American Gothic* and was well-prepared emotionally for the storm of controversy that surrounded him. He said, "I'd rather have people rant and rave against my painting than pass it up with 'Isn't that a pretty picture?'"

Critics usually called *American Gothic* satire, and Grant found himself labeled as a satirist. He was the first to disagree, saying, "There is satire in *American Gothic*, but only as there is satire in any realistic statement. These are types of people I have known all my life. I tried to characterize them truthfully—to make them more like themselves than they were in actual life. They had their bad points, and I did not paint these under, but to me, they were basically good and solid people. I had no intention of holding them up to ridicule." On another occasion, he added, "I admit the fanaticism and false taste of the characters in *American Gothic*, but to me, they are basically good and solid people."

It is unfortunate that my brother could not have lived into old age, if only to observe the ever-quickening tempo of American fascination with *American Gothic*. The famous, from George Washington to Elizabeth Taylor, have been portrayed with pitchfork in front of the little house in Eldon. In 1957, an *American Gothic* tableau opened Meredith Willson's *Music Man* on Broadway. Advertisements and television commercials for cornflakes and many other products featured the Gothic couple. In 1961, a Charles Addams cartoon in the New Yorker depicted the Gothic pair strolling down a museum corridor as if they had come alive and stepped out of the painting.

Edwin B. Green, editor of the *Iowa City Press-Citizen* and Grant's friend for many years, was alert to the significance of the flow of *American Gothic* parodies. He started to save clippings—first in a drawer, then several drawers, then a closet. Finally, his collection threatened to fill an entire room, and he donated it, in 1979, to what is now the Davenport Museum of Art. Nearly every president since 1930 is included in the collection, and Green, a world traveler, found *Gothic* greeting cards wherever he went. He said, "In Los Angeles, Tucson, New York, or Europe, it seems I have only to walk through the door of a store and take one look at the greeting card counter. I can spot a new *American Gothic* greeting card parody even if it's fifty feet away."

A few of the parodies have been obscene, in my opinion, and I resented them. In 1967, I sued *Playboy*, NBC, Johnny Carson, and *Look* magazine for presentations based on a topless parody that appeared in *Playboy*. These matters were resolved in an out-of-court settlement. Ten years later, *Hustler* magazine printed another topless parody, but public attitudes had changed, and my suit was dismissed.

In 1970, the fashion editor of the New York Times proclaimed, "The *American Gothic* hairdo—Grant Wood's heroine is it for '70." Later that year, *Mad Magazine* portrayed the couple separated and embraced by President Richard Nixon, the threesome captioned "Silent Majority."

Instant recognition of the image made it a true American icon. Matthew Baigell from the department of art history at Ohio State University,

wrote in the *Art Journal* in 1966, "*American Gothic* is probably the most famous American painting of the century. The fascination this work holds over people is in itself fascinating. Why, for example, do people invariably laugh when they stand before it or see it in reproduction? Is it a laugh offered in nervous recognition of what they know is true about themselves but try so hard to repress? Do they see their self-portraits in middle age, or those of their neighbors? Wood seems to have painted an equivalent of their life and given them an image of what they may actually be. Certainly, there is the shock of recognition in those faces. Whatever else one may think of *American Gothic*—once seen, it is never forgotten."

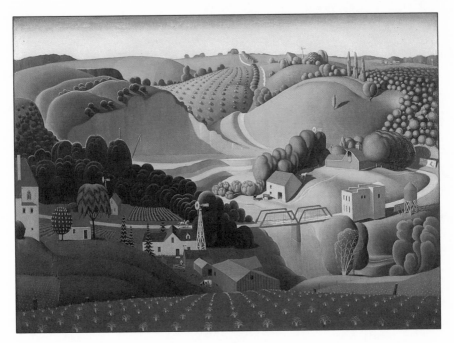

Stone City, 1930
Oil on composition board, 30 ¼ x 40 in.
Joslyn Art Museum, Omaha, Nebraska

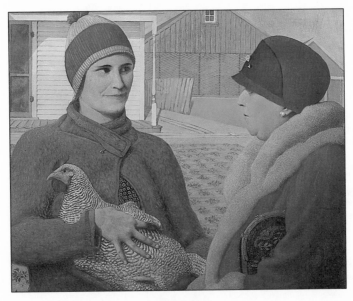

Appraisal, 1931
Oil on composition board, 29 ½ x 35 ¼ in.
Carnegie-Stout Public Library, Dubuque, Iowa

CHAPTER 7
THE PRICE OF FAME

Now it seemed that the whole world was knocking at Grant's door, and I gathered that he was pleased about it. At any rate, media attention did not ruffle him. His art career first made the newspaper when he was in grade school, and his views and doings had been local news for years. Fame merely brought attention from a wider sphere.

Mother and I viewed the situation from a different vantage point. We were shocked and couldn't believe our eyes at some of the developments. Strangers now considered the studio a public place rather than the home where we lived.

Our door never was locked, because we (especially Grant) were always forgetting keys. Now, people walked in without knocking and toured the studio. People we never saw before would open cupboard doors to see whether they really were that or just panels concealing a light meter. They would pull the cords to the curtains that hid our beds, and I heard one of them say, "Mr. Wood sleeps here, and his mother sleeps here and his sister sleeps there." Once they caught me in bed.

A group arrived while we were eating, and one of them said, "You just go right on eating; that's perfectly all right." All of these people had the kindliest of intentions, of course, but one member of the "nobility" came and left town, charging a hotel bill to Grant. My brother laughed and paid it, telling Mother, "Queen Marie (of Romania) is touring America the same way, only on a grander scale." Mother snorted, and said, "I only hope she doesn't come to see you."

One evening while we were eating supper, a young man walked in. He said he was a new art teacher at McKinley School, and that everywhere he went, all he heard about was Grant Wood. He decided to come and see Grant Wood for himself. His name was Elmer Porter, and he lived above the Butterfly Teashop down the street. Nervy but nice, he said, "That pie looks mighty good,"

and proceeded to cut himself a piece. With his usual monumental calm, Grant said, "By all means, help yourself." He even poured a cup of coffee for Elmer, and then the two of them visited about art.

A few months later, Grant was having coffee at the Butterfly when he overheard Elmer's raised voice upstairs. It was saying, "I'm so tired of hearing 'Grant Wood this' and 'Grant Wood that'! I wish people would talk about someone else for a change. That guy is the czar of Cedar Rapids." Grant hollered up the stairs, "Hello, Elmer," and there was total silence overhead. Grant came home chuckling and told Mother and me about it. Very shortly, Elmer appeared with tears in his eyes and apologized profusely. Grant had difficulty convincing Elmer that he found the whole thing funny and was not at all upset about it.

Previously, Grant had sold his paintings for little or nothing, and he had given away most of them. He had a gracious knack of making people think they were doing him a great favor by accepting something from him gratis. It's not surprising that some people concluded he was an easy mark, but that kind of thinking backfired for one woman.

It was summer, and our windows were open. Heels clicking on the alley pavement below alerted us to a woman explaining that Grant had given her a painting and now she wanted another for her living room. "Watch me get it," she boasted to her companion. Grant's facial expression remained unchanged, but I thought his ruddy face deepened in color. I served tea and cake to the two women, and then the hinting began. Grant went right on painting at his easel, oblivious to the hints. Finally, the woman came right out and asked him for a painting. Grant turned from his easel and quietly said, "Where have you been all this time? Things are different now. People give me things."

His observation was true. For every visitor like the ones I have described, there were many more lovely new friends. Grant was especially pleased with the friendship of farmers and their wives. Instant hostility to *American Gothic* from farm sources had been an early reaction, but several factors improved the farm climate: Grant's own comments on his work, the fact that the female model was his own sister, and the fact that he painted in overalls rather than an artist's smock. He was invited to farms to paint, to spend weekends, and to enjoy chicken dinners. He was given gifts of cake, jams, jellies, sweet corn, and samples of all the bounty of the land.

Despite the increasing demands on his time, Grant had a most productive 1930. He still took interior decorating work at $3 an hour, an unusually high figure he never would have charged without David Turner's insistence. He painted four portraits that year—bread and butter work—and he completed three major paintings: *Appraisal, Stone City,* and *Overmantel Decoration.*

Grant's first painting after American Gothic was *Appraisal,* which depicts a city woman about to buy a chicken from a farm woman. Mary Lackersteen was

one of the models. Another was the big rooster Grant bought and housed in the base of the Chinese wicker hourglass chair. Every night, Grant ran a broom handle through the wicker to serve as a roost for the bird.

Grant grew fond of the rooster, calling him a "good old boy." It occurred to me that the rooster might be lonesome, so I showed him his mirror image. This was a mistake. He got red in the wattles, fluffed his feathers, and wanted to fight. Furthermore, he started to crow, and it seemed he'd never stop. At four o'clock the next morning, the crowing resumed. When you are sound asleep and a rooster crows about ten feet from your head, it's an experience. Grant said it was enough to wake the dead in the mortuary next door, and Mother said she hoped we wouldn't be arrested for keeping a rooster in the city. I wasn't very popular. The 4 a.m. crowing was a daily alarm clock until Grant finished the painting and gave "good old boy" to Mr. Bailey, the truant officer.

Appraisal won the sweepstakes award at the Art Salon of the Iowa State Fair at Des Moines, but Grant was not satisfied with it. After it came home, he sawed off the lower part, which showed chicken wire and the rooster's feet, and gave it to his assistant, Arnold Pyle. Arnold was pleased and had it framed. Grant reframed the upper part and renamed it *Clothes,* but the first name stuck. It was purchased by the Dubuque Art Association and hangs at the public library in Dubuque.

Stone City is a delightful landscape with rolling hills, pines and round trees, winding roads, and the Wapsipinicon River. And it includes windmills. When Grant was a boy, every farm had its windmill. They were tall, and the boys were forbidden to climb them. They creaked when the wind changed direction and sometimes with each raising of water from the well. Windmills were so much a part of Grant's life that he decided to use one as his trademark. He told me, "The Old Masters all had their trademarks, and mine will be the windmill. Wherever it is feasible to use it, I will." *Stone City* has five windmills, and in Grant's later style paintings, a distant windmill is not unusual.

A comment about *Stone City* that I was fond of talked about the landscape being controlled by and made regular by the work of man, that the river was bridged, the winds harnessed, and fields and trees were given a regular design; with nothing out of place, the painting was a vision of man's most adored fantasy.

Grant accompanied this painting to Chicago when it was exhibited at the Art Institute, standing nearby and observing the viewers. One man drew unusually close to examine the billboard advertising Chesterfield cigarettes along the road at the right. He read the words, "It Satisfies," grinned and walked away. Those who watched him pressed close in turn, trying to see what he had peered at so intently. All got the message.

When the painting was exhibited at the Iowa State Fair, Grant noticed a farmer standing in front of it for a long time. He said, "The farmer would get

up close to the picture, inspect it, and back away, shaking his head. I thought if I went up and stood by him, he would say something about the painting. Sure enough, he did. He shook his head vigorously and said, 'I wouldn't give thirty-five cents an acre for that land!'"

Stone City was sold to the Joslyn Art Museum of Omaha. After Grant's death, an effort was made to buy it for the University of Iowa with class-donated memorial funds, but the Joslyn declined to sell and remains the owner. In 1944, *Stone City* was named one of America's eight favorite paintings.

Overmantel Decoration was commissioned by Herbert Stamats, the magazine publisher, as a surprise for his wife. They had a beautiful new home on Linden Drive in Cedar Rapids, and Stamats wanted a painting by Grant above the fireplace. At first, Grant declined. He said the children would grow up, the styles would change, and within a few years, they would hate the canvas. However, after pondering the idea, he changed his mind, deciding that a modernized, colonialized approach would be timeless. In the painting, the house is softened with vines. Mrs. Stamats and the two children—Sally Jane walking and Peter in a baby buggy—are in Victorian dress. They wait at the end of the front sidewalk as the husband and father approaches on a horse. This painting hung over the Stamats mantel for many years and was eventually donated to the Cedar Rapids Museum of Art in the mid-1970s.

Mrs. Harry Payne Whitney, who was influential in the New York art scene, saw a reproduction of *American Gothic* in a New York newspaper and in 1931 wrote to the Art Institute of Chicago asking that five paintings by Grant be sent to New York for her viewing. At that time, *Arnold Comes of Age* and *Appraisal* were at the Pennsylvania Exhibit of Art in Philadelphia, and Grant arranged for them to be sent to Mrs. Whitney when the show closed. He also sent *Woman With Plants* and, upon its completion, *Midnight Ride of Paul Revere*. All of the paintings came back in good condition, but if there was any further communication between Mrs. Whitney and my brother, I am not aware of it.

An official reception at the Cedar Rapids Art Association to honor Grant "because he brought honor to the city" featured *American Gothic* (borrowed from the Art Institute of Chicago) displayed on Grant's easel and framed with a laurel wreath. Mayor C.D. Huston presented Grant with an original bronze by Max Kalish purchased by public subscription. The piece was one that Grant had greatly admired, and he was moved by the gift. It was the only statue Grant ever owned.

The *Cedar Rapids Gazette* reported, "An unprecedented ovation was given Grant Wood when six hundred people jammed the Little Gallery to show their affection and esteem for him and to express pride at his achievement."

The newspaper also printed a half-page of testimonials about Grant. Verne Marshall, managing editor of the *Gazette*, wrote, "Original, interesting, unafraid, Grant Wood never changes except as his experience improves his skill. And behind all that skill is an intelligence that explains the man's real genius."

David Turner, Grant's friend and sponsor, wrote, "I know very little about art or artists but do know that I love the many pictures Grant Wood has painted. He has put something into my life that I thoroughly enjoy."

Henry S. Ely praised Grant "because his success has not changed the sweetness of his nature, nor led him to high-hat the scenes of his youth or the friends of his leaner years. . . . He never bartered his birthright for a one-way ticket to any hotbed of culture but had the courage, confidence and common sense to stick to his native Iowa and let the wise men of art follow the trail to his own doorway to do him homage."

Hundreds of such comments were made by hometown people who knew him best, but I particularly cherish a handwritten note from Lou Henry Hoover, the Iowa girl who became First Lady of the land as the wife of President Herbert Hoover. She wrote, "What a rare gift to be able to picture to so many hundreds of thousands of us what we ourselves are—what we are and what our neighbors are in our own everyday surroundings, viewed without false romanticism or embellishment."

Adeline Taylor of the *Cedar Rapids Gazette*, writing in the January 25, 1931 issue, reported that Francis Fuerst of Berlin had requested photographs of *American Gothic* to introduce the painting to England and the Continent. "The Chester Johnson Galleries of Chicago, reportedly scornful of including even one American painting among their European masters, have invited Grant Wood to give a one-man show, as has the Art Institute. Orders for pictures are coming in too fast to fill." She closed the piece with Harry Engle's description of my brother: "Grant Wood is a rotund, compact, stoutish chap with a disarming, puckish grin and a soft deprecatory voice. But keep your eye on that grin—it's going somewhere. And try to remember the soft words—they have a good metallic content. A good guy, but not an obvious one." I thought that Harry Engle's description of Grant was right on the mark, and those who knew Grant well shared my opinion.

Grant arrived at his new, mature style by soul-searching and thinking—or rethinking. His philosophy of art was maturing, and he was arriving at some firm personal viewpoints. His views, which did not change thereafter, are best expressed in his speech, "The Artist and the Middle West," delivered at the fourth annual regional conference of the American Federation of Arts in Kansas City on March 21, 1931.

He began describing the situation of the American writer, who "Up to ten years ago . . . found himself limited as to the background for his stories by the attitude of eastern publishers. He must write of the East."

Sinclair Lewis's *Main Street* changed all that, he noted, saying, "Today, eastern writers come to the Midwest for material. . . . Manuscripts sent to publishers from this region get such eager interest from the publishers that cases are known where outside writers have sent their stories to Midwestern friends to receive a Midwestern postmark in the mails."

That tendency extended to painting, he said, commenting, "A midland address to a painter's name is no longer a liability. It is a distinct asset—seized upon at once by art critics who write of the painting."

One of the most hopeful signs for the reality of the new movement, he said, was its spontaneous growth. Painters in widely separated locations who did not know each other were coming to independent conclusions. "Because the new tendency is conservative, the experiments of the conservative Middle West are looked upon with special interest."

Grant described one of the strongest tendencies of the new movement as the creation of a "literary feeling in art. The story-telling picture is the logical reaction from the abstractions of the modernists." There was danger in this, he warned. The public would favor it because it was easily understandable, and people were bored with "the abstractions of Modernism and with long explanations that do not explain." This public approval could lead us backward to the *Yard of Puppies* and *The Spirit of '76*," he said.

If the new movement did not "get out of hand," Grant said, it might mark the growing up of American art. If it did get out of hand, it would be but a passing fad. "The future of the American movement, it seems to me, lies in the hands of the intelligent layman. If he insists upon decorative paintings and not tinted photographs, the movement will live."

He spoke of the importance of recognition at home for the artist, saying, "There is nothing that can promote an art spirit in the smaller cities better than a feeling that native sons may live and work at home and get recognition

abroad without breaking the personal contacts that are valuable, not only to the artist, but to his fellow citizens."

Grant described the warnings he had received from other painters that he had no chance of gaining recognition if he persisted in living in a Midwest town no larger than Cedar Rapids. He was told that he must go to New York, or at least to Chicago, and cultivate friendships with all the people who might be on juries. Also, he said, "I was told that I must expect to put out at least a thousand dollars a year for a number of years for a press agent," adding, "I have already had the publicity, and it has not cost me a cent."

Some of the advantages of living and working in a town the size of Cedar Rapids, he said, were "economy in living, ease in getting out of a rut, contacts with all types instead of just an artist group, and ease of obtaining all types of models—free from my friends instead of having to hire professional models." When he felt himself going stale, he said, it was only six hours to Chicago and its stimulating exhibits. He told how he would go there, planning to stay a week, and return after three days—eager to paint again.

Another advantage of Cedar Rapids life, he said, was friends for all occasions. "Sometimes when I am only slightly stale, I call in friends I can count upon to be very enthusiastic about what I am doing. They need not be especially intelligent—just enthusiastic. However, if my mental state is in shape for it, I ask in groups of frank and intelligent people who do not hesitate to tear my work to pieces. I could not expect to have this variety in friends in New York. Everyone there would be of my own occupation and way of thinking."

Grant's vision of a spontaneous American art movement among painters who did not know each other and followed no leader became known as the "Regionalist movement," and Grant was regarded as its leader.

Grant's remark about the painter as editorial writer was prophetic of the work he was about to do—paintings as varied in subject matter as *Daughters of Revolution*, *Midnight Ride of Paul Revere*, and *Parson Weems' Fable*.

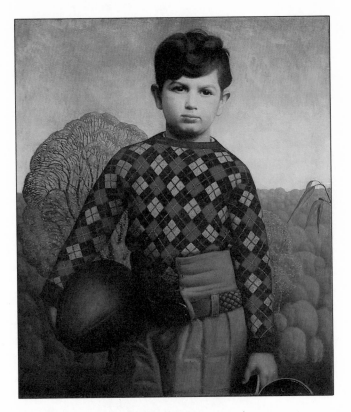

Plaid Sweater, 1931
Oil on composition board, 30 x 25 in.
University of Iowa Museum of Art

CHAPTER 8
VINTAGE YEARS

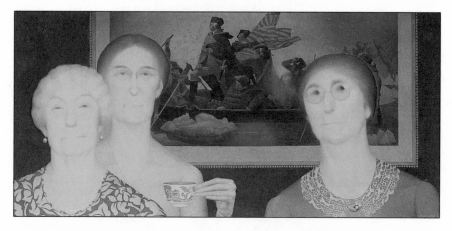

Despite Grant's statement that satire was not the main ingredient of *American Gothic*, many critics looked on him as a satirist. They assumed that *Midnight Ride of Paul Revere* was satire, too, but they missed the mark.

Margaret Thoma had the right interpretation of this 1931 painting and *Parson Weems' Fable* when she wrote, "Humor joins with fantasy in a story book never-never land in his two delightful paintings. . . . Like other works of the artist's, they bore the brunt of strident adverse criticism, this time from zealous patriotic realists. It is unnecessary to defend Grant Wood's patriotism or the guilelessness of his intent. These two paintings are American folklore told in the glorified storybook tradition."

I remember especially that some New York writers looking for satire also pounced on Grant for making Paul Revere's horse look like a rocking horse. Grant read such remarks with amusement. What he had done, he did deliberately. He had borrowed a rocking horse from Charles Clark to use as a model and left it to the viewer to determine the appropriateness of a rocking horse in visual presentation of American folklore's best-known horseback ride. When the idea came to him, he was enthusiastic, considering it an obvious touch of droll humor, and he believed it would be recognized as such.

In the belfry of the church in the Paul Revere painting was a round window. A young music teacher visiting the studio, Roland Moehlman, stuck his finger in the window to see if it was real and smeared the paint. Moehlman later wrote in a letter, "What impressed me most about Grant was his eternal good nature. Although he had every reason to be mad, he said it was all right and that he would paint it over again." Before exhibiting the painting, Grant

called in two friends, Bruce McKay, a contractor, and Mark Anthony, an architect, asking them to check the church and the house for architectural accuracy.

The painting was exhibited at the Art Institute of Chicago and purchased immediately by Mrs. C.M. Gooch of Memphis. Widely exhibited and praised for its masterful understanding and its unusual style and viewpoint, the painting continued to be considered satirical by the critics.

When Mrs. Gooch bought the painting, someone said to Grant, "Don't you think you are making a mistake selling your paintings to private collectors instead of to museums?" Grant answered, "I'm not worried in the least. If a painting is worthy, it will wind up in a museum." Mrs. Gooch eventually gave the painting to the Y.W.C.A., and with her permission, it was sold to the Metropolitan Museum of Art in New York.

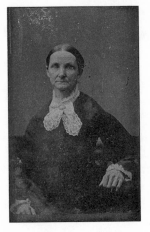

daguerreotype of Grant's Great-aunt
Matilda Peet,
Davenport Museum of Art

Victorian Survival, 1931
Oil on composition board, 32 $\frac{1}{2}$ x 26 $\frac{1}{4}$ in.
Carnegie-Stout Public Library, Dubuque, Iowa

Victorian Survival is another 1931 painting inspired by Grant's childhood memories. It is a painting of Great-Aunt Matilda Peet, Grandpa Weaver's sister, and was done from memory long after Aunt Matilda's death. Grant's sharpest recollection was of the day when she was his baby-sitter. Mother said she warned Aunt Matilda that Grant could have his bad days, but Aunt Matilda refused to believe he would be anything but angelic. She arrived, sweet-faced, neat, prim, and happy. When Mother and Father returned at the end of the day, she looked harried, and her disposition was as disarrayed as her hair-do. "Thank God, you are back!" she said. "This child is possessed—stubborn as a mule. I can't do a thing with him, and I'm completely exhausted."

The painting depicts a long-necked lady sitting next to a long-necked telephone. The phone is the latest thing—with a dial. The lady is from another

era, and her look is severe. The cameo locket on the velvet band around her neck belonged to the Wood family, a gift to me from Aunt Sallie.

Margaret Thoma found the humor of the canvas "caustic, an indictment of the sentimental and starched, poker-swallowing age in which he (Grant) was born. His parents were rigid Quakers, and one wonders where he found, in the strict formality of his upbringing and the hardship of his youth, his wonderful sense of humor." She further noted that Grant's reading of *Huckleberry Finn* taught him "there was something a little ridiculous about the sentimental," and it was a lesson he never forgot.

Young Corn was painted in 1931 at the request of Woodrow Wilson Junior High School teachers, who wanted it as a memorial to a much-loved math teacher, Miss Linnie E. Scholoeman. The scene was of the farm where she was born and reared, east of Cedar Rapids on the road that became the Lincoln Highway (Highway 30). Frances Prescott told me in 1970 that Grant asked $400 for the painting and was promised that amount. Later, he settled for $300 from a spokesperson for the group who told him how hard it was to collect donations for the work.

Miss Prescott wrote, "He said the thing that made him so mad was that he knew she was deliberately cheating him and seemed to glory in out-smarting him." Some time later, she said the Metropolitan Museum of Art offered $36,000 for the painting, and some who had donated toward it hit the ceiling. They sent two lawyers to the president of the school board, who ruled that it would be illegal to sell the painting at any price without the consent of each donor. Because some of the donors were no longer among the living, the sale was dead. The painting remained in the school for years. In 1942, it was exhibited in London, and eventually, the school system placed it on permanent loan to the Cedar Rapids Museum of Art.

Grant's finished paintings almost always differed in some respect from the preliminary oil sketches. The oil sketch of *Fall Plowing* has a tree in the foreground, but in the finished painting, a plow holds that position with a farmstead far in the background of cultivated fields. This 1931 painting won the sweepstakes award at the Iowa State Fair and was exhibited at the opening of the Springfield Museum of Art. The *New York World Telegram* called it one of the finest paintings ever done by an American. Purchased by Marshall Field of Chicago, it remained in his family for many years. Then Deere & Company bought *Fall Plowing* to exhibit in its headquarters building at Moline, Illinois. The preliminary sketch is owned by the Davenport Museum of Art.

Arnold Comes of Age celebrated the twenty-first birthday of Arnold Pyle, a talented youth who assisted Grant on the *Memorial Window* and other projects. Zenobia B. Ness of Ames, director of the Art Salon of the Iowa State Fair, and Louise Orwing, art director of the Des Moines Public Library, persuaded Grant

to exhibit this painting. When it won first place in the oil portrait section of the Iowa State Fair, Grant said he was indebted to the women for convincing him it should be shown. The painting was bought by the Nebraska Art Association at Lincoln.

One Sunday our cousins, Ralph and Stella Conybeare, took us for a ride, and we visited President Herbert Hoover's birthplace at West Branch, Iowa. Grant decided that later he would do a painting of it, and so he made a preliminary charcoal drawing on brown wrapping paper. The cabin in which Mr. Hoover was born had been nearly swallowed up by a later, two-story addition. In one corner of the paper, Grant made a small drawing of the cabin without the addition. In the 1931 oil painting, *Birthplace of Herbert Hoover*, Grant deleted the cabin in the corner, replacing it with a cluster of oak leaves. In both the drawing and the painting, a man points at the house, and the creek in which the president swam as a boy is in the foreground.

The painting had art circles puzzled. They couldn't decide whether Grant was glorifying or satirizing President Hoover. Considering the artist, most of them decided it was satire.

Years later, Grant's friend, Bruce McKay, wrote, "Grant liked the funny trees and Chuck Clark standing out in front. Later, the Hoover family commissioned my firm to restore the house and grounds to the original form with a two-room, one-story cottage. Grant, an ardent New Dealer, used to chuckle and say that I was changing his picture. However, he didn't feel that it hurt the painting." McKay was right about Grant's political sentiments. However, my brother admired both the birthplace cottage and Herbert Hoover personally.

We heard some talk of businessmen buying the painting and presenting it to Mr. Hoover, but it never happened. Gardner Cowles bought it before he became publisher of *Look* magazine, and he sold it years later to Ralph Blum of Beverly Hills. After Blum's death, it was purchased by Mr. and Mrs. Allen Collins of Hopewell, New York. They left it to one of their sons, who put it on loan to the Metropolitan Museum of Art. Edwin B. Green, retired editor of the *Iowa City Press-Citizen*, owned the preliminary drawing.

Despite his busy painting schedule, Grant still was taking interior decorating projects and keeping up with all his other activities. He remained closely associated with the Cedar Rapids Community Players, designing sets and doing other volunteer art work. His program design for *A Kiss for Cinderella* became the personalized book mark of the leading lady, Isabel O. Stamats.

Grant was seldom without pupils. Dorothy Miller (later Brecunier) of Waterloo, took Saturday afternoon classes with Grant at the Cedar Rapids Art Association in the A.N. Palmer house. She was eleven or twelve at the time, and she remembers drawing on white paper with charcoal. She took one drawing home, and her father used the other side to draw a house, a pony, a fence, and

background. The next Saturday, Grant thought the father's work was hers and gave her special counsel—the work was too detailed. Dorothy was too shy to tell him her father had done the drawing, but she didn't want to hear any criticism of her dad, either. She added that Grant encouraged his pupils to "take it free and easy—to let our imaginations run."

Grant did several portraits in 1931. *Master Gordon Fennell* was a likeness of the young grandson of John C. Reid, president of the Three Minute Cereal Company. Reid was a friend to whom Grant occasionally turned for financial advice, but his greatest help would come in the future. When the portrait was completed, Reid didn't like it, and neither did the child's parents, the Gordon Fennells. They said Grant had made the child "gross." Because they didn't like it and because Grant appreciated the things Reid had done for him, he gave Reid the portrait free. It was given to the child's parents, and later, Grant felt that Reid's daughter, Mrs. Catsy Cooper might feel slighted, so he gave her a painting. Years later—after Grant's death—the Fennells told me the portrait was an excellent likeness of their child and said they often wondered how they could have thought otherwise when they first saw it.

Van Vechten Shaffer was the banker who scolded Grant on occasion for overdrawing his account, but the two men were good friends. They were fellow supporters of the Community Players, and Grant had been a dinner guest in the Shaffer home. Grant was commissioned to paint portraits of their daughters, Mary Van Vechten Shaffer and Susan Angevine Shaffer. He was pleased with the finished work, but the father was unhappy over one of them. He said it made the child look like his mother-in-law, a woman Grant never had seen. Grant chuckled when he told Mother and me of this reaction. The portraits are little gems and represent some of Grant's best work.

Verne Marshall, editor of the *Cedar Rapids Gazette* and later a Pulitzer Prize winner, asked Grant to paint a portrait of his dead wife. From a miniature given to him, Grant could see that Mrs. Marshall had been a woman of exceptional beauty. He said he did not care to paint beautiful women, but Marshall prevailed on him, and with the help of the miniature and his own memory, Grant did the portrait. Marshall was greatly pleased.

A man named Hunting who owned a Cedar Rapids lumber company brought Grant two photographs of his deceased mother, one when she was young and the other when she was old, requesting a portrait. Grant, who never had seen her, decided to paint her as a young woman. It turned out beautifully, but Hunting didn't like it. He said he did not remember his mother when she was young and asked for another portrait of her in old age. Grant declined. He later told me, "She doesn't interest me in her old age. It would be just a portrait of another dowager." Grant put the young portrait in the storeroom and forgot it. Fed up with portraits and people's reactions to them, he told me that all the

women wanted to be made beautiful and all the men wanted to be made young.

This was his state of mind when a young couple from Clinton, Iowa, Mr. and Mrs. Michael Blumberg, came to see him wanting a portrait of their young son. Grant had vowed there would be no more portraits, but instead of saying so, he decided to set the price so high that they would go away. He had been charging $300, and when Blumberg asked the cost, Grant told him $600. Mother and I were astounded, but the Blumbergs never batted an eye. They said that was fine, and Grant was disappointed. His tone became severe (for him). "You will have to let me choose his clothes. I want him to look like a real boy, not like Lord Fauntleroy or he'll hate me when he grows up." The Blumbergs agreed, and Grant went to Clinton. He was looking over the boy's surroundings when his subject came in wearing a plaid sweater and carrying a football. "That's the way I want to paint him," Grant said, "just the way he is." When *Plaid Sweater* was completed, the Blumbergs were delighted with it, and Mrs. Blumberg paid Grant with six hundred one-dollar bills. It was her Christmas gift to her husband. The portrait is on long-term loan to the University of Iowa Museum of Art.

With two exceptions, the 1931 portrait commissions were the last that Grant ever accepted. His later portrait of Mrs. Donald McMurray was one of his best, and it also was one of the least known. Mrs. McMurray wanted no public exhibition or announcement. Grant's heart was not in his final portrait, that of Charles Campbell, a Kalamazoo banker, and it dragged on for four years before he completed it in 1940. When a photograph of the portrait appeared in the paper, a letter to the editor said Grant should learn how to play golf before attempting to paint a golfer. The writer said the man wasn't holding his club correctly. As it turned out, Campbell, an excellent golfer, had his own unusual way of holding a club, and Grant painted him as he saw him. Grant told me that Campbell took the criticism as a personal affront, saying this was a free country and he could hold his club any way he wished.

Painted in 1932, *Daughters of Revolution* caused nearly as much furor as had *American Gothic*. Some people said my brother was paying his respects to certain "patriots" who protested the execution of the 1928 *Memorial Window* in Germany, the country of the enemy. Others thought he was repaying the Daughters of the American Revolution for placing Jane Addams, the social worker, on its "undesirable" list, wanting to see if the D.A.R. could take it as well as dish it out. Grant simply said, "I don't like Toryism. I don't like to have anyone set up an aristocracy of birth in a republic."

The sting of the painting is in the self-satisfied expressions of the three women, an image sharpened by a long-fingered hand primly holding a teacup. Placing the subjects in front of the Emanuel Leutze painting *Washington Crossing the Delaware* is a visual reminder of their antecedents.

The painting stirred protests in D.A.R. circles, causing it to be hung behind a door at the Carnegie International Exhibition in Pittsburgh. Grant learned of the placement as he worked at his easel in Iowa and said, "That's fine. I'm painting *Dinner for Threshers* now, and it's so large that no one will be able to hide it behind any door." (*Dinner for Threshers* is twenty inches high and six and two-thirds feet wide.) One member of the Sons of the American Revolution threatened to thrash Grant, and he received other threats, too. He said later that only his pioneer ancestry and his American Legion membership kept things from getting worse.

The Iowa D.A.R. members weren't angry at all. After all the fuss over *American Gothic*, they were familiar with the ways of Grant Wood. When a reproduction of the painting was shown on the screen at the Iowa D.A.R. convention, it drew so much applause that they brought it back twice. They even invited Grant to lecture at one of their luncheons, and I was invited to join the Frances Shaw Chapter of which Aunt Sallie had been a member.

The furor began to subside, replaced by the interest of individuals who thought they recognized one or another of the women. "Where in Heaven's name did you see my Aunt Emma?" one man wrote. At the 1933 Century of Progress World's Fair in Chicago, postcards of Daughters outsold the postcards of all the other paintings.

The ladies were recognized in another way in Europe. The December 1938 issue of Fortune magazine reported, "D.A.R. [sic] was one of the most admired contemporary paintings in the Exhibition of American Art put on last spring in Paris under the auspices of the French government. Why did the French like it so much? Because it made subtle fun of American lady patriots? Not at all. They would study the painting and say, grinning, 'It's the very image

of my Aunt Cecile in Nancy.' And so it would seem, the artist in painting with terrifying candor the exact appearance of these formidable ladies—presumably from Iowa, the artist's home state—has revealed types that are unexpectedly international."

Daughters of Revolution was offered for sale by a New York dealer, but potential buyers passed it up because of its subject matter. Edward G. Robinson, the film actor and art collector, bought it in the late 1930s and wrote about it in his autobiography, All My Yesterdays. He went to the Museum of Modern Art, then "managing very nicely in a private house," because the curator "was having a good show—a French section with the greats and an American section that was neither heavy nor well-attended. But there were several good pictures."

Robinson noticed that all but one had been loaned by museums and private collectors. That one was Daughters of Revolution, which he recognized instantly. "It was one of the most reproduced pictures of our time and at the same time, one of the most infamous. . . . I stared, fascinated, and then I looked it up in the catalog and saw that it merely said, 'Courtesy of the Ferargil Galleries.'"

He went to the Ferargil Galleries and asked, "Is it for sale?" The dealer seemed over-eager, and the two thousand-dollar price shocked Robinson. "I bought it straightaway. The price was so low because no museum—and practically no private collector—would have it. I can tell you that through the years all the museums and private collectors kicked themselves around the block; I was offered any amount of money to part with it."

I know of one offer—$50,000 from the Art Institute of Chicago—which Robinson turned down. "Eddie" Robinson, known as "Little Caesar" for one of his tough gangster roles, was generous in allowing Daughters of Revolution to be exhibited in this country, but its first overseas showing in England was truly an event. His wife later told me that the only reason he allowed the painting to leave the country was that he would be working on a movie in England at the time of the exhibit.

The 1958 divorce of the Robinsons involved a settlement that forced the sale of the entire art collection at a reported three to four million dollars. The buyer was M. Knoedler & Company of New York acting for Stavros Niarchos, the Greek shipping magnate who once was a brother-in-law of Aristotle Onassis. Seventeen of the fifty-eight paintings accounted for more than two million of the total. They included Cezannes, Van Goghs, Matisses, and Renoirs. The New York Times reported the sale, noting, "As famous as American Gothic at the Art Institute of Chicago, the Grant Wood picture in the collection is the equally satiric Daughters of Revolution."

In his autobiography, Robinson said that Niarchos declined a $100,000 offer from Walter Annenberg, later American Ambassador to the Court of St.

James, who wanted to put *Daughters* opposite a Gilbert Stuart portrait of George Washington. When Niarchos sold all the American paintings from the Robinson collections, *Daughters of Revolution* was purchased by the Cincinnati Museum of Art for an undisclosed price.

In 1940, when the painting was exhibited at the Art Institute of Chicago, Daniel Catton Rich, curator of fine arts, recalled Grant overhearing two women who were standing in front of the picture laughing and talking about it. One said, "Did you know that the artist painted his sister as one of those awful ladies?" Grant stepped up and said, "I beg your pardon. I'm Grant Wood, and I did not paint my sister in *Daughters of Revolution*. That was *American Gothic*." The absurd response was, "Oh, Mr. Wood, you must be mistaken! Everybody says you did."

Grant always made it clear to interviewers that he used no single model for any of his faces. I was with him when he worked, and I remember him making composite faces, taking one feature here and another there, from women he knew.

Frances Prescott's hand held the teacup. She also recalled an incident with two women viewers. One said, "Only a monkey could have a hand like that." Miss Prescott stepped up and said, "That's my hand you're talking about. Do I look like a monkey?"

Daughters of Revolution came home to Cedar Rapids for an exhibit in 1954, but the director of the Cincinnati Museum eventually wrote, "The Whitney exhibition in New York is probably the last time our museum will lend the painting since it is in such demand and we are naturally anxious to have it here for our own public."

Grant gave his preliminary charcoal drawing to his friend, John Steuart Curry. At Curry's death, Hildegard, the entertainer, bought it for $2,750. Several years later, she sold it at auction in New York for fifty dollars more. The purchasers were Owen and Leone Elliott, art collectors from Cedar Rapids, who presented it to Coe College for the Grant Wood wing.

CHAPTER 9
THE STONE CITY EXPERIENCE

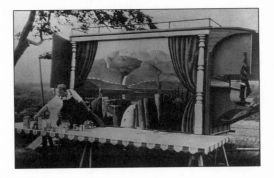

Grant was the moving spirit of the Stone City Colony and Art School, which flourished for six weeks in the summer of 1932 and for eight weeks in 1933. The Colony was immensely successful in every way but financially. Grant expected thirty students and ninety-two came. In addition, fifteen children were brought from Cedar Rapids daily for morning classes. Saturday night dances and Sunday chicken dinners attracted five hundred to a thousand visitors to what had been a sleepy little village.

Grant was an adult when he first saw Stone City. Sturdy stone structures, reminders of past grandeur, rose from dense underbrush in a restful, peaceful setting along the quiet Wapsipinicon River. The rolling hills were an artist's dream come true. Grant painted *Stone City* in 1930, and the little village was in his mind as the idea of an art colony took shape.

Stone had been quarried there since 1852. The exceptionally hard limestone was taken out in blocks and shipped by rail to eight states. The stone was particularly good for buildings and bridges. In 1883, eight years before Grant was born, Colonel J.A. Green, owner of the largest quarry, used the stone to construct a combination opera house, store, and fifty-six-room hotel, Columbia Hall. Colonel Green brought an artist from New York to paint a panorama on the opera house drop curtain: the quarries, Green's stone mansion on the hill, the homes of employees, and Columbia Hall itself. In his fourteen-room mansion, Green constructed seven Italian marble fireplaces, surmounting each with a mural by a prominent artist of the day. Jenny Lind was one of many celebrities who sang in the opera house. The Tom Thumb midget troupe and other attractions also played in Stone City.

The biggest year for the quarries was 1896, when a thousand men loaded 160,000 railroad cars with stone worth $3,240,000. By the turn of the

century, a new product, Portland cement, replaced stone as a building material. The quarries were closed, and the town was virtually abandoned. Columbia Hall still stood during the art colony summers, surviving until 1938, when it was torn down for its stone.

The Green mansion remained a proud monument to the golden age of stone construction. In its last years, the mansion had been the home of the poet Paul Engle and his wife. In 1961, it was gutted by fire; only the walls still stand.

When Grant began to set up the art colony, the mansion had been vacant for three decades. He spent much time and money converting the upstairs into a dormitory for women. He installed plumbing and a row of showers in the basement, rounded up furniture, built long tables of planks on saw horses, bought a bolt of red checkered cloth for the tables, and trimmed the surrounding brush.

For the men's sleeping quarters, Grant wanted ice wagons. An unfulfilled dream of his youth was to buy an old ice wagon and a horse and go on leisurely sketching trips along the back roads with Mother and me. Ice wagons were on their way out in 1932, and Joseph Chadima of the Hubbard Ice Company gave Grant fourteen of them in exchange for a scholarship for the most talented high school art student. That competition was won by Julie Sampson. Grant got official permission to tow the ice wagons to Stone City at 4 a.m., when the highway would be least busy. The wooden wheels were covered with iron bands, and the old wagons protested the move with great clatter and rattling—both on paving and on dirt roads. Townspeople along the way leaned from second-story windows, complaining that their sleep had been disturbed.

At the art colony site, the ice wagons were lined up in a row and fitted with upper and lower bunks. The men painted murals on the sides of their wagons, making the hillside look like a gypsy encampment. The *Cedar Rapids Gazette* on July 17, 1932, described Grant's mural as "An elaborate mid-Victorian scenic view with mountain streams, snow-capped ranges with deer leaping from peak to peak and an Indian standing on one summit peering into the distance. . . . Inside, the mid-Victorian is changed to modernism with a coat of aluminum paint, screened windows that let in the views and keep out the mosquitoes, and folding beds that give ample room to the occupants when sleeping hours are over."

This was the summer when one could dance to the music of Wayne King at Maquoketa (Gents $1.10, Ladies 40 cents) or Waterloo (Men $1.65, Ladies 55 cents); see Greta Garbo, John Barrymore, Joan Crawford, Wallace Beery, and Lionel Barrymore in "Grand Hotel" (Matinee 55 cents, 83 cents, and $1.10) or catch Buck Jones in "South of the Rio Grande" for 15 cents, 20 cents

after 2:30 p.m. You got more for your money at the Stone City Art Colony, where admission to dances at Columbia Hall was 40 cents and admission to the grounds on Sunday (the only day the public was invited) was 10 cents. Sometimes those fees raised more than $100.

The 1933 costs for tuition and living expenses were printed as follows:

Tuition—two weeks, $15; four weeks, $26; six weeks, $30; eight weeks, $36. Colony week begins on Tuesday.

Rooms—Dormitory by the week, $1.50; three weeks or more in advance at $1 per week. Bed linens, towels and blankets not furnished. Rooms in the village, $2 per week and up. Camp site, 50 cents per week.

Board—Excellent cuisine, expert supervision, $8.50 per week.

Instruction at the Art School included a required composition course, advanced creative composition taught by Grant to a limited group, lithography (for advanced students given Colony press privileges), sculpture, life drawing, painting in oil, painting in watercolor, and picture framing.

The faculty was Grant; Adrian Dornbush, director (former director of the Flint, Michigan, Institute of Art); Marvin Cone of Coe College; Florence Sprague, professor of sculpture at Drake University; David McCosh; Edwin Bruns; Leon Zeman; Edward Rowan; and Arnold Pyle. Grace Boston was business manager and took charge of the Sunday chicken dinners, and Grace Craeger was the nurse. All returned for the second summer except Bruns and Zeman. Newcomers were Francis Chapin, artist, and Jefferson R. Smith, executive secretary. Grant arranged for the Art School to be accredited through Coe College and to be represented in Chicago by the Increase Robinson Galleries.

Grant set down the aims of the colony, expressing the need for a "combination camp and summer art school within this section of the Middle West" because mountain and seaside art colonies were too expensive and far away "for the year 1932."

He said the midwestern region was "not as obvious as Taos, Brown County, or the coast of Maine, but neither is it covered with the palette scrapings of previous painters. To those willing to observe and to think for themselves, instead of merely repeating what already has been said, this territory offers new and very usable material."

He described the "accumulated vision" that might be accomplished by "a group of people painting harmoniously together, each contributing his own images."

He insisted that it be clearly understood "that we are not trying to promote our own particular methods of painting. Nor are we interested in methods, except as a means of most forcefully expressing what one wishes to convey." He was certain that "when a painter has a definite message, he will,

by experiment, find the most adequate means of expressing it, let the result be as conservative, as eclectic, or as radical as it may."

Promotion for the 1933 session began with letters. Helen Hinrichsen of Davenport, who recalled years later that Grace Boston's food "was always good, but we worked so hard, running all over the countryside, that anything would have tasted good," saved a handwritten note from Grant dated May 13, 1933.

"Just a note to let you know that Stone City opens up on June 26th and is going to run for eight weeks instead of six.

"We are getting applications from new people right along, but I want to see that you pioneers who took a chance with us last year get the first choice on time and on accommodations."

He asked her to check the dates and send names of other interested people so he could send them catalogs, signing off with, "Wish I had the time to write a more newsy letter, but you will be seeing part of it, at least, in the papers soon. See you in June!"

The second year's "Aim of the Colony" was unsigned, but Grant either wrote it or approved it. It invited artists of every stripe to "join us in working together toward the development of an indigenous expression. . . a stimulating exchange of ideas, a cooperation of a variety of points of view."

The text continued, "If American art is to be elevated to the stature of a true cultural expression, it cannot remain a mere reflection of foreign painting. A national expression . . . must take group form from the more genuine and less spectacular regions.

"It is our belief that a true art expression must grow up from the environment itself. Then an American art will arrive through the fusion of various regional expressions based on a thorough analysis of what is significant to these regions. Stone City Colony has this for its objective."

This was one of the first definite expressions of Regionalism.

In both years, Stone City was a busy and purposeful place. Students devoted their waking hours to art, sometimes in classes in the buildings or on the grounds and sometimes hiking the surrounding scenic areas to sketch and paint. They were happy summers. The Great Depression was not just a miserable and hopeless, jobless chapter of American history. It was for many an almost spiritual awakening in which people shared what they had and what they felt. Hard times brought them together.

Among the favorite memories made at the Colony was the custom of carving one's initials in the bar and tables of the recreation room. All comers were furnished with jack knives for the purpose. The St. Louis Post-Dispatch described that special room: "In the basement of the ice house, where food was stored in the old days, the colonists have fixed up a sort of rathskeller, calling

it 'The Sickle and Sheaf.' A rough board counter has been constructed in one corner of the room and adorned with a sprightly painting of the traveling salesman and the farmer's daughter, the latter a surpassingly coy and buxom creature, the drummer an out-and-out city slicker with a handsome but villainous mustache." It further described the counter that "could be called a bar if there were anything suitable to be served there" (the Prohibition Amendment was in effect both summers) backed by shelves of mugs, flagons, and goblets of assorted colors and shapes; the wagon wheel light fixture and the bare earthen floor of this "quaint lounging room."

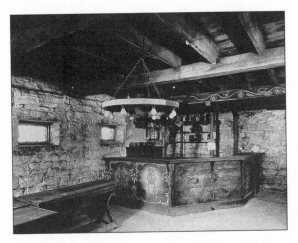

The artists at Stone City built a lounge which they called the Sickle and Sheaf.

Adrian Dornbush chose the top of a round, stone water tower as his abode, sharing it with two others who reached it by ladder. His "room" was known as "Adrian's Tomb." One night, the ladder was missing. After intense detective work, the ladder was found, but the thief was never identified.

On Sundays, visitors who had not made reservations for chicken dinner could buy pop and hot dogs from students who earned their tuition as vendors. Paintings were auctioned every Sunday, and you could buy a stone bird bath for two dollars.

Entertainment, usually with Jay Sigmund as master of ceremonies, might be a concert by the Anamosa State Reformatory band, a community sing, piano selections by Jacques Jolas, or old-time fiddlers.

Cedar Rapids students of Edna Dieman often presented dance programs, and years later, Miss Dieman recalled, "One of the dancers did a dance with her lovely scarf in the style of Ruth St. Denis, but a sudden breeze caught the scarf, wafting it to the meadow. Following the scarf was Grant Wood,

who brought it back to the dancer. She was so overwhelmed—it was a scene I'll never forget."

The school attracted the notice of newspapers and magazines coast to coast. A writer from a Kansas City newspaper was sent to get the story of "goings on" and "nude women" at the colony, but he found no orgies—only serious students who were there to learn. The students included two married couples, the wife of a minister, and a novelist who joined the colony to finish her book. The "nude" report stemmed from a young farm girl who, chaperoned by her mother, posed for classes in figure drawing. After two sessions, the mother said she saw no necessity to come with the girl. The reporter stayed on, and instead of an exposé, he wrote a glowing feature article about Grant and the colony.

Grant first met John Steuart Curry, the Kansas artist, at Stone City in 1932. Curry had been traveling with the Ringling Brothers Circus to do circus paintings, and Grant invited him to stop at Stone City on his way home. They took an immediate liking to each other. They looked somewhat alike, were of similar build, and shared an admiration for Thomas Hart Benton, the Missouri artist.

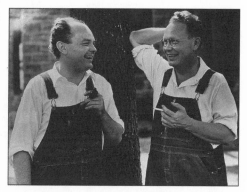

When Curry visited the colony again in 1933, the *St. Louis Post-Dispach* reported, "The Kansan entered whole-heartedly into the life of the place. He wore overalls, like his host, sketched, lent a hand at instruction, and bunked in one of the reclaimed ice wagons which house some of the colonists. Their associates found Wood and Curry surprisingly alike, not only in attitudes of mind, but even in appearance."

John Steuart Curry (left) and Grant Wood, 1933.

The piece went on to compare their treatment by their native states: "Kansas resents Curry. It considers such pictures as *Baptism in Kansas* and *The Cyclone Cellar* bad publicity for the state.... Curry's friends say not one of his paintings has been sold in his own state. It's a very different story with Grant Wood. Iowa acclaims him, is proud of him, and is glad to proclaim that 'Local Boy Makes Good'.... Several hundred of Wood's sketches and paintings are owned in his home town, Cedar Rapids.... Only five of his pictures are still in his possession."

At the end of each summer session, a large auction was held. Thousands arrived to bid on student art, and news stories about those occasions referred to the colony as a most refreshing and unusual episode in American art.

However, at the end of the 1933 session, the art colony was a financial failure and in debt. Some students, including those with the largest appetites,

had been unable to pay their board and room. For them, everything was free. They charged paints, brushes, art materials, and even a pair of shoes to Grant. He could never collect money from these students. Two things he did not know or understand were money and business. Back at his Cedar Rapids studio, Grant scarcely dared stick his nose out the door for fear of encountering a bill collector. His own work at Stone City was given free, and he had put what money he had into the project. What could he do now? John Reid came to the rescue, persuading the Carnegie Art Foundation to pay the outstanding debts of the colony. This life-saving assistance put Grant on his feet again.

Despite the financial problems of the colony, Grant was filled with enthusiasm as he planned the third season. He intended to be more business-like, issuing stock, buying the buildings, and renovating the huge, old stone opera house. Playwrights would be invited to write and produce their own plays there. Grant planned to have someone keep a stable of riding horses on the grounds to be rented for pleasure rides. He planned to bring in boxcars to supplement the ice wagons as sleeping quarters for the men. Saturday night dances, Sunday open houses, dinners, and programs would be continued.

But this was not to be. When Grant accepted an invitation to teach at the State University of Iowa, the colony was left without leadership.

Except for his trips to Europe and the time he spent at his easel, the two joyous, hard-working Stone City summers were the best times of Grant's life.

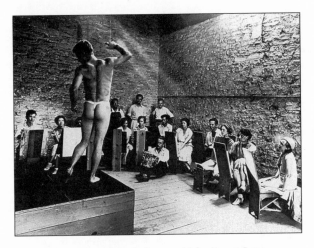

Grant Wood, Marvin Cone, and John Steuart Curry
all taught the life drawing class at the Stone City Art Colony.

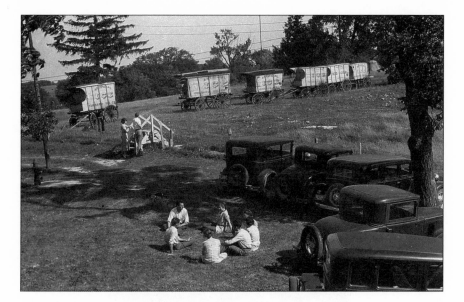

Ice wagons at the Stone City Art Colony, 1932.

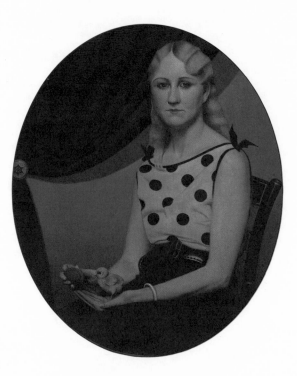

Portrait of Nan, 1933
Oil on Masonite, 40 x 30 in. oval
Elvehjem Museum of Art, University of Wisconsin-Madison. Anonymous Loan.

CHAPTER 10
ARBOR DAY
AND PORTRAIT OF NAN

In 1932, Grant was asked to do a painting as a memorial to two of McKinley Junior High School's most outstanding teachers, Catherine Motejl and Rose Waterstadt. Both had taught at the school during Grant's years there.

When he discussed a theme for the painting with Frances Prescott, the principal, she told him how hard it was to lure Miss Motejl to Cedar Rapids from her rural school near Konigsmark, a town so small that it no longer showed on state road maps. Each time Cedar Rapids offered more money, the local farmers matched the offer and persuaded her to stay. Finally, she made the break, and a few years later, she and Miss Prescott visited the rural school where she had taught. Miss Prescott was struck with the beauty of this little acre—a neatly trimmed schoolyard shaded by lofty trees, mostly evergreens, contrasting with the vast, treeless expanse of surrounding farm fields. "We planted every one of those trees," Miss Motejl told her principal, describing the Arbor Day ceremony held with her pupils each time a tree was planted.

Six years after he taught at McKinley, Grant was taken to that little school by Miss Prescott. He saw the small, white frame building with a belfry in its beautiful surroundings and was inspired to paint *Arbor Day*. The painting keeps alive a scene that has disappeared—the rural school and all that went with it: the schoolhouse, the woodshed where the winter fuel supply was stored, the water pump, the outbuildings, a horse-drawn wagon, a horse-drawn plow, and the children planting a tree.

In later years, *Arbor Day* drew criticsm for showing horses rather than a truck and tractor, but that combination would have been incongruous. In the era of *Arbor Day*, thousands of one-room rural schools existed, each with one teacher and eight grades. It was a time of draft horses and oat fields, of kerosene lamps and mud roads, and of Arbor Day ceremonies. In 1932, the only Iowa

farms with electricity were those on the immediate edge of towns. Grant wisely gave *Arbor Day* the timelessness and soul that have made it of lasting significance.

After the painting was completed, Grant sent it east for exhibition and received offers for it. Miss Prescott and the teachers agreed to let him sell it if he would make another painting on the same subject for the school. The resulting painting was *Tree Planting*, sometimes called *Tree Planting Group*—the same Arbor Day scene from a closer view, omitting the horse and wagon in the foreground.

Edwin Hewett of New York purchased *Arbor Day*, later selling it to motion picture director King Vidor and his wife. The preliminary charcoal drawing for *Tree Planting* was bought by Arthur Mooney of New York.

When the Los Angeles Municipal Art Commission selected twenty-seven paintings for a special exhibit in 1950, *Arbor Day* was chosen along with works by Cezanne, Van Dyck, Goya, Whistler, and Bellows. The *Los Angeles Times* used a photograph of the painting with its story on the event. Grant would have been pleased by this exhibit, because *Arbor Day* was one of his favorites.

The earliest mention of a self-portrait I can find is a clipping from the January 25, 1931 *Cedar Rapids Gazette*, which reads, "The background will be the usual loafing bystanders who find time to watch an artist sketching—faces reflecting contempt, scorn, and an 'I know I could do it better' look." Grant didn't get around to using that idea until 1935, when he made a drawing, *Return From Bohemia*, intended for the book jacket of an autobiography he never finished. The 1932 painting *Self-Portrait*, resulted from a suggestion Grant made to the Iowa Federation of Women's Clubs. He urged them to sponsor a state contest in which all entries were self-portraits, and when they acted on his suggestion, he went to work on his own entry.

First came the preliminary charcoal drawing. I watched Grant make the painting as he stood in front of the bathroom mirror. As he worked, he gave me pointers, and I took a long look at my brother. At forty-one, he seemed slightly older and heavier. His hair had receded a little. He wore white gold eyeglass frames that hooked behind his ears. He would look intently at himself in the mirror and squint. He squinted at all his subjects, as though he were framing the view with his eyelids, shutting out everything that would not be on the canvas.

He told me that the space over the head should not be too great, nor should it be horseshoe-shaped. He pointed out that his hair, which he wore straight back, was too near the size and shape of his face. To offset this, he excluded the top of his hair from the painting.

Grant was wearing his painting uniform—overalls and white shirt. The overalls were blue with white pinstripes and had shoulder straps. Although his self-portrait placed first in the contest, he later decided that the overalls detracted from the face. He painted them out, intending to do more work on

the painting later, but he never got around to it. After Grant's death, I asked Marvin Cone to paint what he thought Grant would want, and he wrote to me, "I have repainted only the little, somewhat triangular shape, following very carefully the original lines. I am very well pleased with the result and think Grant would be."

I loved the self-portrait and treasured it for years. It is now owned by the Davenport Museum of Art. Grant gave the charcoal drawing to Arnold Pyle.

He made two precise drawings of horses in 1931. *Race Horse* is a sleek, well-groomed animal being held by a jockey. The people in the grandstand create a formation like stars in the flag. The bandstand is draped, and a bit of a flag may be seen, indicating a special occasion such as the Fourth of July or Labor Day. In the foreground are an empty Cracker Jacks box and lots of peanut shells. This work was purchased by Mrs. C.S. Petrasch, Jr., of Mount Kisco, New York. The other, *Draft Horse*, was painted for McKinley School, Cedar Rapids, and is now on permanent loan to the Cedar Rapids Museum of Art. This horse is the stocky, spotted type often seen on Iowa farms. A farmer or hired hand holds the reins, keeping a wary eye on the horse in case it becomes excited and frisky. In the background is a big Iowa barn.

In 1933, the Palmer Method Company of Cedar Rapids, known for the Palmer Method of writing, commissioned Grant to do a series of paintings depicting the history of penmanship for the company's exhibit at the Chicago World's Fair. The works were titled *Picture Writing of the Stone Age, Stylus and Wax Tablets of the Greeks, Brush of the Medieval Monk, Colonial Penman,* and *Modern Method of Writing.* The paintings became the property of the Palmer Method Company. Four of the preliminary charcoal drawings were acquired by the Davenport Museum of Art, and the fifth, *Colonial Penman,* was a gift from me to our brother Frank in Waterloo. At the urging of Frank Collard of Waterloo, our Frank sold it to the Home Savings and Loan Association of Waterloo, which eventually presented it to the Waterloo Municipal Art Gallery.

Life was never dull around Grant's studio. This was the gangster era, the time of Dillinger. Directly across the street from Turner's Mortuary was a little hamburger joint that specialized in bootlegging. As we ate our meals, we could look down from our upstairs window at the comings and goings, the well-wrapped and mysterious packages quickly hidden beneath coats. One day a carload of men who looked like gangster types to me drove up in front of this establishment. Something was thrown from the car into the open door of the place, and the car pulled away with screeching tires and raucous laughter. A loud explosion and a lot of smoke chased everyone out onto the street, including the proprietor, who shook his fist at the vanishing car. What we thought was a bomb turned out to be a giant firecracker.

This wild scene provided Grant with a hearty laugh and an idea for a painting. He said he was going to paint a double-faced man. One side would be a minister, and the other side would be a gangster. The idea frightened Mother, who said it was one thing to stir up the ire of farmers but quite another thing to antagonize gangsters who might take Grant for a ride. Only when he assured her he would give up the idea did Mother relax.

Another incident was announced by a knock at the door—unusual in a place where nearly everyone just walked in. It was Sunday. Mother had cooked a nice dinner, and we had just sat down with her remark, "I hope we can enjoy this meal without someone coming." I went to the door, and there stood a tall, skinny youth who didn't look overly bright. He asked to see Grant.

Grant went to the door, and when the young man said it was something private, they stepped outside and pulled the door shut. They talked so long that Grant's dinner grew cold. "What do you think all that privacy is about?" I asked Mother, and she said, "It's probably someone wanting to borrow money."

Later, Grant told us the visitor had shocked him by saying, "I'm your son, and I've come to see you." He said that when he was a baby, his mother left him with a woman in Waterloo, saying, "The father of this boy is Grant Wood. When he grows up, tell him to go and see his father."

That's just what he did, he said, and he asked Grant, "What is your wife going to think about this?"

"I have no wife," Grant told him.

Then the fellow said, "You were working on the murals in the Russell Lamson Hotel in Waterloo when you met my mother."

Grant said he had painted those murals just three years earlier, adding, "You look a little big for a three-year-old. How old are you?" It turned out that the man was just ten years younger than Grant, and my brother told him, "The next time you try to pull this, you had better do a little research. Tell me, were you planning to blackmail me?"

"No, I just thought it would be nice to have you for a father and come and live with you. Can I come up and watch you work once in awhile?"

"By all means," Grant said, "but don't try anything funny." That was the last Grant ever heard of him.

PORTRAIT OF NAN

Portrait of Nan, painted in 1933, was really a portrait for Nan. Grant felt that deep down, I was hurt by people calling me the "missing link" and "the face that would sour milk" as a result of my posing for *American Gothic*.

This time, Grant wanted my hair marcelled (the iron dog, as he called it), and instead of the scolding lock and the bun at the back of my neck in *American Gothic*, he wanted my hair to hang loose. Unable to find satisfactory polka dot material, he tore up an old sheet and stamped large polka dots on it with half of a potato. Then he asked me to make a blouse from it.

The baby chick I am holding in the painting was not a gift—not "an Easter chick for Nan," as some have said. I was never in my life given a baby chick. We were reared in a strict Quaker tradition, and although Quaker families today are more relaxed about such matters, the Wood family viewed Easter as the Resurrection, period. Easter chicks, eggs, and rabbits were out of place— fables, like Santa Claus—and we were to have no part of them.

I was thirty-three and had been married eight years that Saturday night before Easter. I went into the dime store and saw that they were selling baby chicks. I bought two, not because it was Easter, but because they were so appealing. It was cold out, and I carried the chicks in a sack under my fur coat to keep them warm. One chick was sickly and didn't live. As I was showing the survivor to Grant, I held a plum I was about to eat in my other hand. He said, "Hold it. That's how I'm going to paint you. The chick will repeat the yellow of your hair, and the plum will repeat the color of the background."

Grant took his time painting my portrait. The chick was growing up in the studio and becoming badly spoiled. It stayed up all hours of the night and slept late. For breakfast it wanted buttered toast, eating only from the center of the slice. My shoulder was its favorite roost, and it would stretch its neck and tug at a lock of my hair. It seemed fascinated by my teeth, and Grant said that was because chickens have no teeth.

Someone had given Grant a sponge-rubber cigarette which he occasionally put into his pack. He would offer a visitor a smoke, then casually toss the rubber cigarette to the young pullet. She would squeal with delight as she pounced on it, running around the room with it thinking she had a worm. This routine always got a big laugh, but one day she swallowed it whole. We were worried, as we had become fond of her, but she lived to coax for more. Eventually, we gave her to one of David Turner's employees who raised chickens. He told us she became the best mother hen he ever had.

As Grant put the finishing touches on my portrait, he said, "Nicky, the portrait is yours whenever you want it. I will never sell it. It's the last portrait

I intend to paint, and it's the last time you will ever pose for me." I was astounded and somewhat hurt, having posed for Grant all my life. I asked what was wrong, and he said, "Your face is too well-known. I don't want to type my people." Grant sent the portrait to the State Fair Art Salon, but for exhibition only. He had won every prize there and said it was time to step aside and let someone else win.

I dearly loved my portrait. Grant painted me just as I was—without distortion and with no attempt to prettify me. No satire was intended. Most critics saw it for what it was—a portrait of the artist's sister painted with love and affection. The eastern critics had other views. The most vicious comment was by Emily Genauer of the *New York Herald-Tribune*, who said Grant had endowed me with all the stupidity, bigotry, malice, and ignorance rife in the provinces which were "Wood's special target."

The *New York Sun* commented, "*Portrait of Nan* leaves one wondering. Perhaps the young lady arrayed in her Sunday best, holding a fluffy chick in one hand and a plum in the other, typifies some up-to-date rural goddess of the farmyard and orchard."

Another critic said I had an inscrutable look on my face that made *Portrait of Nan* a latter-day *Mona Lisa*, and many viewers stood in front of the painting pondering the significance of the plum in the hand.

Grant loaned the portrait for exhibition only a few times. After the Emily Genauer response to it, he never loaned it again. He said he did not want things read into the painting that were not there.

This was the only painting in his mature style that Grant kept for himself. When he moved to Iowa City several years later, it was the only one of his paintings to be hung in his home, and it occupied the place of honor above the living room fireplace. Grant planned the color scheme of his living room entirely around *Portrait of Nan*. The flowered wallpaper, the dark rose upholstered Victorian gentleman's chair, and the dark green drapes all repeated the colors of the painting.

After Grant's death, the portrait was purchased by the Encyclopedia Britannica for its collection, which toured the nation. When that collection was sold at auction, the highest bidder for *Portrait of Nan* was the director of the exhibition, William Benton, who said it was his favorite painting.

In 1970, *Portrait of Nan* was exhibited in Tokyo in Expo '70. The sponsors wanted *American Gothic*, but since it was no longer being loaned, they settled for my portrait.

DINNER FOR THRESHERS

Dinner for Threshers had the distinction of attracting favorable comment before it was painted. My brother made two pencil sketches—the end sections of what would eventually be the final work. They were purchased by the Whitney Museum of New York, then chosen for the U.S. Section of the International Exhibition of Art in Venice, Italy. When Grant made a preliminary drawing of the entire work, Stanley R. Resor of New Haven, Connecticut, purchased it from the Ferargil Galleries. This drawing was reproduced in the *Sunday New York Times* in May 1934 with an article by Edward Alden Jewell.

In Jewell's opinion, *Dinner for Threshers* was "an American document that is tender, deep, reverent and altogether just; fine in its sympathy, its understanding; beautiful in spaciousness and dignity and grave, unhurried poise."

I arrived from Albuquerque in 1934 to find Grant hard at work in the studio. *Dinner for Threshers* was nearing completion, and he had spared no details. The mashed potatoes had a dab of butter, and the wooden match holder that had been in the kitchen of our farm home was on the wall. The heads of the matches and the very warts on the pickles in a jar on the cupboard were visible. The painting includes a cat with distinct whiskers, the red checkered tablecloth, the piano stool one man sat on, and even the politeness on the men's faces as the women served them food.

In Grant's youth, many farm homes exhibited a reproduction of a painting of horses in a storm. He hunted everywhere for one of these, but they seemed to be a thing of the past. Then Dr. McKeeby remembered that the mother of his dental assistant's boyfriend had one hanging in the parlor of her farm home. Before the dental assistant got around to borrowing it, she quarreled with her boyfriend, and Grant had to play peacemaker to secure the picture.

We were eating lunch one day when we heard a loud crack as the easel broke under the weight of this large painting. Grant had just put the finishing touches on it, and we turned with a sense of dread, fearing it had landed on its face. Luckily, it fell on its back, receiving little damage except to the wallpaper in the background, which Grant had to repaint.

Completion of *Dinner for Threshers* provided the occasion for an exhibit of Grant's works at Ferargil Galleries that drew record attendance. More than eight hundred visitors signed the register, including Eleanor Roosevelt, George Gershwin, Edna Ferber, Carl Van Vechten, Fanny Hurst, and MacKinlay Kantor. The register was presented to Grant and is now at the Davenport Museum of Art.

Grant was becoming accustomed to emphatic comments when he unveiled a painting. *Time* magazine noted that *Dinner for Threshers*, "what most critics consider his most important painting, won no prize at the Carnegie

International at Pittsburgh but was voted third most popular by the public. Simple and direct, the picture bears as genuine a U.S. stamp as a hot dog stand or a baseball park."

The public responded with a flood of nit-picking letters which the magazine printed. One said the shadows under the chickens should have been on the side at that time of day. That writer had no idea of Grant's thoroughness. Before he started a painting, he researched every point, including shadows—exactly where they would be at the hour depicted according to the angle of declination of the sun's rays at the time of year involved.

Grant finally wrote, "Dinner for Threshers is from my own life. It includes my family, our neighbors, our tablecloth, our chairs and our hens. It was painted with my paint and my brushes, and on my own time. It is of me and by me and readers Millard, Ridenour and the Wren from North Dakota have no right to attempt to force upon me their families, their clothing, or their screen doors."

Grant was most amused by the woman seated near him at a dinner in New York who gushed, "Oh, Mr. Wood, I am so fond of your pictures—especially the one entitled 'Luncheon for Threshers.'"

We were overjoyed when Dinner for Threshers sold for $3,500. The painting changed hands several times in rapid succession, advancing in price each time. Grant was never told what the work brought after he sold it. Letting the artist in on such information was considered bad business, bad ethics, or something. The last purchaser in the rapid turnover was George C. Moffett of the Corn Products Company, and the painting eventually was acquired by Nelson G. Rockefeller, who served as governor of New York and vice-president of the United States.

THE IOWA STATE UNIVERSITY MURALS

Before the dust had settled from the 1933 Stone City Colony and Art School, a chain of events began that would affect Grant's career for the rest of his life. He was asked to become Iowa director of the Public Works of Art Project (PWAP), a federal program to give "work relief" to unemployed artists. When he accepted, President Raymond Hughes of Iowa State College of Agriculture and Mechanic Arts (now Iowa State University) at Ames asked that Grant execute, as a PWAP project, murals for the college's new library. Grant welcomed the undertaking, both for its aesthetic potential and as a logical means of offering work to artists. In addition, Grant was asked to join the faculty of the graphic and plastic arts department of another institution, the State University of Iowa (now the University of Iowa) at Iowa City. He also accepted this invitation.

Grant chose his theme for the murals from a speech on agriculture delivered by Daniel Webster in 1840 at the statehouse in Boston. Webster said, "When tillage begins, other arts follow. The farmers therefore are the founders of human civilization." Grant planned seventeen murals; eleven, devoted to agriculture and the practical arts, were completed. The final six, which were to have depicted the fine arts, never got beyond the idea stage.

Swamped with two hundred and thirty applications, Grant decided to hire only those who had exhibited at the Art Salon of the Iowa State Fair. The quota for Iowa was thirty artists working a minimum of thirty hours a week. The work began in Iowa City in an old university swimming pool, the only available space on the campus. Grant commuted from Cedar Rapids, usually by interurban railroad.

From Grant's initial sketches, Francis McCray made life-size charcoal drawings on great sheets of brown wrapping paper. Canvas was hung for several weeks to remove creases caused by shipping. The image was transferred to the canvas, and the artists who did the painting followed a small color sketch by Grant.

Federal programs changed swiftly during the Depression. In January 1934, Grant's appointment as a lecturer at the State University of Iowa was announced by President Walter A. Jessup and Rufus H. Fitzgerald, director of the School of Fine Arts. The announcement that Grant had been appointed state director of art projects for the Civil Works Administration (CWA) was made on the same day. The PWAP was dead, but the program lived on, unchanged, under the CWA. The announcement story said Grant had "already selected about fifteen artists" for the project. Among them were John Bloom of DeWitt, who had studied and taught at the Art Institute of Chicago; Francis McCray, who became Grant's faculty assistant; Arnold Pyle; and G.E. Giles.

The first three murals were *Veterinary Medicine, Farm Crops,* and *Animal Husbandry,* all recording for posterity a way of life that is now gone. No one dreamed that the farmer of the future would buy milk in a store or that electricity and petroleum would doom the windmill and the big, red barn.

In the spring of 1934, the first three murals were displayed in Washington, D.C., first in the main building of the Department of Agriculture, and then at the Corcoran Gallery. Edward Bruce, national CWA director of art projects, was enthusiastic about the Iowa murals. Harry Hopkins, director of the Public Works Administration (PWA), a graduate of Grinnell College in Iowa, and President Franklin Roosevelt's close adviser, inspected the exhibits from all states. When he came to Iowa City to dedicate the State University of Iowa Theater built with PWA funds, Hopkins pronounced the Iowa mural display "the A-number-one exhibit of the whole Public Works of Art show at the Corcoran."

The first eight murals were installed at the Iowa State Library late in 1934, covering 1,231 square feet of wall space. Among the comments were those of *Fortune* magazine, reporting in the January 1935 issue, "Every detail was studiously checked and rechecked by members of the faculty of the college. The breeds of hog and horse, the kind of hay, the chemical experiment in progress— all such details were selected not merely for aesthetic but for literal, even statistical reasons; and all are exactly, even scientifically reproduced. The very blueprint on the wall in the last picture is an actual blueprint, an actual bridge."

Dr. Bertrand R. Adams of Ames, one of the mural artists, wrote that he did "all of the lettering, the surveyor transit, blueprint, hayfork and any part requiring fine detail." He also posed for the veterinarian with syringe. Dr. Adams said, "Grant was a superb designer," describing how he prepared a pilot color study about three feet square for each of the walls.

Each member of the team had his job, Adams said, describing how Francis McCray made life-size figures on brown wrapping paper. "Their outlines were perforated, then powder was poured through the perforations onto the large canvases to transfer the outlines."

Arnold Pyle mixed larger quantities of paint to match Grant's pilot sketch, and "color matching was quite exact by being matched under glass."

Adams said the artists used a two-story scaffold mounted on large swivel casters. "From time to time, Grant would have the scaffold rolled to one side so he could judge the pulling together of the design, color balance and the many varied qualities that went into the mural."

The artists were invited to comment on the progress of the work, Adams recalled. "It is surprising how some things have to be altered when a three-by-three sketch is blown up to eighteen-by-eighteen."

When the murals were ready for transport to Ames, they were rolled, paint side out, on a large metal cylinder. "On arrival at the library, they were unrolled, the back sides were coated with wheat paste, and the installation proceeded under a director sent from the Art Institute of Chicago."

Grant's public works experience led him to propose federally financed regional schools for gifted art students in connection with universities or other centers of culture. In speeches he gave in New York and Iowa City in 1934, he said, "The French government has carried on a similar project since Napoleon's time." He called for "taking art out of the large population centers" and making it the subject of regional rivalry. "I believe that the hope of a native art lies in these regional movements—in them and in the stirring up of rivalries between one section and another. That done, you would have a return to the spirit that raised the cathedrals of France, one city vying with another."

Dealing with jobless artists brought Grant both pleasures and disappointments. He was so pleased with his initial group of thirteen that he referred to them affectionately as "my boys." He said they worked so harmoniously that the murals appeared to be the work of one artist. With a threatened cutback of federal funding, Grant pondered whether the artists should draw lots to see who stayed. The artists themselves voted to pool whatever paychecks came in, dividing the money equally. They decided that even if all federal money was cut off, they would finish what they had started. They said they would pitch tents on the campus and have their wives do the cooking; some men would paint murals and others would seek outside work to bring in grocery money for the group. These measures became unnecessary when the threat of lost federal funding eased.

An incident that disturbed my brother occurred when a newspaper reporter gained entry to the locked studio on a Sunday, took photographs of uncompleted work, and wrote a story implying that Grant was teaching socialism. This story ran in a number of newspapers, and Grant had to explain to university administrators that he was an artist, not a political theorist. He hated this experience; it was one of the few times I ever saw him furious. Retaining an intense dislike for the reporter, Grant would not talk to him in person or on the telephone.

Grant's greatest disappointment involved a petition that originated with the twenty-one work-relief artists who were his second group. Jealous of what they supposed was Grant's higher salary, some of them sought to have one of their number appointed as Iowa director. What they did not know was that Grant had refused all pay for his work. He wanted all the government money available to be used in hiring unemployed artists. The petition was sent to Washington without Grant's knowledge, and Washington simply sent it back

to Grant. I was with him when he opened the envelope, and I'll never forget the look of disillusionment and shock on his face as he read the petition. Name after name was signed at the bottom, and few had remained loyal to him by refusing to sign. Grant resigned immediately, ending the Iowa State mural painting by work-relief artists.

The Daily Iowan of October 17, 1935, reported in a story headlined "The Empty Throne," that artists in Iowa "now appear to be leaderless as far as public projects are concerned. Grant Wood's refusal of the directorship of the painting and sculpture division under the WPA seems to have come as a great surprise to some 300 of the younger artists of the state who have been in contact with him." The story suggested that the artists of the state nominate a director by ballot.

When the petitioners realized that none of them would become the Iowa director, some of them asked Grant to change his mind and return. He refused. "Maybe they did me a favor," he told me. "It's a big relief. Now I can get back to my own painting."

Grant's final murals for the Iowa State Library were done by his University of Iowa art students from 1935 to 1937 under the direction of Francis McCray. As the earlier murals preserve the memory of farming in the 1930s, the final murals, Breaking the Prairie, reach back in time to the 1840 era. The center panel depicts the breaking of the prairie sod with an ox team pulling the plow in the background and horses pulling the plow in the foreground. The mural spans the twenty-three-foot alcove wall for which it was designed. At right angles on adjoining walls are two end panels showing pioneers chopping trees to clear the land.

The Daily Iowan of February 6, 1937, commented, "The research by which the details of the mural have been authenticated has been especially exacting owing to the fact that the scene deals with a period before the camera was in common use. Exact information was secured of pioneer types, costumes, native Iowa topography, animals, plant life and pioneer implements."

Total federal funds paid to artists working on the murals is not a matter of record, but Iowa State spent $1,200 on the project, and a 1974 restoration of the murals cost nearly ten times that amount. The National Endowment for the Arts and Iowa State University funded the restoration work directed by Margaret Randall Ash, a conservator.

CHAPTER 11
UNIVERSITY TEACHING

The beginning of Grant's teaching at the University of Iowa in January 1934 was a time of joy for him. On his Iowa City days, he would bundle up, walk to the interurban station, and ride this galloping electric steed the twenty-five miles south. Everyone favored the seats in the center of the car because that portion proceeded on a relatively straight path above the tracks. The front and back ends, however, swayed violently from side to side, a quirk that led students to dub the train "the vomit comet."

Grant would teach classes, lunch with a new group of friends which usually included Frank Luther Mott, meet with students in the afternoon, and sometimes be home for dinner. On his days in Cedar Rapids, he painted.

His university appointment as a lecturer was only until June and seemed temporary, but Grant remained with the university the rest of his life except for a leave of absence in 1940 and 1941. In June 1934, he became an associate professor with a raise in salary, and in 1940, he became a full professor—quite an accomplishment for a high school graduate who once had to teach rural school a year to qualify for teaching in the Cedar Rapids school system.

Grant believed he was invited to join the university faculty because his presence would attract students and because he could bring favorable attention to the institution, then struggling with Depression problems. His appointment was well-received. The *Des Moines Register* commented, "The *Register* can think of nothing more appropriate than that the State University of Iowa should take into its art faculty a native son who has made for himself a national reputation. . . . It is gladdening that Mr. Wood is not without honor in his own land."

Applications from students who wanted to study with Grant came from all over the United States and even from Sicily. When he arrived, the department's enrollment was 550. A year later, more than 750 students were registered.

Grant's starting salary was $4,000 a year, a substantial amount in the Depression years. His paintings were now selling for $10,000, and when

someone asked how he could afford to teach, he said, "No artist can afford to lose contact with life. These students are the changing generation. If I can maintain contact with that changing generation, I will be able to change, too. That's the real reason I like to teach. A work that does not make contact with the public is lost."

More and more people were coming to the Cedar Rapids studio to ask Grant's advice. He would tell them, "Don't copy the other fellow's work. Be original. Don't give up your job in order to paint. Only a few top-notch artists are able to live by art alone. You'll find time to paint in your spare moments and on your days off." Many who came were meeting Grant for the first time. If he had been a businessman, they would not have presumed to go to his office and take up his time, but with an artist, they thought it was different. They came at any hour of the day or night. Even when Grant tacked a sign on the door that read, "My Working Hours Are From 9 to 6," it did no good. Considerate people and friends he would enjoy seeing turned away, but others simply thought, "Good. We can watch him work."

In desperation, he rented an upstairs studio and hideaway in an old store building in downtown Cedar Rapids. He didn't tell Mother or me where it was so we could honestly say we didn't know.

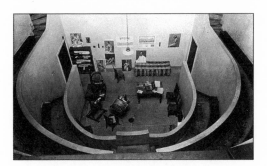

Grant held critiquing sessions for his university art students in the former medical amphitheater.

Then Grant proposed a free art counseling program. That way he could tell some of his Cedar Rapids visitors to come to Iowa City instead. University administrators gave him the only vacant room they had, the medical school's former surgical amphitheater. The location provided the name and the theme—the Art Clinic. The headline on a story in the October 30, 1934 Daily Iowan read, "Grant Wood, Clinician. His Patients: Artists; His Operations: On Pictures!" The story went on to say that the "clinician will find all his ailments in pictures. Or, to put it in other words, Professor Wood will begin his Saturday class course in art criticism." It described the clinic as an outgrowth of the Stone City Art Colony and said it was intended for non-resident students desiring college credit. An accompanying editorial noted that Grant was pioneering again with this venture, listing his previous pioneering projects as his return from France with a "beard and lively ideas," the Stone City Art Colony, and the Public Works of Art project.

Writing for the *Daily Iowan* in those days was a student named Tom Yoseloff, whose interest in art was evident in his articles and who later became a book publisher in New York and London. In his *Daily Iowan* column, "Seen from Old Capitol" published December 16, 1934, Yoseloff wrote of visiting Grant's clinic "just out of idle curiosity" and watching while Grant dissected the drawings and paintings of about two dozen students. "To a layman knowing little of the technique of art . . . Professor Wood's criticisms were a revelation. A redrawn line, a suggestion on change in perspective, a reduction of sky area, and a mediocre sketch took on new meanings and new possibilities in a few moments. . . . It's a great thing Professor Wood is doing here. There is probably no other state in which an awakening in art has been so certain and distinctive as it has been in Iowa. The state has become art conscious in the last few years, and it requires a doubter of the first water to doubt that Professor Wood has been largely instrumental in this awakening. . . clearly evident when artists will come to the university from as far as Chicago to obtain his criticism."

Attendance at the clinic varied with the weather but averaged fifty. The following year, these sessions were moved to the fine arts building, but the name and mystique of the original "Art Clinic" endured as long as Grant conducted the sessions. Starting in 1935, Francis McCray, by now an instructor in figure anatomy, assisted Grant at all clinic sessions.

What were those sessions like? A 1935 *Daily Iowan* article describes one: "People, old and young, professionals and amateurs, bring as many as 100 paintings in an afternoon to this clinic. Each 'ailing' picture is clipped to an easel and 'diagnosed' by Professor Wood." Grant would speak of planning a painting according to the principle of "thirds," dividing the paper into nine equal oblongs and relating all lines in the picture to lines which could be drawn from corner to corner of these oblongs. "I used to fight against the idea of mechanical devices in a painting," he said, "but after I began teaching, I found that a simple device like this is of great help to beginners." The object was to do away with lines that would carry the eye away from the picture instead of back to the center of interest.

Through his friendship with Frank Luther Mott, Grant became a member of the Times Club, which brought interesting guests to speak in Iowa City. Then Grant helped Mott start a smaller group, The Society for the Prevention of Cruelty to Speakers, which dedicated itself to entertaining speakers after their lectures. Roland Smith offered the group the second floor above his Smitty's Cafe rent free, and they decorated it in what Grant called "the worst style of the late Victorian period." Many of Grant's personal guests became Times Club speakers and enjoyed the hospitality of the Society for the Prevention of Cruelty to Speakers. They included authors Sterling North and Thomas W. Duncan, artist Thomas Hart Benton, art critic Thomas A.

Craven, and editor Christopher Morley, who wrote a *Saturday Review* piece on the charms of little Waubeek on the Wapsipinicon River, a spot to which Grant had lured him.

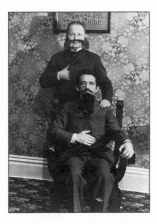

Grant (standing) and Thomas Hart Benton (seated) at the clubrooms of the Society for the Prevention of Cruelty to Speakers.

Of all the celebrities who visited Grant, I admired Christopher Morley most. Like Grant, he was kind and humble despite his fame. Also like Grant, he had the gift of making other people feel they amounted to something, too. Thomas Hart Benton also won my admiration for his kindness and his modesty. Also, he didn't know the meaning of fear. Once he was scheduled to lecture somewhere and wanted Grant to go along and introduce him. It was the middle of winter and snowing. Benton was dressed for the weather, wearing big, flappy overshoes and ear muffs. He had chartered a small private plane that had trouble in the storm and landed in the stubble of a corn field. Telling us about it later, Grant said the incident didn't faze Benton one bit.

By 1934, Grant was embracing the term "Regionalism" with enthusiasm. He thought it would convey to others what he had been advocating. In 1931, he had spoken of "American subject matter." In 1932, he emphasized "Middle Western material." The 1933 statement on the aims of the Stone City Art Colony referred to "an American art" arrived at "through the fusion of various regional expressions." In 1934, the idea of fusion gave way to What is Regionalism? Is it an American art? Is it midwestern? Is it fusion or is it rivalry? Is it localization and retreat? Does the term relate to the artist or to the art? Questions such as these were discussed passionately. Writings which purport to express Grant's views should be tested for accuracy against his own recorded remarks. He did not use the term in 1931 or 1932 and eventually came to dislike it. However, he said he could think of nothing better and used it though reluctantly.

Writing in the November 1933 issue of *Country Gentleman*, Thomas Craven said, "That Iowa artist, Grant Wood, apart from his individual achievements in painting, has carried out an undertaking that is without parallel in the history of American Art. Single-handed with himself as leader by right of genius, he has founded and set in motion a local or regional movement in art." Craven called it "Regionalism," and other writers adopted the term of this prominent art critic. So did Grant, even though he always had tried to avoid being labeled or categorized.

Writers discussing Regionalism frequently have quoted an essay with Grant's byline, *Revolt From the City*, published in Number One, Whirling World Series, Frank Luther Mott, Editor, Clio Press, Iowa City, Iowa, 1935. Dr. Mott directed the School of Journalism at the University of Iowa. In the late 1970s, Dwight M. Miller, senior archivist at the Herbert Hoover Presidential Library at West Branch, was browsing in an Iowa City book store and came across *Revolt From the City*. He bought the copy, which carried a hand-written inscription, "Dear Mr. Knott, I 'ghost-wrote' this for Grant. Frank Luther Mott." In view of that inscription, I seldom cited that oft-quoted article. Undoubtedly Grant read and approved the manuscript, but his own writings and speeches are far more accurate statements of his thinking. The article includes the idea of "revolt," which Grant would have used only as a discussion tool. He was easy-going, and revolt was not part of his nature.

In 1937, students in a graduate English class taught by Norman Foerster, director of the University of Iowa School of Letters, sent Grant a definition of Regionalism and asked for his reaction.

Titled "A Definition of Regionalism (Insofar as it is an American literary movement or tendency)," it read, "Revolting against domination by the city (especially New York), against industrial civilization, against cultural nationalism and cosmopolitanism, and against an abstract humanism— all of them conceived as making for an artificial, rootless literature. Regionalism seeks to direct preponderating attention to the natural landscape, human geography, and cultural life of particular areas of the country, in the belief that writers who draw their materials from their own experience and the life they know best are more likely to attain universal values than those who do not. A tentative formulation by the members of English 293, October 1937."

Invited to comment, Grant edited the definition slightly. His hand-written version was as follows: "In this country, Regionalism has taken the form of a revolt against the cultural domination of the city (particularly New York) and the tendency of metropolitan cliques to lay more emphasis on artificial precepts than on more vital human experience. It is not, to my knowledge, a revolt against industrial civilization (in the William Morris sense), though it has reemphasized the fact that America is agrarian as well as industrial. It has been a revolt against cultural nationalism—that is, the tendency of artists to ignore or deny the fact that there are important differences, psychologically and otherwise, between the various regions of America.

"But this does not mean that Regionalism, in turn, advocates a concentration on local peculiarities; such an approach results in anecdotalism and local color. Regionalism, I believe, would denote a revolt against the tendencies of the Literary Humanism which you represent, to lay (what seems to me) disproportionate emphasis on cultures of the remote past and to remain

aristocratically aloof from the life of the people at large. But it should be remembered that this so-called Regionalism, as I have used the term, pertains to artistic methods; it is an elaboration of the general proposition that art, although potentially universal in significance, is always more or less local in inception. The term, therefore, is strictly limited in scope and cannot be compared with Literary Humanism, which, as I understand it, is a general philosophy of life and art." The comment was dated November 16, 1937.

This response contains the first indication that Grant might be having some second thoughts about the effectiveness of the term, backing off by saying "so-called Regionalism."

By the end of the decade, Grant had begun to wonder whether use of the term actually reversed its message as he understood it—whether it was being shackled with a limiting or geographical interpretation. He told me he would have preferred that the movement be called "Painting of the American Scene." As far as art was concerned, he said, one region was as good as another. He believed that the artist is at his or her best when dealing with the region of that person's formative and most impressionable years. Based on art exhibits he attended, he said he could notice a certain overlapping and merging of three groups of objective painters—the regionalists, the propagandists, and the surrealists—which made him think they were learning from one another. What he had seen made him hope that soon they would all be working together toward a definite American art.

The *San Francisco Chronicle* quoted Grant: "Regional art is not a particularly fortunate name to describe contemporary painting, but nothing better has been found. Regional sounds almost geographical, and there is nothing essentially geographical about the work." The story, with a Los Angeles dateline, appeared the day before Grant's speech on "Regional Art" in Royce Auditorium at the University of California, Los Angeles.

I heard that lecture and recall that he questioned the term Regionalism, but I was too taken up with sisterly concern to listen closely. I had not heard Grant address an audience for years, and I feared he would have stage fright or that his voice would crack. I was greatly relieved to find him totally at ease.

Was my brother a "regionalist"? Is or was the term an aid to understanding? I leave these questions to others. For myself, I return to something Grant said in 1936 in response to some criticisms of *Spring Turning,* "Because I have painted a few 'satirical' things, the classifying school of critics has labeled me as a satirist. And they go on finding satirical meanings in things that do not have any satire in them. Of course, I have been satirical; but I have to keep on insisting that I am not a satirist so that people won't get an easy and incorrect notion of what I am about. It is always easier to judge an artist by a label than by what he does, and often such judgment is worn-out and irritating to an artist."

RED FLANNELS

At the top of the list of pictures my brother intended to paint but never did is "The Bath—1880." Even if it never existed, it inspired nationwide newspaper coverage.

"I have an idea for a painting," Grant told me one day in 1934. "I wish I could find a suit of old-fashioned red flannel long underwear. I want to have a man standing in front of the kitchen stove in his underwear, about to take a bath in a wooden wash tub. He's ready to pour a teakettle of hot water into the tub. I'll call it 'The Bath—1880.'"

Finding no red flannel underwear, Grant ran a short ad in the *Cedar Rapids Gazette*. He got no response, so he placed another ad in a Minneapolis paper, and suddenly news stories were appearing coast to coast with headlines like "Red Flannels Elude Search" and "Real Red Flannels Provide Warmth for Artist's Hot Sketch."

Grant was interviewed and said, "I'm going to do this picture in a very serious vein—regardless of how people take it. But it must be quite authentic, and the question arose whether the red flannels of that period had knitted waists or pull-up strings. The only way to settle it was to get a suit."

The manager of the J.C. Penney store in Fort Dodge placed a scarlet undershirt in the display window with a sign tweaking the "nose for news" of newsmen who had failed to find a suit of red flannels. Seeing the display, District Judge Sherwood A. Clock of Hampton, a former journalist, wrote of his "next-of-skin" relationship with red flannels.

The genuine and original article, he said, was born of necessity and rose to prominence in the 1880s. "It was not designed at all," he wrote, "but was built from plans and specifications based on knowledge of the peculiar needs of that generation—need of warmth and need of cheapness." The material "had the texture of a new Brussels carpet and wore like iron. When you first put them on in the fall, you thought the hives and seven-year itch had descended on you at once. The suit became more comfortable after a time, but with each washing, the old troubles returned. The color was not a bright red but was a sort of apologetic red with a few flecks of white woven into it." The judge described the puckering string construction of the garment, saying, "When a new suit was put on, it looked like a Turk's trousers," and concluded, "If Grant Wood wants genuine red flannels, as worn by the Iowa pioneers, he will have to find them in the trunk of some old settler."

Grant received no red flannels, but for weeks he was deluged with letters from people having a good time with the search. One man wrote that he knew an old maid who wore them, but he didn't know how to approach her without having her sick her dog on him. A sorority wrote that its members had

pledged to wear red flannel underwear, asking him to recommend a red dye. A fad of "red snuggies" and red flannel ski underwear and pajamas started, a fraternity elected Grant an honorary member, and Grant gave all the letters to me, telling me to use my own judgment in answering them.

Finally, after two months, Grant received a pair of red flannels from Gustav Wadsten of Minneapolis, who explained that his father, Lars Wadsten, who founded a Swedish settlement in North Carolina in the early 1890s, bought them as a protection against rheumatism. He believed the theory that the red color did the trick.

In January 1935, Grant began a series of lecture tours which took him to major cities and universities annually for the rest of his life. He also became a juror for many art shows and began an autobiography that year that never was completed. With all of these demands on his time, plus his teaching schedule, Grant found less time for painting.

In February, Clarence Guy Littell brought together sixty-seven of Grant's paintings for a one-man show in Chicago. This was the most comprehensive showing of Grant's work ever organized to date. Littell was president of R.R. Donnelley & Sons Company with its Lakeside Press, and he organized a momentous occasion with engraved invitations and a $10,000 catalog—a lot of money for an art catalog in the 1930s.

Ed and I had been living in Albuquerque three years when Grant wrote to me later that February to say Mother was not feeling well and asked me to come home. Only after I arrived at No. 5 Turner Alley did he tell me that she had suffered a heart attack. We visited Mother daily in the hospital. At home, I helped Grant paint his workshop, which he was turning into a bedroom to give Mother some privacy on her return. Both of us were paint-smeared when Grant suddenly realized what time it was. A woman named Sara Sherman Maxon was expected. She arrived dressed fit to kill, saw the situation, and asked for a paint brush. Grant looked at her clothes and manicured nails and refused to give her a brush. This was my first meeting with Sara.

She was taller than Grant and five years older. Born in 1886 in Monticello, Iowa, she grew up in Cedar Rapids. She married at seventeen, and at nineteen, she was a dramatic actress and operetta singer in Chicago. After her triumphant return to Cedar Rapids in *Robin Hood*, her father remarked, "She sang all right. Has her mother's voice. But I must say I was shocked. She wore tights in front of all those people!"

Mother had been home from the hospital just four days when I was called back to Albuquerque. My husband had been hit by a car, and although his injuries were not serious, I went home. It was a month before I could return

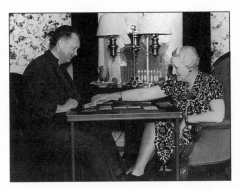

Grant Wood and Sara Maxon Wood, c. 1936

to Cedar Rapids. During that month, Sara took wonderful care of Mother, making her comfortable in every way and bringing her books, magazines, and flowers.

On the day of my return, Sara took me for a ride in Grant's car and told me they were making plans. The next day, Grant told Mother and me, "Perhaps you've guessed it. Last night, Sara and I decided to get married. I think we're ideally suited. She was a light opera star, you know. We're both artists, and we think alike and like the same sort of people. She's a little older than I am, but she doesn't look it, and she is so gracious and hospitable—she'll make a wonderful hostess. Best of all, she fits in with you two. Like us, she has been through many hardships."

Mother had grave misgivings about Sara as a person, but she didn't let Grant know it. Wiping away a tear, she told me, "Grant has been so wonderful to us—his happiness comes first. He's now in a position to support a wife the way he wants to. We mustn't stand in the way, and we will pray that the marriage works out."

Several of Grant's friends who knew Sara tried to talk him out of marrying, but Grant rebuffed them all. One of them was David Turner, and their friendship was never the same again. The incident contributed to Grant's move to Iowa City, and David told me years later, "I learned one lesson; never meddle in another man's romantic affairs."

Grant and Sara married in March 1935.

In Cedar Rapids and Iowa City, Mother lived with Grant and Sara until her death in October—a period of six months during which she was bedfast. My husband and I were on a pleasure trip to the East when Mother died. It was unexpected, as we had received a cheerful letter from her dated October 1. She wrote that Grant and Sara had surprised her with two warm Munsingwear nightgowns, a nice knit dress with white trimmings, and two pairs of silk stockings. But the big news was, she said, "Grant sold a painting to Katharine Hepburn the other day and then she sold it to Mr. George Cukor and wants Grant to paint another one for her."

Three telegrams awaited us in Fayetteville, North Carolina. Our precious little mother had died. Unable to find us, Grant had sent the highway patrol out to look for us. When Grant met me at the Iowa City depot, his usually ruddy face was white and drawn. At home, I asked where Mother would be buried. I always had resented the place where Uncle Clarence said Mother belonged, but Grant and I had never discussed the matter.

Grant hesitated, then said, "Mom will be laid to rest in the Weaver family lot." This was in Riverside Cemetery in Anamosa, adjoining the Wood lot which Uncle Clarence had favored.

"Oh Grant, I'm so glad!" I said.

Grant looked vastly relieved, and he said, "Nan, you and I think alike."

Grant selected Mother's coffin. He requested "Little Brown Church in the Vale" and other favorites of hers, asking that the service be brief and that nothing be said about him. Mother's funeral was the last time we were to see our brother John. He died two months later and was buried near her.

Near Sundown is a 1935 painting of rolling hills and round trees with a far-distant farmer following his cows home to be milked in the last chore of the evening. The painting with its golden lights and heavy shadows drew rave notices, but some eastern critics tried to find a touch of sarcasm in it. Sarcasm in a landscape? This was the painting Katharine Hepburn bought and sold to George Cukor.

When *London Studio*, the English fine arts and home decoration magazine, printed a story about Grant, *Near Sundown* was one of five paintings reproduced. The story said Grant had discovered a quiet drama in the lives of Midwestern people, adding, "As for Grant Wood, he is himself a calm, self-contained person who looks at life with

Hattie Weaver Wood, age 71

a clear serenity that even a cataclysm of the worst violence could not long upset."

Grant's 1935 painting, *Death on the Ridge Road*, was inspired by an automobile accident which was a close call for Jay Sigmund and his family. Sigmund was a poet, a prominent Cedar Rapids businessman, and Grant's friend. He wrote several poems about Grant and persuaded him to spend a summer at rural Waubeek on the Wapsipinicon River near Cedar Rapids. In the painting, one car is passing another on a hilltop as a truck approaches from the opposite direction. This vivid picture, a far cry from Grant's peaceful farm scenes, received much comment and praise at the International Show at the

Carnegie Institute in Pittsburgh. It was purchased by Cole Porter, and the preliminary charcoal drawing was bought by Lee Howard, mayor of Surfside, Florida. Not long after Grant made the painting, Sigmund was killed in a hunting accident. Grant could not bear to attend the funeral and wanted to remember his friend as he had known him in life.

Accepting a contract with the Lee Keedick Lecture Bureau, Grant said he thought the university administrators liked the idea of his going on the lecture circuit because of the publicity it would generate for the university. Wherever he went, Grant was interviewed on art subjects, and lengthy stories appeared in the newspapers. His first tour, starting early in 1935, took him to Washington University in St. Louis; the Kansas City Art Institute; Tulsa University; Monmouth in northwestern Illinois; Indianapolis; Saratoga Springs; Scranton, Pennsylvania; the Western Arts Association meeting at Chicago; Northwestern University in Evanston, Illinois; Kalamazoo, Michigan; and to Duke University in North Carolina. Grant received $500 for a two-hour lecture, paying his travel expenses and lecture bureau commission from that amount.

Grant served as a juror for art exhibits in Indianapolis, Madison, Kansas City, Chicago, Milwaukee, Columbus, New York City, and Philadelphia. Controversy had long stalked the annual Exibition of Chicago Artists at the Art Institute of Chicago, and it did so again in 1935. Eleanor Jewett, *Chicago Tribune* art critic, called the show "a brilliant, glittering, virile and vigorous affair. It is the best Chicago show we have had in many seasons. . . . It is as though Chicago had discovered for the first time the real meaning of creative art."

At the other end of the critical spectrum was C.J. Bulliet, art critic for the *Daily News*. He fired salvos at Grant, totally ignoring the other highly qualified jurors, Edward Bruce and Henry G. Keller. From 1,200 entries, they had chosen 256 for the exhibit and nine for prizes. Bulliet wrote, "Wood's star just now is in the ascendent in America. . . . You find a veritable flock of little Grant Woods in the 'regimented' show at the Art Institute. How the heart of Juror Wood must have swelled to note his 'influence' billowing up toward the height of Matisse's."

Back in Cedar Rapids, Grant's friend John Reid asked, "What do you plan to do about this Bulliet?"

"I'm not going to do anything," Grant said. "You can't fight the press."

"Good," said Reid. "When they ignore you is the time to worry. As long as they say something about you—good or bad—it shows they think you're important or they wouldn't bother with you."

Reid's words made Grant feel better, and the two of them went off to the interurban depot, which Reid said was the only place in town where you could get a good bowl of chili.

Grant was under contract to Doubleday Doran Company to write his autobiography, but the writing was to be done by Park Rinard, his private

secretary. Both names were to be on the cover, and it was to be titled *Return From Bohemia*. Grant had used that title for the drawing intended for the book jacket. Carrol Sax of New York bought the drawing, which is now owned by International Business Machines Corporation.

It seemed that Grant could do nothing that was not controversial. Even his acceptance of membership in the National Academy of Design raised some eyebrows. The academy had a staid and conservative reputation, and John Steuart Curry accepted membership about the same time that Grant did, but Thomas Hart Benton was offered membership and declined. The *Daily Iowan* of March 13, 1935, called Grant's membership "a queer affiliation," adding, "There are those lovers of art who will feel that Artist Wood is fair on his way to becoming a respectable burgher. . . . Whether the pleasing symmetry of design in *Dinner for Threshers* can take the place of the stern photography of *American Gothic* is a question. . . . A deadening conservative attitude has a way of sort of sneaking up on a man when he's 40 and has an income."

Grant dismissed such commentary, telling an interviewer, "My election amuses me." He said he saw "a trend away from the conservative attitude of the Academy."

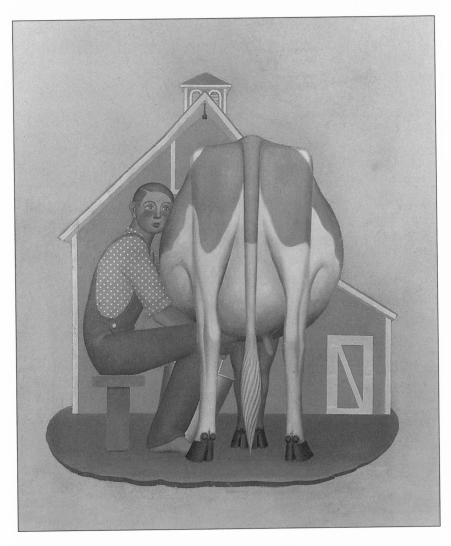

Boy Milking Cow, 1932
(From Fruits of Iowa)
Oil on canvas, 45 $^1/_2$ x 39 $^1/_2$ in.
Stewart Library, Coe College, Cedar Rapids

CHAPTER 12
THE GOOD LIFE IN IOWA CITY

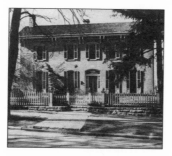

In the early period of Grant's university teaching and his marriage to Sara, life in Iowa City was exciting and stimulating. He paid $3,500 for the grand, old, Civil War house at 1142 Court Street, eventually spending $35,000 on its remodeling. Grant, Sara, and Mother moved into the house and Grant also invited Sara's son, Sherman Maxon, his wife, and daughter to live with them.

The living room ceiling was high, and Grant decided to reduce that apparent dimension with wallpaper and a dado at the base of the walls. He had the lumber yard cut perpendicular "V" grooves spaced on sheets of Masonite so the edges could be beveled and joined unobtrusively. The sheets were so successful that Grant lined the entire kitchen with grooved Masonite paneling. Sara wrote the Masonite people about it, and they were delighted. They sent a photographer, gave Grant the masonite, and began to manufacture grooved paneling. Other manufacturers followed suit.

Guests seeing the house for the first time were quick to recognize the Grant Wood touches. Atop each fence post was an acorn ornament Grant had designed. He also designed a gate latch easily tripped with an elbow if both arms were loaded with grocery sacks.

Inside were many pieces designed by Grant. He had found so many lounging chairs to be uncomfortable that he designed his own with a matching ottoman of the same height to give the effect of a chaise lounge when the two pieces were pushed together. Grant ordered the manufacture of his design from the Martin Company of Cedar Rapids, and H.R. Lubben of that company was so impressed that he urged Grant to patent it. Grant wasn't interested and told Lubben he could do so.

Lubben and John Carey of Cedar Rapids obtained the patent, formed a company, and manufactured the chair and ottoman. Grant allowed them to call it "the Grant Wood chair," and *Time* magazine printed a picture of Grant sitting in the chair under the heading "Overstuffed." He enjoyed the joke.

Life-size photographs of Grant were mounted and placed beside the furniture in window displays. Lubben gave one of these figures to Grant, who set it up as a dart board during a party at his home for university students.

The Iowa City living room boasted many typical Grant touches, including the lounge chair he designed.

The move to Iowa City brought new sounds—the music of Sara playing the piano and singing, the childish laughter of her granddaughter Sally, the chimes of the front door, the telephones ringing, the voices of welcome company, the tinkling of glasses, and the maid announcing, "Dinner is served." Mrs. Oaks next door might call to say the lights had been left on in the barn, cellar or attic, and the rhythm of street traffic altered as people driving past slowed down to point at the house.

Grant now began to dress more casually. He still bought dark blue suits, but he added brown to his wardrobe and light tan shirts to go with the brown suits. He changed from all black neckties to various subdued colors, rust with brown being his favorite. He bought black and white checked trousers and chose ice-cream pants to be worn with a brown sports jacket. He wore glasses with white or silver frames that hooked behind his ears. Some have pictured Grant with thick, bone-rimmed glasses, but actually, he wore those spectacles for just a short interval. He never needed or wore thick glasses.

One birthday I sent Grant a brown ascot tie I had made. He was pleased and wore it with his tan shirts. Later, I sent him another tie—bottle green with a small figure—and it wasn't the hit the first one had been. Grant wore it once or twice. In winter, he wore a brown overcoat and matching hat. I suggested that he buy a beaver coat, but he laughed and said it would make him look like a little brown bear.

Both Grant and Sara loved to entertain, and their dinner parties were famous. The typical guest list would be a mix of students, faculty, a visiting celebrity, and town friends from Iowa City and Cedar Rapids. Visitors included authors Carl Sandburg and Christopher Morley, philosopher John Dewey, singer Lawrence Tibbett, U.S. Secretary of Agriculture Henry A. Wallace, and many artists—John Steuart Curry, Thomas Hart Benton, Yasui Kuniyoshi, Arnold Blanch, Doris Lee, Adolf Dehn, James Chapin, and Millard Sheets.

Grant enjoyed good times elsewhere, as well. With Benton and Curry, he was asked to judge the costumes at the Kansas City Beaux Arts Ball. Sara went along, and they stayed with the Bentons, enjoying a spur-of-the-moment concert with Benton on the harmonica, his wife on the guitar, and their son playing the flute.

One of Grant's biggest parties was for a homecoming football game. Sixteen house guests were invited for the weekend. Grant had cots set up in the barn for the men, an extra maid was hired, and four turkeys were ordered. Game tickets were purchased, and a bus was chartered to take everyone to and from the stadium. Expense was no object.

Professor Lee Travis recorded Grant's brain waves and those of Professor Carl E. Seashore, head of the psychology department, trying to determine whether electrical charges motivate brain action or vice versa. He found Seashore's waves somewhat irregular and complicated, but Grant's were rather large and smooth. He said this showed that Grant was the more relaxed of the two. Grant was so newsworthy that even pictures of his brain were of interest. On another occasion, a photographer caught him shaving, and the photograph appeared in papers all over the country, headed "Artist in a Lather."

Grant's greatest pleasure came from the increased enrollment in the university's school of art observable since he joined the staff.

He also took pride in his first honorary degree, conferred in 1936 by the University of Wisconsin. Grant was one of eight recipients, including Katharine Cornell, the great actress. As the sober ceremony proceeded, Miss Cornell leaned toward Grant and whispered, "Are you educated?"

Grant joked in a whisper, "I never finished high school."

"Ha!" said Miss Cornell. "I never finished the eighth grade."

Spring Turning was Grant's only 1936 painting. When it was shown at the Carnegie International Exhibit in Pittsburgh, reviews were mixed. The Pittsburgh Post-Gazette described the farm landscape as "lyric" and said it showed richly felt emotions. It likened the hills to the swells of nature's breast. Still looking for satire, Henry McBride, art critic of the New York Sun, said Grant had gone too far with his vast checkerboard fields—it was one thing to poke fun at the D.A.R. and another to poke fun at Mother Nature.

Several other reviewers inappropriately took this occasion to call Grant "the all-time satirist," and he objected.

Even those critics who were not satire seekers were puzzled by Spring Turning. Thomas Craven wrote that Grant had "simplified the country into an abstraction, into immense and vacant and billowy protuberances . . . leaving the impression that Wood, unconsciously, perhaps, has aimed at something of 'Universal Significance.' The result, however, is a bit of vague symbolism." Craven wanted Grant to "paint a naked statement of the Iowa terrain, a closely

135

studied, realistic job without frills or fantasy, a picture in which the trees and farms are as sharply characterized as the faces of his portraits."

Life magazine recognized Spring Turning with a two-page color reproduction about half the size of the original. The painting was bought by Alexander Wolcott; in 1978 it sold for $195,000.

The November 1980 issue of The Smithsonian reproduced Spring Turning in a three-page color fold-out captioned, "No landscape in all of art history has better conveyed simple love of the land: Spring Turning, 1936."

Grant felt this simple love so deeply. He said, "I have a strong feeling for the ground itself. Trees and houses seem trivial and so temporary in comparison to good, solid ground."

THE DANFORTH CHAPEL

One of Grant's great pleasures was to drive into the countryside for sketching. When he was in Cedar Rapids, he often invited his friends of the Cedar Rapids Republican and McKinley school to go along. In the mid-1930s, Grant and Sara enjoyed Sunday drives out of Iowa City, and on one such trip, Grant spotted a small brick church about eight miles northeast of Iowa City near the town of Morse. He noted the simplicity of over-all design, the pleasing roof lines and window patterns, the perfect harmony of the steeple with the main structure. It was love at first sight. Obviously, this fragile structure had outlived all the farm people who erected, cherished, and cared for it. Now, abandoned and decaying, it was nearing its own end.

Built in 1874, St. John's Methodist Episcopal Church, also known as "Old Zimmerman Church," had served its congregation for thirty-six years before being abandoned in 1910. Grant was fascinated by the architecture. The chapel was a visual gem worthy of being enjoyed by future generations, but the building had deteriorated beyond restoration. Grant was determined that an exact replica should be built on the State University of Iowa campus near the Iowa River and the School of Fine Arts.

The Great Depression was still on at this time, late 1936 or early 1937, and money for such dream projects did not exist. Grant was undeterred by this practicality. He made many more trips to the church to photograph and sketch it. He engaged George L. Horner, the university architect, to make the measured drawings and architectural plans. All of these went into a "hope file."

After a conference with Grant on February 6, 1939, Earl E. Harper, director of the School of Fine Arts, noted, "Professor Wood stated that with

reference to the chapel project, he was deeply interested in it because of his interest in Iowa history and Iowa art. He would not care to prepare murals for any other building he can think of. Certainly not for any building at present on the campus. He would not be interested in preparing murals for any kind of Gothic chapel, no matter where erected. His interest centers in the project as developed, involving the reproduction of the little brick chapel and its situation across the road from the Fine Arts campus. His clear understanding was the work was to be done in time for the centennial of the university in 1947. He states that it is utterly impossible for him to begin work on any murals until the building has been completed." Grant had planted his feet and would not be moved.

The original church was torn down in 1941, less than a year before Grant's death, but by that time, all the plans, drawings and sketches for the replica had been completed. The reconstruction on campus a decade later was made possible by two $5,000 gifts from the Danforth Foundation and Mr. and Mrs. William H. Danforth of St. Louis plus a similar amount in smaller gifts from others. No public funds were involved.

The dedication ceremony January 11, 1953, was conducted by Professor M. Willard Lampe, head of the university's School of Religion. In response to the remarks of William H. Danforth, Virgil M. Hancher, president of the university, said, "It was my good fortune to have seen the old St. John's Church when it was still standing, and I was told that it was the hope someday to reproduce it on this campus. . . . Standing, as it does, in the midst of a campus of rare loveliness to which the thoughts of tens of thousands of devoted alumni habitually return, it will be a continuing witness, to those who pass this way, of all that is immortal in the human spirit."

In accordance with the wishes of the Danforths, no denominational or sectarian services have been held in the chapel. The 36-by-26-foot building has served for private and small-group worship, for weddings, and for student education.

Because Danforth Chapel was named for its principal donors, the Grant Wood part of the story was soon forgotten. But it was Grant who discovered and adored this tiny architectural treasure. It was Grant who was determined to make it possible for future generations to enjoy its beauty. For Grant, the little church he saved was as much the creative inspiration of his Iowa City years as were *Spring Turning* and the lithographs.

MAIN STREET

The wedding of the talents of Sinclair Lewis and Grant Wood was a natural. Each, in his own medium, poked gentle fun and satire at widely accepted midwestern mores, but it was tempered by feelings of affection for the subjects they each knew so well.

Sinclair Lewis won the Nobel Prize in literature for his novels; one of the most famous was *Main Street*, a crisp delineation of the rites and types of small-town America, published in 1920. Ten years later, *American Gothic* was unveiled and Walter Pritchard Easton wrote in the *Boston Herald*, "Sinclair Lewis surely ought to purchase this picture out of his Nobel Prize money."

The talents of Sinclair Lewis and Grant Wood were brought together by the Limited Editions Club of New York City with a membership limited to 1,500 collectors who paid dues of $108 annually.

The *St. Louis Post-Dispatch* observed that the dues were a bit steep and were indeed limiting. "Gopher Prairie (the fictitious village of the book) won't see many copies of this edition. The notion of reprinting Sinclair Lewis's novel *Main Street* with Grant Wood illustrations is so pat, one automatically wonders why nobody thought of it before now.... That the practice of commissioning book illustrations by distinguished painters is virtually unknown in the United States may have something to do with it."

George Macy, director of the Limited Editions Club, said he was trying to think of a book for Grant to illustrate when he received the *Main Street* suggestion in the mail. He lost the letter or misplaced it in his files and forgot who sent it. Otherwise, he said, the person who made the suggestion would have received a free copy of the book.

In a special preface for this edition, Sinclair Lewis, a native of Sauk Center, Minnesota, turned the calendar back to 1905, when my brother was entering high school. He told how he returned to his own "Minnesota village for vacation" after his sophomore year at Yale. "After two months of it...I was converted to the faith that a good deal of this neighborliness was a fake; that villages could be as inquisitorial as an army barracks. So in the third month of vacation, fifteen years before it was published, I began to write *Main Street*."

The limited edition was eagerly anticipated. A year before it came out, Monroe Wheeler wrote in a catalog for the Museum of Modern Art, "It might be the most interesting American illustrated book to date."

Designed by William Kittredge and printed by the Lakeside Press of Chicago, the book was described by the *St. Louis Post-Dispatch*: "Printed on coarse tan rag paper and bound in neat blue-gray and yellow linen intended to harmonize with Wood's palette, the whole is obviously the darling of everyone who handled a single detail of its construction. It is the illustrations, however,

which hold the spotlight." The *Post-Dispatch* reported that Grant admitted the difficulty of boiling down any adequate conception of the book into nine drawings and then the paper proceeded to describe how well he had done it.

"They are Grant Wood's own conception of American village types, and they are the fruit of his years of concentration on such people. As such, they go a good deal beyond the scope of ordinary illustration and have a place of their own, possibly as prominent as the novel itself." The paper also noted that five of the drawings had been exhibited at the Art Institute of Chicago, a "tacit recognition of their individual importance."

The nine drawings were done first with black and white pencil on brown wrapping paper. Completed in 1937, several of them appeared that year in *Scribner's* magazine to illustrate an article on Grant by Thomas Craven.

At home, the drawings created a sensation as people recognized the models. Wanda Montz wrote in the May 9, 1937 *Cedar Rapids Gazette*, "Over here in Cedar Rapids, they are saying it is you, Dr. Frank Luther Mott, who struck the humorous pose for *Booster*, and those of us who studied journalism under your instruction at the University of Iowa insist that if it isn't you—then who is it?. . . We never have seen you in a suit just like this one, Professor Mott, but one can imagine that Mr. Wood would see to it that the Booster wore a suit of that kind."

The models for the drawings were the following people: Dorothy Maxon, Sara's daughter-in-law, posed for *The Perfectionist*, the Carol Kennicott type. Charles Sanders, professor of advertising in the School of Journalism, posed for *Sentimental Yearner*. Sherman Maxon, Sara's son, was the model for *The Radical*. Dr. A.W. Bennett, Grant's physician, provided the hands for *General Practitioner*. Molly Green, dining room hostess at Iowa City's Hotel Jefferson, posed for *The Good Influence*. Norma Englert, librarian for the College of Engineering, was the model for *Practical Idealist*. Frank Luther Mott was, indeed, the model for *Booster*. The other drawings were *Main Street Mansion*, the frontispiece, and *Village Slums*.

Sinclair Lewis said Grant was a "natural" for illustrating *Main Street*. Lewis greatly admired *American Gothic* and once tried to persuade Lillian Gish to get herself up like me in my pose for the painting. He wanted her to stand with him in front of the painting and have a picture taken. Lewis said they would make a perfect likeness, but Miss Gish refused. I think it was a terrific idea and don't know why she declined. Had she known of the thousands who would strike that pose in the years ahead, perhaps she would have reconsidered.

Before the books were put together, the back pages were sent to Grant for autographing. As he did so, he quipped, "I hope my writing won't improve so much by all this practice that the bank won't recognize my signature on a

check." The check he received from the Limited Editions Club for his drawings was for $2,000.

I don't know who owns the original *Main Street* drawings today. I had *The Radical*, and obviously there were two, because a Beverly Hills art dealer showed me another. He said he was having difficulty selling it because people with no knowledge of farm tools thought the sickle in the drawing was a communist symbol. The drawing he had was slightly different from mine, and it was the version used in the book. Both were done on brown wrapping paper with black, white, and blue pencil, chalk, and India ink. I donated my drawing of *The Radical* to the Riverside Art Association when they exhibited my collection of Grant's early works, and it was purchased by an anonymous buyer.

Grant's lithograph series resulted from a 1937 request from Associated American Artists, an unusual New York organization formed in 1934 by Reeves Lewenthal and Maurice Leiderman, prominent art dealers who sought to encourage American art. They developed new markets for artists during the Depression, finding lithography to be the ideal medium. Associated American Artists sent catalogs all over the country, offering lithographs for $5 each. Grant was their twenty-fourth cooperating artist, and they offered him a monthly check for four lithographs a year. When he accepted, he also made Associated American Artists his agents. The relationship lasted until his death, and they have continued to represent me.

Grant had been familiar with lithography for a long time. He engaged Francis Chapin of the Art Institute of Chicago to teach it at Stone City, but he himself did not practice it until 1937.

In lithography, the artist usually works on a smooth stone with grease crayons. The stones which arrived from New York were smooth and entirely coated with a material which may have been tusche. Grant put a stone on a pulpit on his back porch. Attached to the pulpit was a pencil sharpener. As Grant worked, he would refer to his preliminary drawing, then scratch or cut the infinite detail of the image. He used old dental tools Sherman Maxon obtained for him, sharpening them to the shape he wanted. I still have one of these tools. Grant told me that everything had to be the reverse of the original drawing or else all the right-handed people would be left-handed in the final image. Grant returned the completed stones to New York, where the press work was done.

Editions of the lithographs were limited to two hundred and fifty, which were sent back to Grant for his signature. He returned them to New York to be mailed to purchasers. To his surprise, his first lithograph, *Tree Planting Group,*

sold out in advance. So did the dozen that followed in the catalog offerings.

Grant's 1937 lithographs were *Tree Planting Group, January, Seed Time and Harvest, Honorary Degree, Fertility,* and *Sultry Night.*

In 1939, he created *In the Spring, July 15th, Shrine Quartet,* and *Midnight Alarm.* The only lithograph he made in 1940 was *Approaching Storm,* but in 1941, he produced *February, March, December Afternoon,* and *Family Doctor.*

All but *Family Doctor* were for the catalog series. The exception was commissioned by Abbott Laboratories, Inc., through the Associated American Artists. Dr. Lewis E. January of the University of Iowa Hospitals recalls how it was distributed. A young medical intern at the time, he returned a coupon to the company and received a free signed lithograph. It hung on his wall for many years, until a patient, the late Edwin B. Green, asked Dr. January if he had any idea what it was worth. After checking, Dr. January took the lithograph home.

One lithograph intended for the catalog never made it. *Sultry Night* featured a male nude, and when Associated American Artists showed it to a postmaster, they were advised not to risk mailing it—it might be barred. Writing in Iowa City, John Selby said, "It is about as pornographic as a statue of Apollo." Nevertheless, it was withheld from sale until after Grant's death, when it was offered at a starting price of $75.

Sultry Night is a scene taken from Grant's memories of childhood. "In my boyhood," he said, "no farms had tile and chromium bathrooms. After a long day in the dust of the fields, after the chores were done, we used to go down to the horse tank with a pail. The sun would have taken the chill off the top layer of water. We would dip up pails full and drench ourselves."

The men never got into the trough or tank for fear of disturbing the settlings in the water. Horses are finicky, refusing to drink if the water has been disturbed.

Grant made both a lithograph and an oil painting of *Sultry Night.* The painting suffered a rude fate, whether as a result of the postal advice, I do not know. Grant was bothered by the thought that some detractor might try to create evil where there was none. He sawed off the portion that portrayed the nude farm hand and burned it. More than half the painting remained—oddly

shaped because the painting had been arched on top. Grant had an odd-shaped mat made for it and framed it, selling it to Dr. Wellwood Nesbit of Madison, Wisconsin.

Grant's second honorary degree was awarded in 1937 by Lawrence College, Appleton, Wisconsin, and it inspired his lithograph, *Honorary Degree*. Other recipients included two of Grant's university colleagues, Carl E. Seashore, then dean emeritus of the graduate college, and Norman Foerster, director of the School of Letters. The lithograph depicts Dr. Seashore and Dr. Foerster presenting the degree to the central figure—Grant, who stands small, awkward, and humble before the tall, assured scholars. Grant told me that was exactly the way he felt. He was proud of his honor, yet a smidgen of a smile betrayed inner amusement.

Gustave von Groschwitz, retired associate director of the University of Iowa Museum of Art, wrote, "*Honorary Degree* has a special meaning for me. As a young curator of prints at Wesleyan University in Connecticut, I was delegated to meet Wood before he received his honorary degree. He was friendly, likable, and had a warm smile. This lithograph is a delightful take-off on the questionable meaning of the American honorary degree. Wood, who had no college degree, looks at his academic superiors (?) with an expression of mock humility in the awesome setting of the college chapel."

Without telling Grant, Associated American Artists sent the lithograph *January* to the international show in Venice, where it took a world prize. Grant received a letter from Pope Pius XI wanting to buy one of the lithographs, and Grant sent him one as a gift. *January* is a snow scene that shows superb craftsmanship, and Grant said it was the rhythm and balance that won him the prize. He pointed out to me how the eye was carried from the center of interest, a large corn shock, to the corn stubble on the right-hand side, around the top of the painting, and then down the left side by means of the rabbit tracks to the foreground and back up to the center of interest.

Dr. A.W. Bennett, who was Mother's doctor and Grant's, kidded Grant about *January*. His wife told the story: "They became well-acquainted. They had a tremendous respect for each other and each other's work, but they did poke fun at each other. Once my husband was kidding Grant about the rabbit tracks in the *January* lithograph. He asked if Grant had ever seen a rabbit jump in a straight line like that. Grant replied that if he should ever want to paint a picture exactly as it was, he would just take a photograph."

Grant used Dr. Bennett's hands twice in drawings. The first time was for *General Practitioner* for the limited edition of *Main Street*, and the second was for *Family Doctor*, the hands holding the stethoscope and thermometer with the watch on the table registering 3 o'clock—in the morning, no doubt. The second drawing was used in *Hygeia* magazine and was part of the lithograph series.

Mrs. Bennett recalled, "Grant Wood gave our family both originals, along with four others. Once we invited him for dinner, and he came about a half-hour early. While I was in the kitchen fixing dinner, he entertained the children, telling them about the house plants I had. A few weeks later, a package arrived in the mail from him. We thought surely it was a mistake. We opened it, and it was the colored lithograph, *Tame Flowers*. Dr. Bennett always said how generous Grant Wood was to everyone. While he was a patient at the University Hospital, he gave a signed lithograph to every janitor, nurse, orderly, and doctor."

January was so well received that in 1940, Grant made a painting of it. With the exception of a few early paintings he made at the Cheley Camp in Colorado, this was his only snow scene. It was purchased by King Vidor, the Hollywood producer.

One of the first things Associated American Artists did after signing Grant was to block the profiteering on his paintings that had occurred with *Dinner for Threshers* and others. They had their lawyers draw up a contract stipulating that each buyer of a Grant Wood painting who resold the work would turn over to Grant half the profits. Writers in this country and abroad cited this contract as an example for other artists, invariably pointing out that Grant was "shrewd." The fact is, my unshrewd brother never would have thought up such a provision. It was entirely the idea of his agents. Grant himself never tried to enforce this contract. Other protective steps were his idea, however. After two persons—both printers, I think—filed for copyright on *American Gothic* before the first legitimate copyright application reached Washington, Grant began two practices. First, he posed for a photograph standing in front of each new painting. Second, when he sold a painting, he reserved all reproduction rights.

In 1972, when the then Cedar Rapids Art Center director Donn Young organized an exhibit of Grant's prints and drawings, eighty-two were collected, starting with youthful drawings and his illustrations for his high school magazine, *The Pulse*. These were but a fraction of Grant's work, which included even earlier childhood drawings, the sketches of doughboys and officers in World War I, and many others. In some cases, Grant prepared for a painting by making a preliminary drawing rather than an oil sketch. The catalog article by James M. Dennis, associate professor of art history at the University of Wisconsin and author of the book *Grant Wood*, suggested that in such cases, the drawing "is essentially the original work of art." The

cover of that catalog was a reproduction of the self-portrait, *Return from Bohemia*.

One of Grant's most delightful series of drawings was for *Farm on the Hill*, a children's book by Madeline Darrough Horn of Iowa City. Grant created eight illustrations plus a dozen smaller drawings for the inside covers, and they were so beautifully done that many purchasers of the book framed them. The setting of the book is a small Iowa farm where Bill and Tom visit their grandparents when school is out for the summer. James Allison Flynn of the *Omaha World-Herald* art staff wrote, "If you are familiar with farm life, you will like these drawings, and if you have never lived on or visited a farm, they will make you realize what you have missed. Here you have ... a taste of those priceless experiences of every small visitor to a farm—milking, churning, even the clothes-tub bath in the kitchen. Grant Wood must have done these pictures with great relish, farm boy that he was and artist that he is."

Grant sent the original drawings to the Walker and Ferargil Galleries in New York. They were exhibited at the Walker Galleries from April 14 to May 4, 1936, and the exhibition brochure read, "As illustrations they unquestionably are among the best in that field. But it hardly need be pointed out that they are a great deal more. Being an artist of integrity and supremely fine talent, and being bent on doing the job as well as he possibly could—as Daumier did, and Homer and John La Farge and other masters whose illustrations we now prize—Wood gives to his eight original characterizations of farm life the larger scope of decoration and sculpturesque design, which, together with his superb craftsmanship, sly personal humor, understanding and affectionate observations, make them little masterpieces of his art."

The drawings were titled *Boy Milking Cow*, *Grandma Mending*, *Animals*, *Boy Churning*, *Grandpa With Popcorn*, *Hired Man*, *Hired Girl With Apple*, and *Boy Taking Bath*. They were sold, and I lost track of them. The original drawings for the inside covers, however, were my gift to the Grant Wood School in Cedar Rapids when it was dedicated in 1951. The Walker Galleries brochure titled them *The Early Bird*, *Hero Worship*, *Envy*, *Joy Ride*, *Young Calf*, *The Escape*, *Surprise*, *Insect Suicide*, *Profane Setting Hen*, *Bold Bug*, *Lucky Bunny*, and *Competition*.

Charles Scribner published the $2 book, and copies autographed by both the author and Grant later became collectors' items.

Grant's first book jacket illustration was done for Vardis Fisher's 1933 book, *In Tragic Life*. He drew the faces of many characters in the book and found that a book jacket could be as much work as a painting. Another Vardis Fisher novel, *Passion Spins the Plot*, was about a woman with a double personality, and Grant's thoughts returned to an earlier idea he had for painting a double-faced man—a minister on one side and a gangster on the other. He had dropped that idea when it frightened Mother, but now he decided to do a double-faced woman. He consulted Florence Sprague of the Drake University art depart-

ment who had taught at Stone City. From Grant's sketch, she made two clay heads—one of a sweet, young woman and the other of the same woman when she was older and more sophisticated. Miss Sprague sliced the heads and brought the two versions together, giving Grant the model for a drawing in his own style.

Grant's next book jacket was for Thomas W. Duncan's *O, Chautauqua*. When Grant was young, a chautauqua tent was set up each summer on the grounds of Coe College. He heard and saw Sousa's band, many well-known artists and a succession of prominent speakers. Relying on his memories, Grant drew the tent and the crowds going into it, placing a church with a tall steeple in the foreground.

For the book jacket for *Plowing on Sunday* by Sterling North, literary editor of the *Chicago Daily News*, Grant again consulted memory. As a child, he had carried a jug of cool water to the grateful men who were threshing oats in the hot sun. The water was liberally spiked with vinegar, which was supposed to quench the thirst better than plain water. This book jacket showed a farmer drinking from a jug held by a forefinger and raised by elbow and upper arm to let water flow into the mouth. In the background is a freshly plowed, rippling field.

Malcolm Johnson of Doubleday Doran commissioned a small painting for the jacket of *Oliver Wiswell* by Kenneth Roberts. The publisher bought reproduction rights, and the original was purchased by the author. Park Rinard wrote to me on January 17, 1941, "I don't know if you caught any resemblance or not, but I posed for 'Wiswell' in a smelly old wig we got from a Chicago outfitting company. At the time, I was coming down with appendicitis, and my innards were very unhappy. Both the publisher and the author remarked how wonderfully the expression interpreted the character. Grant said it was my appendicitis that turned the trick. Just as Oliver Wiswell was torn between the Tory and rebel causes, I was torn between keeping my appendix and letting it go."

Grant did a portrait of Henry A. Wallace for a *Time* magazine cover in 1940, when the former editor of *Wallaces' Farmer* was completing eight years of service as United States secretary of agriculture and was about to become vice president in Franklin D. Roosevelt's third term.

Wallace and Grant were not strangers. They had breakfasted together in Iowa City a few years earlier and had met on other occasions. At one of their meetings, Grant offered a plan to boost clover production by a third.

"How?" asked Wallace.

"Plant nothing but four-leaf clovers," Grant said with a chuckle.

I still have a letter Wallace wrote to Grant on March 7, 1940, commenting on the clover suggestion. "Enclosed is a memorandum which I have received from the chief of our own bureau of plant industry. You will note we are hot on the trail, but we haven't got there quite yet."

Grant did two drawings for Steuben Glass. The first was of a farm woman feeding poultry. The image was transferred to crystal by expert craftsmen, and the vases sold for $1,500 each. The second was a small drawing of George Washington, also for a vase.

At the request of Mrs. Ernst Lubitsch, wife of the motion picture director, Grant made a drawing for a poster, *Bundles for Britain*. The Lubitsches had left Germany for the United States in 1922, and now, eighteen years later, the United States was not yet at war, but Britain was suffering from German air raids. Grant's drawing took all the glory out of war with bombers in the sky, shattered buildings, and a young and terrified mother crouching over her little boy, trying to shield his body with her own. The drawing was auctioned off, and Mrs. Lubitsch wrote to ask Grant whether the money should be spent for an ambulance, an operating table, or what? He told her the group should use its own discretion. This incident and others refute the accusation Chicago art critics made after his death—that he had been "isolationist."

Grant's contractor friend in Cedar Rapids, J.B. (Bruce) McKay, wrote down some of his recollections at Grant's urging. He told the story of a man who so admired one of Grant's drawings that Grant gave it to him, only to learn that the man immediately sold it for $125. McKay added, "Grant said he would be more careful of gifts in the future."

I'm sure that Grant said that, but he continued to give away many of his works as long as he lived.

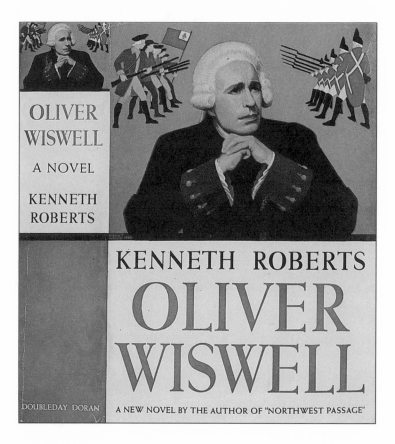

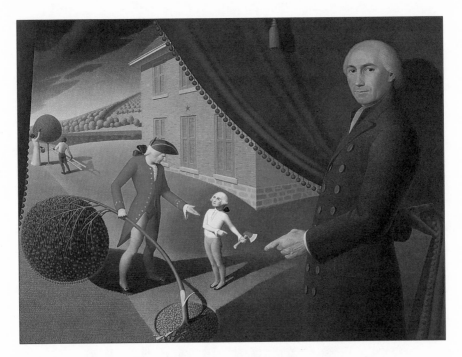

Parson Weems' Fable, 1939
Oil on canvas, 38 $^1/_2$ x 50 $^1/_8$ in.
Amon Carter Museum, Fort Worth, Texas

CHAPTER 13
THE MARRIAGE ENDS

I am no expert on what went wrong with Grant's marriage. Ed and I were in the West nearly all of the three years between the wedding and the separation. The marriage had its happy moments, but eventually it turned into a traumatic nightmare for Grant, who came out of it shaken and hurt.

I can think of three areas where things probably went wrong, and the first was financial. My brother, who wrote checks as long as there were blanks in his checkbook, expected Sara to bring good management to his affairs, and he turned the finances over to her. Actually, they were two of a kind. Her magic words were, "I'm Mrs. Grant Wood. Charge it, please." Their marriage was a time of grand spending. In the year before they separated, Grant earned $24,000, only to find they had spent twice that much, and he was in debt for the balance.

The artistic arena also became troublesome, I believe. Heretofore, no one other than innocent town friends ever tried to tell Grant how to paint or what to paint. He had vowed never to do another portrait, but under pressure from Sara, who wanted the money, he accepted two portrait commissions and was miserable about them both. I suspect there were other problems in this area, as Grant produced few paintings during his marriage and returned to the easel with enthusiasm after the separation.

Then there was the social side. Sara had a great need or urge to dominate and direct social conversations. When every guest at their typical dinner party was interested in art and in Grant Wood, she must have been frustrated. Winnifred Cone recalls the time when Grant, after dinner, suggested that everyone repair to the living room. To his surprise and that of the guests, Sara vacuumed the crumbs under the table, put the vacuum cleaner away, and went to bed without a word, leaving Grant to entertain the guests. Billie Stamats recalls the time when she and her husband, Herbert, received a telephone invitation from Sara. As instructed by Sara, they dressed to "rough it" at an

outdoor barbecue on a cool fall evening. They were greeted at the front door by Sara, who was wearing a long evening gown, and they were the only guests dressed for an outdoor party.

Throughout the marriage, Grant had been pressured to adopt Sara's son. Even Mother, in all her innocence, thought it comical that a grown married man with a child, a dentist who had a perfectly good father of his own, would want to be adopted. Grant held out and did not adopt Sherman, but he was fond of him and his wife, Dorothy, and used them as models for two of his Main Street drawings.

A different look at the relationship between Grant and Sara was found in a 1978 letter from Doris M. Jones of Iowa City, who said, "My mother (Mrs. Alma M. Jones) and I went to work for Grant and Sara Wood in March of 1938. We were hired to keep the house clean and do the cooking. Our quarters were on the second floor of the house at 1142 E. Court. I still can remember Grant sitting at the long table in the dining room at a formal dinner party with his foot in a bucket of water (after he broke a bone in his foot). Other memories are of Dr. Sherman Maxon, his wife Dorothy, and daughter Sally constantly bickering with Grant and picking on him for money. We left their employ because of the discord and trouble of their marriage. He was a grand person—never mean or high-hat despite a lot of inner turmoil."

Doris Jones and her mother saved the recipe for Grant's favorite salad dressing:

> 2 level tablespoons sugar
> 1 heaping tablespoon salt
> 1/4 teaspoon pepper
> 1 level teaspoon dry mustard
> 1 cup olive oil
> 1 cup tarragon vinegar
> 2 whole cloves of garlic

Mix well in covered jar and store in refrigerator. Use over mixed greens of your choice. Remove garlic buds before serving.

Grant hated emotional scenes and arguments. Rather than argue, he usually gave in. He could not paint unless he had peace of mind. A bad emotional scene and argument preceded the separation in 1938. At the climax, Sara proclaimed that she was having a heart attack. Grant, who had been through the same scene before, was unmoved. He asked Sara's son to call an ambulance, and he himself waited outside until it was gone. Years later, a nurse recalled that Sara arrived with her own satin sheets and pillow cases because she couldn't stand hospital bedding. She couldn't stand hospital cooking, either, and had her maid

bring meals to her. Grant went to Clear Lake for the weekend, leaving a note that said if he found Sara at home upon his return, he would leave for parts unknown. Sara borrowed money from Grant's close friend, George Stoddard, dean of the graduate college, for a trip to New York.

Ed and I were back in Iowa for Uncle Clarence's funeral at the time (Grant refused to go) and were living in Cedar Rapids temporarily while sorting out Uncle Clarence's estate. Sara wrote to us from New York, asking if she could ride with us to California when we went back. I talked with Grant, who confided that the marriage had been a ghastly mistake and that he was planning a divorce. He said he would allow Sara's son and family to go on living with him because Sherman had promised to testify in Grant's behalf when the divorce came up. Grant said, "Nicky, do me a favor. Go to California and take her with you. I'll be forever grateful."

Sara arrived by train, and the three of us set out by car for California. Ed and I could have made it if we had been alone, but Sara was not accustomed to eating at hamburger stands. We ran out of money, and Sara had to pay the bills for the last half of the trip. She was morose and moody. She couldn't figure out why the marriage had failed, and she was upset over Sherman's arrangement with Grant. She said her son had let her down. It was Christmastime, and in Los Angeles there was a $100 check for Sara from Grant with a note that said "Merry Christmas." He also sent me a $25 check and a note saying that Sara would have to learn to live on $100 a month, as that was all he could afford with all those debts to pay.

Grant obtained an uncontested divorce on September 25, 1939. Sara asked for and received Grant's car and $5,000 in settlement. In return, she agreed that she would no longer use the Wood name. Later, she came to my home to pick up her sewing machine and some clothing she had left with me. She gave me Grant's black cameo ring and the cameo pin Grant brought Mother from Italy—that much-painted brooch. She also gave me a handmade silver brooch Grant had brought Mother from Paris.

Because the divorce was uncontested, Sherman's promised testimony was not needed. This was fortunate, as Sherman told Grant he never could have testified against his own mother. Even so, Grant did not ask Sherman and his family to move for nearly a year, and when he did so, it was because of a typical squabble. Dorothy wanted some new drapes. Grant said the old ones were not yet paid for, telling Dorothy she would have to cut down on expenses. Sherman demanded that Grant apologize to Dorothy. With that, Grant suggested that they find an apartment and leave his house. As they departed, Sherman was certain Grant soon would call them back. He said Grant couldn't run things without them.

Eventually, Sara settled in the Seattle area. In a 1969 interview with Don Duncan of the *Seattle Times*, she was identified as Mrs. Sara Sherman, 83. She told of her early singing career and of notables she had met (including gangster Al Capone). Near the end of the story, Duncan wrote, "She also married the famous American painter, Grant Wood. Mrs. Sherman refers to it only as 'the Grant Wood episode' and quickly changes the subject to something she finds more palatable." Sara died in November 1979 at the age of 93. Her ashes were returned to her birthplace, Monticello, Iowa, for burial beside her parents.

THE COLORED LITHOGRAPHS

Arriving in Los Angeles after our motor trip with Sara, Ed and I were flat broke and jobless. We were not alone; the Depression was still on. Men walked down Hollywood Boulevard carrying "Work Wanted" signs. People slept in their old cars. Boxcars were jammed with tramps riding the rails, girls took to the road, and relief lines were long. Grant knew our plight. He came up with the idea of colored lithographs solely as a means of providing work for us. He checked with the Associated American Artists, who greeted the idea with enthusiasm, and only then did he tell us his plans for our future. We were delighted and grateful.

Grant's four colored lithographs were *Fruits, Vegetables, Wild Flowers,* and *Tame Flowers.* Because of the broken bone in his foot, Grant could stand only for short periods while working at the lithograph stones on his pulpit. As with the black-and-white lithographs, the editions for these were limited to two hundred and fifty. The paper had to be of the finest quality, capable of absorbing watercolors evenly without puddling or running. Several kinds were sent to Grant for testing, and he finally made a choice. After the printing, Grant did the watercoloring on the first lithographs, which are now at the Davenport Museum of Art. Grant was photographed with the colored lithographs, standing to touch up tiny specks the watercolors did not penetrate and seated, smoking a cigarette while autographing with a lead pencil.

At this point, Grant wired me money for the train fare to Iowa City, so he could teach me to color the rest of the editions. A second wire said not to come right away, as he was entering the hospital for his broken foot. However, he left the hospital after two weeks, and I returned to Iowa for my instruction in colors. Taking green as an example, Grant mixed Grumbacher tube watercolors with little jars of water until the desired greens were obtained. I made notes and numbered each jar. With three jars, each a different shade of green, innumer-

able greens could be achieved by using one color over another and then, perhaps, a third. I was totally amazed at the large number of green shades that could be created.

Upon my return to California, I taught Ed what I had learned, and together we began the coloring of the lithographs. It took us three years, off and on, to complete the work, and these lithographs were sold by Associated American Artists for $10 each. Ed and I received a monthly check of $100 for our work, and it was a life-saver. We actually saved a little, and we were pleased, too, to know that our work was satisfactory.

Grant was quick to tell us that, writing on June 28, 1939, "I'm tickled to death that you and Ed are doing so well with the lithographs. You two make a grand combination. As for the quality of the lithographs you have been sending, there is no need whatsoever of my checking them any more." He had, in fact, suggested to the company that the prints be sent to him for signing before being sent on to us. He said, "I am certainly feeling good about the whole business and so are the Associated American Artists." He mentioned a trip to Wisconsin, where he met and liked Robert La Follette, and said he had breakfasted with Henry Wallace. His postscript to that letter advised us that he had "about whipped the charcoal drawing of George Washington and the cherry tree."

In November 1939, he wrote saying he had received twenty-five lithographs of the flowers, which he signed and sent off, and that he was working "day and night on George Washington and it is coming along swell. Did I tell you that I sold the charcoal drawing of it to the Nesbits? I am also working up the small sketch in oils that was the design for the pioneer plowing murals at Ames. I am very much excited these days about some plans for the future. Now that I am single again, I have no need for the big house and plan to rent it." Again, he expressed his satisfaction with the "grand job you kids are doing," saying he would see us when he came to Berkeley to lecture in February.

When he returned from that lecture tour in May, he wrote about another project, little dreaming he would never complete it. "When Reeves was here, I showed him a very rough sketch for the next colored lithograph—a farm dinner scene, along the *Dinner for Threshers* idea, but a smaller and more intimate group. He was very enthusiastic about this and feels that the market for it will be unlimited. I am to do this colored lithograph and one other as soon as possible so that you two can go to work coloring them for the fall business. Incidentally, I am feeling swell these days—getting a lot of work done and also getting a lot of exercise and outdoor work in, too."

From the lithographs evolved a fabric idea developed by Associated American Artists and Riverdale Fabrics. Works by several artists were used; in

Grant's case, a painting. The result did not appear until after Grant's death, and the publicity said, "*Midnight Ride of Paul Revere* from the original by the late Grant Wood, whose classic *American Gothic* draws thousands to see it at the Art Institute of Chicago. Designs express Regional Art and have vibrant colors."

Associated American Artists gave me enough fabric to make the bedroom drapes which are now at the Davenport Museum of Art. The fabrics were sold by Macy's in New York City, by Carson, Pirie Scott in Chicago, and by other large department stores in the nation. I don't think these fabrics sold well because they were not, as advertised, in "vibrant colors." The blues and greens were quite dark. An unexpected development was that people bought the fabric by the yard for framing.

PARSON WEEMS' FABLE

Grant and I both had good reason to be curious about myths, fables, and fairy tales, all proscribed by our Quaker upbringing.

Grant painted *Parson Weems' Fable* fully believing that in the advanced year of 1939, everyone knew that the story of George Washington and the cherry tree was not true—that it was a piece of folklore. Grant was mistaken, and he was taken unawares by the storm of controversy that greeted this painting.

An understanding of *Parson Weems' Fable* must begin with the Rev. Mason Locke Weems. The Harold Kellock biography, *Parson Weems of the Cherry Tree*, makes it clear that Weems never was personally associated with Washington. Kellock wrote that Weems "occasionally held services at Truro Church that Washington attended in Mount Vernon. This was, however, after Washington worshiped there."

Parson Weems left preaching to become a traveling peddler of books—mostly his own. Weems wrote *Life of Washington* which was a best seller with seventy editions.

According to Life magazine, "In the fifth edition (1806), he first inserted the cherry tree story, explaining vaguely it was told him '20 years ago by an aged lady who was a distant relative' of the Washingtons. Without further substantiation, this yarn became one of the most celebrated bits of American history."

Fully aware of this background, Grant decided to create a painting based on the cherry tree story. The painting depicts Parson Weems in the right foreground pulling back a cherry-red, cherry-fringed curtain to reveal the tableau of the father confronting young George with the chopped-down cherry tree. George, painted child-sized but with the face of Stuart's adult Washington in powdered wig, points to the hatchet. Presumably he is speaking the words of the fable, "I cannot tell a lie, Pa; you know I cannot tell a lie. I cut it with my little hatchet."

Grant worked six months on this painting—twenty-two hours at one stretch toward the end. Life magazine reported on February 19, 1940, "Just before Christmas he shipped it to his New York dealers, the Associated American Artists, who sold it the next day for $10,000." Grant's secretary, Park Rinard wrote to me on January 15, to say that Grant had received $7,500 for the painting plus $1,000 for the drawing. The Life story said the painting was on exhibit during February at the Whitney Museum in New York and "literal-minded patriots bombarded Wood with angry letters because he depicted the cherry tree story frankly as a fable invented by Parson Weems. They accused him of debunking Washington."

Time magazine said Grant was "placidly ignoring the storms such paintings raise," but this was not true. The criticisms bothered him. One comment he made played right into the hands of his detractors. Explaining why he gave the boy Washington's adult face, he said, "no one would recognize him otherwise." He went on to volunteer that Parson Weems pictured young George as "smug" and that he intended to paint him that way. The word "smug" was seized upon. The Chicago Tribune intimated that Grant was in sympathy with the "Lenin and Stalin" clique in art—that he belittled the father of our country while taking government money as Iowa director of the Public Works of Art Project. In actuality, Grant had resigned that position four years before painting Parson Weems' Fable, and he never had accepted pay for it in any case.

Grant tried to calm the troubled waters. In a widely reprinted Press-Citizen interview, he said the idea behind Parson Weems' Fable was preservation rather than ridicule. He said, "When I was a boy, we all learned the story of George Washington and the cherry tree and accepted it as gospel truth. The present, more enlightened younger generation, however, is well aware that this incident never happened, but that it was the invention of Washington's most famous biographer, the Rev. Mason Locke Weems. It is, of course, good that

we are wiser today and recognize historical fact from historical fiction. Still, when we began to ridicule the story of George and the cherry tree and quit teaching it to our children, something of color and imagination departed from American life. It is this something that I am interested in helping to preserve.

"As I see it, the most effective way to do this is frankly to accept these historical tales for what they are now known to be—folklore—and treat them in such a fashion that the realistic-minded, sophisticated people of our generation can accept them.

"It didn't seem right to separate Parson Weems from the story he invented. So I decided to include him in the picture. One of the things about the old colonial portraits that has always amused me is the device of having a person in the foreground holding back a curtain from or pointing at a scene within a scene."

Grant continued with the suggestion that he had taken a tip from the good parson and used his imagination freely "in the attempt to make an effective pictorial design and at the same time tell the essentials of the story as the average person visualizes it." He said he hoped the painting would help reawaken interest in the cherry tree tale and other bits of American folklore too good to lose, concluding, "In our present unsettled times, when democracy is threatened on all sides, the preservation of our folklore is more important than is generally realized."

Professor John C. Briggs of the University of Iowa posed for Parson Weems in front of Grant's Iowa City house. Professor Vance Mulock Morton was the model for George Washington's father, and nine-year-old James Parks Morton posed for the boy George. After Grant's death, I learned from the boy model's mother, Virginia Parks Morton, that she and her son were descendants of Parson Weems. I was sorry that Grant never knew this. Young James Morton later became Dean of St. John The Divine Cathedral, New York City.

When Grant received a Swedish magazine with a reproduction of *Parson Weems' Fable*, he asked Dean Carl E. Seashore to translate the accompanying text. It read, "This Weems was a most original and realistic pioneer figure. He played the violin and appreciated the good of this world so much that he became less and less suitable for the service of the church. . . . Wood has secured a certain contract to receive 50 percent of the profit each time the painting changes hands. It now remains to be seen if any Swedish artist will take up this smart idea."

After the painting was exhibited, a canning company promoted "Cherry Week," featuring a recipe for "Parson Weems' Cherry Cobbler."

John P. Marquand purchased the painting, and it is now owned by the Amon Carter Museum of Western Art at Fort Worth, Texas. The charcoal preliminary drawing was bought by Dr. Wellwood Nesbit of Madison, Wisconsin, who completed his pre-medical studies at Coe College in 1911 and married the former Genevieve Runkle of Cedar Rapids.

Parson Weems' Fable was Grant's second painting of an American legend. The first, Midnight Ride of Paul Revere, received artistic criticism but not this flood of public comment. Even so, there would have been a third painting of this type had Grant lived. He told the Press-Citizen that the next famous tale he would make into a painting would be the story of Captain John Smith's rescue by Pocahontas. That legend would have qualified for his attention, as Time magazine pointed out, "Captain Smith did not mention it in the 1608 account of his Virginia exploits, adding it in 1624 after Pocahontas had been lionized in London as Powhatan's attractive daughter." Grant would have enjoyed working with still another bit of American folklore "too good to lose."

Life without Sara meant more time at the easel. With the departure of Sara's son and his family, Grant was living alone for the first time in his life—and in a very big house. He once wrote me that he might move to a smaller place, but he never did. As usual, everyone, including the laundryman, had a key. Grant frequently had none, having given his last key to a friend. He kept the maid, telling her that she no longer had to wear a uniform. Sometimes when Grant entertained, she was the best-dressed woman present.

Although Grant continued his full schedule of teaching, lectures, and other duties, I was delighted to see him achieving the peace of mind and uninterrupted time essential for painting. Parson Weems' Fable signaled Grant's return to important painting, and Adolescence restored his positive enthusiasm.

He wrote to me on May 7, 1940, saying, "You will remember the drawing of two hens and a cockerel. Well, this turned out better than I had dreamed it would as a painting. Reeves is very enthusiastic about it, and I am to ship it to the coast tomorrow. I am feeling very good about it because I feel it is a definite step ahead in my work. It is grand to be on a big working streak again—and no prospects of interruptions just when I am going strongest."

Indeed I did remember Adolescence. Grant's comprehensive one-man show in Chicago and New York in 1935 featured American Gothic, Dinner for Threshers, and sixty-five other paintings. A little sleeper in the exhibit was Adolescence, a small pencil drawing on brown wrapping paper lent by Clarence Guy Littell. Time magazine, April 22, 1935, reported, "It showed a gaunt, pin-feathered Plymouth Rock cockerel rising in the faint light of early dawn for his first lusty crow. . . . Artist Wood's good friend and competitor, Thomas Benton, saw it, grew hugely excited, wrote Grant Wood that if he did not make a painting of it at once, Benton would do a picture on the same subject."

The drawing was reproduced in the January 23, 1936 *New York Herald-Tribune* with an interview that said Grant spent a lot of his time answering letters from people who objected to his pictures either because they were not "typical" of their subjects or because they were not accurate. Grant said, "The first objection I don't even answer. It's a tag line for Benton and me and all regional painters, but we don't deserve it. I never try to paint 'typical' scenes or people, because if I did, I would have to leave out all the interesting, individual details."

The second charge was made almost as frequently, *Time* reported, "and sometimes, he said, with justice. His picture *Adolescence*, shown last year at the Ferargil Galleries here, depicted a fledgling rooster between two hens on a barn roof. The picture was exhibited all over the United States before one correspondent wrote to ask the painter how the rooster, which had no feathers, managed to get on the roof."

The oil painting of *Adolescence* was first shown at the Academy of Motion Picture Arts in Hollywood and was purchased by Charles S. Downs of Abbott Laboratories, Chicago.

Twin landscapes, *Haying* and *New Road*, were scenes along the road between Iowa City and Lake Macbride. Both paintings were in Grant's meticulous style, although they were finished in the record time (for him) of three weeks. Grant had a deadline. He wanted to exhibit them at a 1939 University of Iowa Arts Festival. Both landscapes were purchased by the Irwin Strasburgers of White Plains, New York.

Grant's third honorary degree, Doctor of Fine Arts, was conferred in 1939 by Northwestern University at Evanston, Illinois. This time, a fellow honoree was Edgar Bergen, the ventriloquist.

Grant's value to the university was noted when *Life* magazine printed a major article on the fine arts at Iowa in 1939. Dean George D. Stoddard of the Graduate College revealed in a letter to Earl E. Harper, director of the School of Fine Arts, that the *Life* writer told him "the original plan had been to write up Grant Wood, but that, at Mr. Wood's insistence, they had agreed to extend the scope of the materials to include the fine arts of the university and its relation to American culture. The university has received extraordinary recognition, and for this I believe we should all thank Mr. Grant Wood."

When Grant spoke to the Iowa Conference on Child Development and Parent Education at the State University of Iowa in 1936, he had said it was as natural for children to draw as it was for them to breathe. "They are very serious about their earliest efforts. Here is a great test for parental patience. Don't criticize these early gropings. Don't laugh at them. They are important to the children who make them."

He went on to say that later, if particular ability were noted, special training would be splendid, "but whether great talent ever develops or not,

painting and drawing always are wonderful means for self-expression."

He told of his own childhood bashfulness and his inability to "speak a piece at the Sunday School entertainment or sing a song at the school assembly." But, he said, "I could pour out all my emotions and longings in a painting, and my mother understood and encouraged me. Everyone should experience this joy of creation. We associate painting too often with gallery exhibits. Artists, to us, are people who make a living by selling their work. I should like to see, frequently, exhibits of the work of amateurs, produced for the sheer need of this form of self-expression."

Grant made the point that early association with good pictures or reproductions of famous paintings aids in the development of art appreciation and good taste in the home. He expanded these thoughts into an article for the October 1938 National Parent-Teacher magazine, and in 1939, the article became the State University of Iowa's Child Welfare Series, No. 73, *Art in the Daily Life of the Child*.

These were the days of Grant's friendship with Eric Knight, author of the Lassie stories. Knight came to Iowa City to teach in the Writers' Workshop at the university, and he rented Grant's upstairs apartment. Eric and Jere Knight and their daughter Betty became Grant's close friends. Grant learned that Eric once aspired to be an artist but had to give it up when he discovered that he was color blind. The arrival of royalties for Eric's book, *This Above All*, was the occasion for ordering a case of champagne for a Court Street celebration.

On one of his visits to Iowa City, Reeves Lewenthal, head of Associated American Artists, told Grant that one of his most devoted fans was right in Iowa City. He said that Edwin B. Green, then managing editor of the *Iowa City Press-Citizen*, had a standing order to buy each Grant Wood lithograph as it was issued. Then Grant discovered that Park Rinard had known Ed Green in college and asked Park to invite him to dinner.

Grant took an instant liking to Ed's quiet ways and unassuming manner, and a lasting friendship resulted. Ed was a frequent dinner guest and sometimes was a partner in a game of Russian Bank, a card game Grant enjoyed. Ed also took Grant on many auto trips in the late afternoons and weekends, giving Grant a chance to sketch or paint. When Grant and Park went on long trips, Ed was left in charge of the house.

Ed Green became the foremost collector of the many parodies of *American Gothic*, and he and I exchanged many of them. Portions of his collection have been exhibited at and donated to the University of Iowa Museum of Art and the Davenport Museum of Art.

Ed played a joke on Grant only once. Iowa City had been selected for the world premiere of a movie featuring a gorilla. Ed brought the gorilla to Grant's home, followed by a crowd of the curious. When Grant opened

the door, he was brushed aside by the big "gorilla," who went straight to the piano and started to play. The people outside laughed and cheered, and Grant said, "Wow."

One of Grant's students in 1939 was Willis Guthrie of the art faculty of Carroll College, Waukesha, Wisconsin. Like Grant, Guthrie was a "native Iowa Quaker, and our having the same birthday (February 13) was to me an impressive coincidence. I knew firsthand his subject matter, especially where it concerned rural Iowa."

Grant hired Guthrie to do some work around the house to give him money for painting supplies, and Guthrie recalled, "I alternated between the role of hired hand and guest, wearing the same overalls in both functions. I would often be called from yard work to join Wood and his guests, artists and writers, and I would eat and laugh as heartily as the rest. His cook and housekeeper was an Amish girl with a real talent for serving wonderful dinners, and the table was set with antique ironstone china from a loaded side board."

Grant also wore overalls for any occasion, Guthrie noted, adding, "His knowledge of garden craft was good, and he was very concerned about how his plants related to the warm colors of the fine old sand brick house." Guthrie described the neat yard and the acorn-topped fence posts and enthused about the "beautiful draftsmanship of the working plan prepared" for the carpenter and handyman, J. L. Coon, who made the gate latch that could be tripped with an elbow. He said, "It was done on brown wrapping paper with the same devotion that he had given the *Main Street* characters."

Fame had some strange by-products, Grant discovered. Someone impersonated him in Chicago and charged some purchases to him. He also wrote me, "I must somehow get time to write Aunt Jeanette a nice letter. She is entirely mistaken in thinking that I have been in Omaha recently, and the matter makes me feel a little queer because the man who resembles me so closely that he fools my friends was here in Iowa City a week or so ago and added to the confusion by wearing an overcoat and hat like mine."

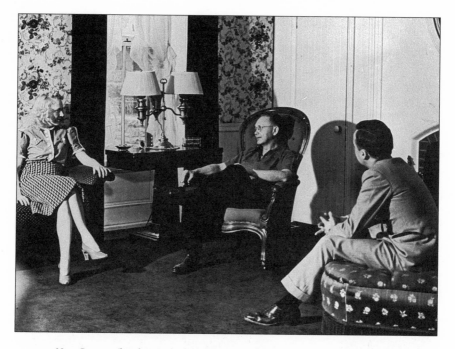

Nan, Grant, and Park Rinard relax in the living room of Wood's Iowa City home.

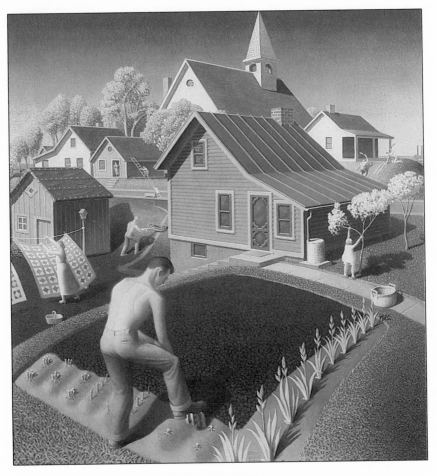

Spring in Town, 1941
Oil on masonite, 26 x 24 $^1/_2$ in.
Sheldon Swope Art Museum, Terre Haute, Indiana

CHAPTER 14
HOLLYWOOD
AND ACADEMIC POLITICS

Although Grant had been to Europe four times, he didn't visit the west coast of his own country until the 1940 lecture tour. Following his lecture at Berkeley on January 19, the *San Francisco Chronicle* commented, "Grant Wood does not look like a storm center. He doesn't look like he could be at the bottom of a controversy. He is soft-spoken, slight, and has twinkly eyes. His approach is thoroughly peaceful."

We met Grant at the Union Depot in Los Angeles. His lecture agent had made reservations for him at the Beverly Wilshire Hotel, and Ed stopped the car a block away, saying, "Grant, you had better take a taxi from here. I don't think it would do for you to ride up in this old jalopy." Grant insisted that we take him to the hotel and come in with him. He had a suite of rooms where a stack of letters, telegrams, invitations, gifts, and even a case of beer were waiting.

We didn't stay long, but at Grant's invitation, we were back the next morning for breakfast. A waiter pushed a stove on wheels into the suite, then wheeled in a complete dinette set, just as we had seen it done in the movies.

After breakfast, I asked Grant how he would like to spend the day, and he said, "I would like to picnic on the beach and lie in the sun." I still have the pictures we took that day.

I told Grant how Ed and I started for a short ride one Sunday, and the day was so lovely that we drove to Arizona and didn't return for four days.

"Sometimes I envy you," Grant said. "You are so carefree and do whatever you want to."

We didn't attend his lecture at U.C.L.A. since we would hear it the following evening. The next morning we opened the paper to find a picture of Grant and a big headline, "Grant Wood Denies He Is the Glamour Boy of Painters."

Ed Graham, Grant Wood, and Nan Wood Graham, 1940.

We met Grant at the hotel, and he said his lecture had gone well and he was the honored guest at a party at the Zebra Room of the Town House. The party lasted most of the night.

When we showed him the newspaper with his picture, he said, "Great Scott!" He read a bit and burst out laughing, read more and said, "Wow! Send this to Parkus [Park Rinard]."

The piece said, "I'm far from a glamorous person. Some people have felt it necessary, I guess, to make me so. Frankly, I'm just a middle western man with a Quaker family background who loves Iowa. I like it there because I've grown up on the farm, of course. Psychologists tell us that we're conditioned in the first 12 years of our lives and that everything we experience later is tied up with those 12 years.

"If I hadn't become a painter, I think I'd like to have been a writer or an architect. At heart I'm a farmer. Pretty darn good farmer, too. Things grow for me. I'm pretty strongly rooted, and I like to be home.

"But I'm crazy about the sunshine and warmth here. I'd like to come back every year about this time for a vacation. . . .

Grant relaxed on the beach during his 1940 trip to California.

"The prices on my paintings do not represent such a large income, when you consider that I did only one painting (*Parson Weems' Fable*) in three years. And if I paint two pictures a year, it is an arduous task. The public does not realize, perhaps, the amount of work that goes into one painting before I begin to set it down on canvas. In my last picture, I spent two months—fourteen hours

a day, including Sundays—sketching, making notes, rejecting ideas. Because I paint so few pictures, I must necessarily be highly selective before I start to work."

We took Grant to the home of Millard Sheets, head of the art department at Scripps College, Claremont, and later claimed our reserved seats for his lecture at the college. He was perfectly at ease speaking to the packed auditorium, his old hesitating manner gone.

We spent the next two days talking; we had a lot to catch up. Grant said that Millard wanted him to teach at Scripps College, and he had almost decided to accept—unless things changed considerably at the University of Iowa. I was elated at the possibility, which meant I would see him often. I also performed some sisterly needlework for Grant. George Stoddard had brought him a pair of pongee pajamas from the Orient which he loved, but they were wearing out. He asked me to repair them and use them as a pattern for another pair.

When Grant left for his next lecture in New Orleans, we didn't expect to see him for a long time, but he was back in a few months. Reeves Lewenthal had come up with an idea for publicizing Eugene O'Neill's film story, *The Long Voyage Home*, that had been approved by Walter Wanger, the producer. Reeves phoned Grant from Beverly Hills to say that Wanger was commissioning nine American artists to make paintings from scenes in the movie. The others were Thomas Hart Benton, George Schreiber, George Biddle, Raphael Soyer, Ernest Fiene, Robert Philipp, James Chapin, and Louis Quintanilla.

Grant was the last to arrive, but Director John Ford took one look at the others and snorted. He said, "This is the damnedest miscasting I have ever seen! They all look like businessmen." Then Grant came in wearing a suit and tie and strengthened the impression. The *Hollywood Sunday News* headline read, "Noted Artists Don't Act Up. Hollywood is Disappointed."

The accompanying story reported, "They show no temperament, and all they do is work and like it. Their amiability is disconcerting. Hollywood isn't used to it and is wondering if these fellows are really so important after all. They didn't notice that they made up the largest group of important artists ever brought together on a project. They didn't notice that they were in Hollywood, either. They just set up their easels, dusted off their brushes and went to work. All nine of them acted like men who had reached their eminence in their field the hard way. Like men who had got where they were by tending to business. They went to work like workmen, not artists at all. Because these bona-fide artists displayed no temperament, artististic temperament will be banished to the Hollywood dog house."

Time magazine reported Raphael Soyer's reaction to Hollywood as "an artist's paradise" with free models, flunkies to run errands, set men to make easels, and chauffeurs at one's beck and call. The article said the artists swam, played tennis, ate, drank, and took time off about every fifteen minutes to listen

to war news. Finally, they went to Walter Wanger's big bash with four hundred members of Hollywood's Who's Who. How the artists got any work done at all was a puzzlement, *Time* reported.

The artists were free to paint what they pleased. They were to have studios on the movie lot and were to receive fees totaling $50,000 (which eventually became $65,000) plus all expenses.

Grant first watched the movie being made. He liked the characters in a scene with a group of sailors and wanted them to pose. The high-salaried movie stars who willingly obliged for hours were John Qualen, John Wayne, Thomas Mitchell, Joseph Sawyer, David Hughes, J.M. Kerrigan, and Barry Fitzgerald.

Grant described his painting to an interviewer, saying, "I have titled it *Sentimental Ballad*. The group of sailors, one Norwegian, one Swedish, one Cockney, fascinated me when I saw them on the set. On shore leave after a long voyage through the war zone, they are catching up with their drinking in a Limehouse pub. They begin to sing; presently the sentiment of the song overtakes them, and they are all crying into their beer. In the movie, the arrangement was not what I wanted for my painting. I wanted to put a strong accent on Barry Fitzgerald, so I rearranged the figures, seating him alone at the table."

Wanger purchased *Sentimental Ballad* for his own collection, allowing it to tour with the rest of the paintings to twenty-six major cities. Associated American Artists reported record attendance at the exhibits, and Grant received $10,000 plus expenses.

At the studio, Grant and Frederic March took an immediate liking to each other. When Grant was able to visit us, March drove him to our home, and Ed and I were thrilled to meet our favorite movie star.

Grant, Ed, and I talked far into the night, mostly about Grant's experiences at the studio, where they treated him like a king. Every wish was granted immediately. When Grant asked for paint rags, they brought nearly a ton. Each night there was a party for Grant, the other artists having completed their work and left. The nicest occasion was a dinner given by Joan Bennett and her husband, Walter Wanger. Two hundred movie people came, and Grant said with a chuckle, "Here I was among all those celebrities, and they treated me as if I were the celebrity." Grant was seated between Joan Bennett and Marlene Dietrich with Loretta Young nearby. He had read that Marlene Dietrich was aloof and haughty, but when he asked about her daughter, her face lit up, and he knew he had hit on the right subject.

The next morning, the studio sent a car and a uniformed chauffeur, and away Grant went. It would be a year before I would see him again.

Of all the press commentary about Grant in California, my favorite appeared in the February 23, 1940, *Beverly Hills Citizen*. It read, "Today, after many

kudos have been heaped upon him for his work, he is still soft-spoken, shy and quiet. He smokes continually, lighting his cigarettes with as much deliberation and care as he might use in approaching the canvas. His brown curly hair is thinning in front. He wears thin horn-rimmed glasses which fail to hide the humor lines of his eyes. Florid of face, not a tall man, he nevertheless gives the impression of a great man."

Grant never would have dreamed that he himself would be featured in a movie, and I'm sorry he did not live to see it. The film, *Adventure in Art*, featuring the lives and works of six painters from the fifteenth to the twentieth century, was produced a decade after his death. Grant represented the twentieth century, and the others were Bosch (1450-1516), Carpaccio (1460-1526), Goya (1746-1828), Toulouse-Lautrec (1864-1901), and Gauguin (1848-1903). The full-length feature produced by Pictura Films was inspired by the success of a film on Van Gogh which won the Academy Award.

Various directors and cameramen worked on *Adventure in Art*. Footage was shot in Italy, Spain, France, and the United States. I attended the premiere showing December 21, 1951, in Hollywood, an event sponsored by the Los Angeles County Art Association and the Los Angeles County Museum. The picture ran five straight weeks in Hollywood and then was shown in colleges throughout the nation.

In the opening scene, Vincent Price talks with a group of students on the U.C.L.A. campus. He also narrates the first episode featuring the Bosch painting, *Garden of Delights*, the story of Adam and Eve. Carpaccio's *The Legend of St. Ursula* is narrated by Gregory Peck, Goya's paintings by Harry Marble, the Toulouse-Lautrec portion by Lilli Palmer, and the Gauguin segment by Martin Gabel. Leonid Gipnis produced the Grant Wood film narrated by Henry Fonda.

An outline of Iowa's borders opens the segment, followed by *American Gothic* and close-ups of Dr. McKeeby and me. Other paintings featured are *Woman With Plants*, *Portrait of Nan*, *Old Shoes*, *John B. Turner*, *Pioneer*, *Stone City*, *Herbert Hoover's Birthplace*, and *Midnight Ride of Paul Revere*, as well as several of Grant's lithographs.

The *Los Angeles Times* said the film "taps a treasure vein of pictorial subject matter that motion pictures have only learned how to exploit in recent years." The *Los Angeles Examiner* commented, "Art connoisseurs and laymen alike will be overwhelmed by the magnificence of our own great American Grant Wood's paintings—so vividly brought to life against the pleasant background of the homespun Fonda voice."

After the film was shown at Coe College, the *Cedar Rapids Gazette's* Pete Hoyt wrote, "Grant's love for the soil, for his native scenes of lush trees and endless corn fields, is sympathetically portrayed. The film carefully delineates his fine sense of humor—the way he could paint a rooster, for example, that looked like a prim old spinster."

Francis Henry Taylor, director of the Metropolitan Museum of Art, New York, called the film "magnificent" and referred to Grant as "the American artist who has so faithfully portrayed the American scene, its humor and simplicity."

Undercutting of Grant by some university art faculty members surfaced late in 1939 and early in 1940. Petty attacks were made on Grant behind his back, and students were channeled more to books than to paints and brushes. The back-biting was of no significance, but the curriculum dispute had substance. When Grant was lured to the university faculty, he was assured that a creative program of art instruction would be emphasized. He now felt that the creative program was being undermined.

Grant wrote to Dr. Earl E. Harper, director of the School of Fine Arts, on January 26, 1940, saying, "In recent weeks, I have had an opportunity, for the first time in a year, to organize and clarify in my mind a number of impressions about the current status of our department of graphic and plastic arts. My conclusions are as follows: (1) We are at a critical point in the development of our department. (2) Unless some major adjustment is made fairly soon, the gains and achievements of five years will be virtually wiped out.

"Inasmuch as I am convinced that the situation has been otherwise represented to you, I am taking this opportunity of summarizing it for you, as I see it.

"About five years ago, the creative art program (as a part of the general program in the School of Fine Arts) was launched in the Department of Graphic and Plastic Arts, and I was hired by the university to participate in it. The central feature of the program, as I understood it, was the absorption of creative effort in the fine arts into the core of the university curriculum, alongside of and on a par with the scientific and scholarly research the university had traditionally fostered. Thus, the young painter or sculptor was to be enabled to develop in the university's broadly cultural atmosphere without being overwhelmed by academic requirements unessential to his art.

"In other words, it was proposed that in the art department, the creative (as opposed to the fact-memorizing) approach would prevail. Moreover, it was our thought that the creative atmosphere thus engendered would spread to persons not professionally interested in art and would awaken them to a real and vital appreciation of art.

"Through the cooperation of the various administrators concerned, the program was quickly put into effect. Within a few years tremendous steps were made in the furthering of it. A number of students were awarded the

degree of Master of Arts with the creative work serving as the major part of their theses. The new degrees of B.F.A. and M.F.A. were authorized. The reputation of the art school spread to all parts of the country. Our enrollment increased substantially. And, last but not least, an unprecedented enthusiasm for art began to be manifested in the university as a whole and in the state and region. Such have been our accomplishments.

"Recently, however, I have become increasingly aware that our creative program, so promisingly begun, is being dammed and diverted at its source so effectively that unless some major change is made in the department, the program will soon peter out entirely.

"The blocking of our work is being accomplished by a department head who is out of sympathy with the general aims of the creative program and hostile to my own theories of art and teaching. So far as I know, Dr. (Lester) Longman has not publicly declared that he is endeavoring to completely change the character of the school, but that, in effect, is what he is doing. Here, in general, are the methods by which he is seeking to attain his objectives:

(1) Overemphasis of the historical or fact-memorizing approach to the point where it is stifling the creative spirit in the department.

(2) Interference with the technical part of art training, of which he is wholly ignorant. Inefficient handling of the faculty so that in many cases, students are not being adequately grounded in the fundamentals of creative work.

(3) General disparagement of my work and what I am working for in the department to such an extent that I feel we are working at cross-purposes.

"At your convenience, I should be glad to meet with you and go over these matters more explicitly. My deliberated conviction is, however, that unless the policy of the department is removed from Dr. Longman's jurisdiction, the creative program will collapse."

Grant met with Dr. Harper March 2, and Grant said he did not ascribe Dr. Longman's actions to malicious intent—he simply believed Dr. Longman was unable to work with creative artists. Dr. Harper's notes on that meeting say that he suggested Grant might not be too familiar with degree requirements. He said that more than half an art student's semester hours in the field of art could be in creative art, but not half the total collegiate semester hours, which would include liberal arts requirements outside the School of Fine Arts. Grant said that sixteen semester hours of art history was "entirely too much" and was confusing to students working in thesis painting. Then Grant threatened to quit, saying he felt he was being used as bait to draw students who felt betrayed and disappointed after they arrived. Urged not to quit, Grant decided to take a one-year leave of absence.

Dean Carl E. Seashore wrote to him on June 21, 1940, saying, "May I add a personal word of great concern in regard to the uncertainties involved

in your plan for a year's leave of absence?" He asked to talk the matter over with Grant when convenient and continued, "You have your feet planted in Iowa; you have portrayed to the world an Iowa atmosphere; the university is the highest center for the advancement of art in the state. Iowa is deeply appreciative of your great achievements, and we all hope that your connection with the university may continue indefinitely under such circumstances as will give you the greatest freedom and facilities for your creative work and at the same time maintain some contact with the rapidly increasing body of youthful artists who worship at your feet.

"Do not let organizational difficulties enter into or interfere with this plan. We are passing through a period of extraordinary development. We have had a great satisfaction in seeing the university change its attitude toward creative artists in various fields; but this is only a beginning, and I sincerely hope that you will continue as a most outstanding example of the creative artist in a university atmosphere."

Despite his official absence on leave, the petty sniping at Grant continued. *Time* magazine received a "tip" that Grant actually had been fired and would not be back. Eleanor Welch of *Time* arrived on campus November 18, 1940, to check out the tip, saying the letter had come from the Department of Graphic and Plastic Arts. About that time, a professor many believed had written the "tip" sent a letter to Grant that said, in effect, "I do not like you, and I do not like your paintings." Grant responded with a friendly acknowledgment of the communication.

The late Rev. Edward M. Catich, who studied with Grant at Iowa and later headed the art department at St. Ambrose College, Davenport, Iowa, knew nothing of the controversy, but in the 1970s he said, "We can have Ph.D.'s as art historians, but to have Ph.D.'s as studio men—as qualified painters—that's a great rarity. Grant was a studio man—a competent, efficient painter. And on the other hand, you have the degree people. There always has been a certain amount of animosity between the two."

Thomas Hart Benton responded to the situation with harsher words. After Grant's death, he wrote, "Wood was pestered almost from the beginning of his university career by departmental highbrows who could never understand why an Iowa small-towner received world attention while they, with all their obviously superior endowments, received none at all."

University administrators were eager to preserve both the art history/philosophy approach to the teaching of art and the creative/technical approach. As a result, Grant, who had been an associate professor in the Department of Graphic and Plastic Arts, returned to the university with a new arrangement after his leave of absence.

His jubilant letter of July 7, 1941, explained it: "The biggest news in the last few months for me is a new university appointment as a full professor. That will be grand. It will give me all sorts of freedom so that I can teach without interfering with my painting. Best of all, it puts me in a position where I cannot be interfered with or sniped at. . . .

"It is a professorship of fine arts; thus, I am in the School of Fine Arts (school includes departments of drama, music and graphic and plastic arts) rather than in the department of graphic and plastic arts. In other words, the way it is working out, I will have a little section of the university all to myself and will have every freedom and convenience for my teaching.

"For example, I do not have to have regular classes but can meet my students when and where I please. Thus, I can arrange my teaching around my working time. Moreover, if I want to get away for a little vacation, that can be arranged, too. So another major problem of mine has been solved, and I am feeling grand about it."

Grant had less than a year to live, but at this point, there was no doubt that he was "feeling grand" in every way and had no inkling of his approaching illness.

Again seeking a chance to paint without interruptions, my brother spent the summer of 1941—the final summer of his life—at Clear Lake in northern Iowa, where Park Rinard's parents lived. Grant stayed in a two-story cottage on the lakeside and had his studio a half-mile away in a former railroad depot moved to the site.

He wrote to me on July 7, saying, "I am putting the finishing touches on my two companion landscapes, *Spring in Town* and *Spring in the Country*. I have had a dickens of a lot of fun with these and feel they are going to turn out well. Reeves [Lewenthal] was out here a while back, saw the paintings and was crazy about them. In about a week now, I will have them finished. I would have had them done before this but had to interrupt work on them to do a Christmas card design."

Grant's depot studio sat a few feet off the ground on cement blocks. Busy Highway 18 ran between the cottage and the lake, and on sunny days, sheep found shade beneath the elevated depot. Frequently, they shook the building so much that Grant could not work. Finally, the farmer-landlord fenced the foundation to force the sheep to seek shade elsewhere.

The *Cedar Rapids Gazette* of August 10, 1941, described Grant's studio as "simplicity itself. Formerly a three-room station, one of the partitions has been

torn away to make a large, airy room where Wood does his painting. The bare, unpainted walls are covered here and there with rough drawings of stick men and animals. Wood does those when he's concentrating—just walks around with a pencil or a piece of chalk and sketches something on the wall.

"Or you may run across a scrawl of writing: 'Yours 'til hell freezes over and the devil goes a-skating.' That, too, is a sign of concentration.

"The room itself is unfinished. Light pours in through the boughs of apple trees outside the cloth-covered windows. The cloth is to keep the bugs out. [Note: It did not keep the bugs out at night, however, and if Grant worked then, the bugs would stick to the paint, so although he preferred to paint at night, he was restricted to daylight hours because of the many lakeside insects.]

"If you want a drink of water at the studio, you get it from a dipper in the bucket in the corner. There's a granite pan there for washing your hands, too.

"On one side of the room are a couple of long benches with dull cushioning. On another a table covered with paint, bottles of oil and paint removers, a radio and odds and ends of sketches. And that's just about all, except for the tall easel to which is clamped *Spring in the Country*. *Spring in Town*, already in its frame, hangs against the north wall."

The piece goes on to describe the difficult method of entering and exiting the studio, "just as though you were climbing into a low boxcar on a siding," and the narrow pathway through boards and boxes to Grant's airy domain.

The writer continued, "We stood by and watched as the artist looked at his nearly-completed *Spring in the Country*. To us, it looked perfect and complete, but its creator's eye was a great deal more critical. He looked it over from top to bottom, and his eyes came to rest on the water bucket on the ground near the woman in the picture. The bucket, he decided, looked out of proportion to the size of the woman. He took the water bucket from the corner of the studio and set it on the floor. Then he arranged his secretary beside it, stepped back and surveyed the proportion. The bucket in the picture didn't look so bad after all. The thing was forgotten.

"But a few minutes later, Wood took a compass and measured the distance between plumb line and bucket on the charcoal sketch from which he does his finished oil painting. The measurement taken, he compared it with the distance between plumb line and bucket in the oil painting. That was it! He therefore decided that by dropping the bottom of the bucket just a wee bit, the proportion would right itself. That's a picture of the meticulous Mr. Wood at work, and his finished product is a far finer product because of it."

One day Frances Prescott dropped in and sat down to watch Grant working on *Spring in Town*. His back was toward her, and he seemed to be working on one spot for an unusually long time.

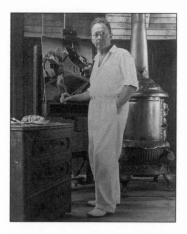

Grant spent the summer of 1941 at Clear Lake and painted in a converted railroad depot he named "Kare No More Studio."

"Grant, what in the world are you doing?" she asked with her usual peppery impatience.

"I'm painting the shadow of each blade of grass," he said.

For *Spring in Town*, Grant sketched a small Iowa City home. The young man with spading fork was modeled by George Devine, a university senior and son of Coach Glenn Devine.

Two months after Grant's death, Dorothy Dougherty wrote in the April 12, 1942, *Cedar Rapids Gazette*, "In typically charming Grant Wood style, the picture is full of homely touches, such as the panties showing on the little girl reaching for a flower from the tree. One morning as the artist was walking to work, he saw a youngster trotting along beside her mother, one hand clutching a bag of candy, the other clinging upward to parental protection. And the upraised arm made her panties visible. The delighted artist made that a part of his picture.

"This intimate, familiar feeling was characteristic of Grant Wood. He saw the world as a little thing; not often was he a builder of the heroic. He saw people as ordinary people; he made art out of ordinary things. In this particular painting are everyday tasks—rug-beating, lawn mowing, roof-mending, gardening, washing—all significant to the subject, but all common things, just a part of American living."

Spring in the Country shows a farm woman digging small holes with a hoe. Following her and setting small cabbage plants in the holes is a boy. To keep the rows straight, they have stretched a string between two sticks. They are following the line of the string with care, for a farmer is known by the straightness of his rows, whether in field or garden, and those with crooked rows are considered shiftless. Coming over the hill is a farmer plowing with horses, and in the distance, cows munch contentedly on the first spring grasses.

The people of Clear Lake were eager to see the two paintings, and Grant decided to hold an unveiling in Park Rinard's home. The rooms were too small for many visitors, so with the full approval of the Rinards, Grant had the partition between living and dining rooms removed to create one large room and had the walls repainted. Two hundred people came, and a farmer of Danish descent studying *Spring in the Country*, reportedly said, "By golly, you can see the shadows under the cows!"

The *Cedar Rapids Gazette* reported, "Grant Wood is an artist of our time. We are lucky not only in knowing his work, but in knowing him, as well. The name of Grant Wood will live through the coming periods of American art. His canvases are capturing the life of the nation as we know it, realistically and beautifully, and one day, long after we are gone and the Middle West has changed, the works of Grant Wood will remain as the clearest, most human documents of the Iowa we knew in the Twentieth Century in which we lived."

Spring in the Country was purchased by Cornelius Whitney for his private collection. *Spring in Town* was purchased by the Sheldon Swope Art Gallery, Terre Haute, Indiana, and one-time reproduction rights were bought by the *Saturday Evening Post*, which used the painting as a cover.

Grant wrote the brief text that accompanied that cover, and it probably was his last published comment. He said, "In making these paintings, as you may have guessed, I had in mind something which I hope to convey to a fairly wide audience in America—the picture of a country rich in the arts of peace; a homely, lovable nation, infinitely worth any sacrifice necessary to its preservation."

The magazine came out after Grant's death.

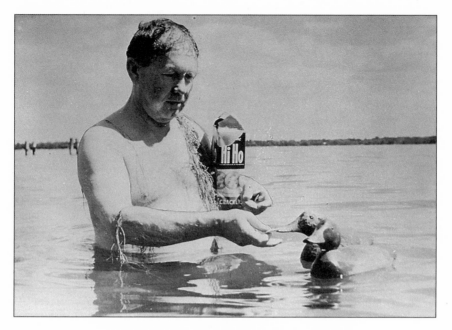

Grant clowned for the camera with a duck decoy at Clear Lake.

CHAPTER 15
THE FINAL ILLNESS

As long as a year before his final illness, Grant had not been feeling well. He went to his doctor for sinus trouble and was advised to cut down on cigarettes. The doctor gave him a small, soft rubber ball to keep in his pocket and squeeze when he felt the urge to hold a cigarette. He also told Grant to carry lots of gum and chew it when he wanted to smoke.

Park Rinard wrote to me on January 17, 1941, saying, "Grant didn't simply cut down; he quit entirely. Giving up tobacco made him pretty nervous at first, but now he doesn't seem to miss his three packs a day."

Grant's 1941 lecture tour ended March 2 at Atlanta, and instead of rushing back to the classroom, he went to Key West to rest and relax. He went deep sea fishing with Arnold Blanch, Doris Lee (Mrs. Blanch), and George Schreiber and visited with fellow vacationers John Dewey and Max Eastman. He spent several weeks there, giving his lecture to benefit the Key West artists' organization, and on the way home, he visited in Sarasota with the MacKinlay Kantors.

He wrote to me in April, saying, "Key West was swell and I had a grand vacation.... In the daytime I walked and lay on the beach, and every night there was a party for me. One of my best experiences was a day at sea in the *Hurricane* with the Ray Kaufmans. They are the Des Moines people who went around the world in their little sailing vessel, the *Hurricane's Wake*.

"I had a wonderful time, but it was best of all to get back home again. I am feeling just grand and am working on a couple of new landscapes. Sure wish you could see them. I have a feeling they are going to turn out pretty well. Let me know how you are getting along. Best to you both and much love."

Even well rested, Grant was not feeling up to par. Giving up smoking had not helped much. Doctors couldn't find anything definite—just a general letdown. Grant decided to try exercise. He bought a rowing machine and used it faithfully. He also made regular use of other exercise equipment he bought and kept in a closet. Outside, he fenced off a small area with tall shutters for sun-bathing. Spending the summer at Clear Lake, he continued his exercises and got plenty of sun.

Back in Iowa City, he began the fall semester's teaching schedule, and Eric Lloyd Miller recalls a warm day in early October in 1941 when Grant asked the thirteen students in his studio class to come to his home with paints, palette, and a Masonite board of a specified size.

Miller relates, "As the group arrived, he asked if everyone had wipe cloths, and for those who had forgotten, he sent the maid to the attic for cloths, which turned out to be old underwear. We went in several cars to a hill north of Iowa City where we spent three hours. We were told to note the shadows and where they were falling and were told the effect of shadows in tying the composition together. Afterward, we drove the cars—three as I recall—to the Wagon Wheel Inn and were told the steaks would be on Grant Wood."

Miller, who in the late 1970s was professor of art and art history at Towson State University, Baltimore, and at Johns Hopkins University, said that on another occasion, Grant brought Thomas Hart Benton to his classroom to lecture.

At this point, the United States had not entered World War II and would not do so until the December 7 attack on Pearl Harbor, but the nation was readying itself for war. Grant wrote of the role of the artist in defense for the *Iowa City Press-Citizen*, saying, "Here in America, we have everything we need to meet any threat—men, machines, resources, inventive genius. Our chief weakness, as the president has pointed out, is that we are going about our defense effort half-heartedly. And our half-heartedness goes back to the fact that we aren't really awake to what we stand to lose.

"Here, it seems to me, is where the artists come in. This isn't any time for smart, sophisticated stuff in any of the arts. On the other hand, I think the other extreme of flag-waving is just as bad. I don't mean that artists should paint screaming eagles and goddesses of liberty upholding flaming torches. I mean they should go on painting, as artists always have done, the simple everyday things that make life significant to the average person.

"Once the people are jarred awake to the real worth of what they possess in the way of life, no force on earth can beat them or push them where they don't want to go.

"It is time for painters, including myself, to put aside attempts at cleverness and sophistication in favor of a simple, straightforward approach. It is time for us to admit that we believe in the values and goals we mean, in

general, when we say 'the American way of life.' We have been going through a period when we were so tangled up with doctrines we were ashamed to be caught believing anything. As a consequence, we are weakened now with cynicism and defeatism.

"The artist, as an artist, hasn't any place in his make-up for despair. Whatever his attitude may seem in other situations, when he stands before an easel and puts everything he has into an effort to make a sincere painting, he is a believer and a builder in the spiritual sense. As such, he has, in time of great national crisis like this, an important part to play."

On a beautiful autumn afternoon, Ed Green drove Grant along the back roads near Iowa City on a sketching trip. Grant thoroughly enjoyed the afternoon and brought back a small preliminary oil sketch of an Iowa corn field. It was a little gem. The trees were warm, rich autumn gold, red and orange, and the sky was the bright blue of Indian summer. *Indian Summer*, Grant's last oil sketch, is owned by the Davenport Museum of Art. Grant planned to make an oil painting of it, but he did not live long enough to do so.

At this time, he had no intimation that so little time was left to him. He set off for New York and Durham, North Carolina, for conferences concerning a commission from the American Tobacco Company.

When he returned to Iowa City, he entered University Hospital on November 28, sorry to miss a conference of artists and educators at the university. He was to be on the program, and many of the two hundred conferees had traveled a great distance to hear him.

He wrote to me on December 1 about the American Tobacco Company commission, saying he was "very much excited about it. Instead of pretty girls, Lucky Strike is going to reproduce paintings by American artists in their advertisements. Benton, Paul Sample, Peter Hurd, Alexander Brook, Ernest Fiene, Schreiber, Curry and a number of others are in the series."

He explained that he took Park Rinard along on the trip because he was "not feeling very well." He collected reference material, notes, and sketches and said he had "two absolutely swell ideas" for the paintings.

Then he told me he was having University Hospital doctors give him a thorough examination to find out what had been bothering him. "They have been making tests for several days. So far, they have found out that my stomach, heart and lungs are in good shape organically. However, apparently I have some infection somewhere—it may be my tonsils or something of that nature—that is causing my liver to misbehave. I feel that it is sensible to take the time to get whatever it is tracked down and fixed so that I will be 100% again."

He also mentioned that Paul Fiene of Woodstock, New York, a sculptor and the brother of Ernest Fiene, the painter, was in Iowa City doing a portrait head of Grant. "He is modeling in clay now and will do the finished job in terra

cotta," Grant wrote. "He is a nice fellow, and we enjoy having him here."

Although Grant was trying to reassure me, I think he knew in his heart that his last sickness was upon him. Park phoned me December 18 to say that Grant would have surgery the next morning, and he was wiring me money for a plane ticket home.

I arrived shortly after the surgery was completed and said, "Park, tell me the truth. Is it cancer?"

Park bowed his head and said, "Yes, Nan. How did you know?"

I shook my head impatiently. "Can't something be done?"

"No, Nan. Grant has three of the finest doctors—Dr. Bennett, Dr. Green, and Dr. Peterson—and they all agree that nothing can be done except trying to make him comfortable."

I cried, and then I said, "Oh, Park, Grant mustn't know it. Please tell the doctors to keep it from him."

"I'll tell them what you have said," Park promised, "but you're wrong. Grant is a man, and a brave one, and he's entitled to know what ails him."

Park was right, of course. I went to the hospital the next morning, and Park went into Grant's room to tell him I was there. When he came out, he said the doctors already had told Grant of his condition, though they told him he might live another year.

The hardest thing I ever did in my life was to go into that room knowing that Grant knew the worst. I paced up and down the hall, trying to get the courage to face him without breaking down. Finally, I went in. Grant was thin and yellow, but he wore the sweetest, most serene smile I have ever seen on a human face.

As we clasped hands, I burst out, "Oh Grant, they shouldn't have told you."

"I should know," he said simply.

Those were the only words he ever said to me about his impending death, or to anyone else, to my knowledge. All his talk was cheerful, and he spoke of the future as if an earthly future lay ahead of him. He asked about my trip, about Ed, and about a new trailer we had just purchased in a voice that was natural, warm, and friendly with no trace of strain or despondency. Park told me that after Grant had learned of the cancer, he'd said he was going to shut it out of his mind and make plans just as he had before his illness.

When we were away from the hospital, Park handed me a sealed envelope and said, "Grant wrote you this letter before he entered the hospital. He said you are not to open it until after his death."

My mind went back to a time earlier in the year when Grant had Park write to me about his life insurance and his will, saying it was "just routine business." I knew, even then.

Each day I visited Grant, but I didn't stay long. He was under sedation part of the time. It was near the end of the school term, and he wanted to make sure his students received the proper grades. Sick as he was, he kept in touch with them by telephone.

Grant heard that someone in the hospital had Malta fever from drinking unpasteurized milk and became worried about us. He told Park to be sure to check with the milkman, for he did not want us drinking unpasteurized milk.

One day Grant suddenly said to Ed Green and me, "I want to go for a walk."

We supported him from both sides and startled the nurses by walking him up and down the hall. Grant's eyes twinkled at their surprise, and he said, "They're kidnapping me."

Each day he seemed to have new plans, from moving to California with Ed and me to moving to another side of the world. He talked about painting a portrait of our father, which he'd never done.

For Christmas, besides the trailer, which had been Grant's gift, he surprised me with a gorgeous, gray-blue quilted satin housecoat lined with coral taffeta. I gave him the set of ironstone chicken bone dishes I inherited from Aunt Sallie because he had always admired them. He was pleased with the gift and said, "Everyone is so good to me."

A constant flow of visitors came to the house and to the hospital. George Stoddard, dean of men, and his wife Margaret invited me to have Christmas dinner with them, and Grant insisted that I go. He said he didn't want me to be alone.

February 13 would be Grant's birthday. Four days earlier, Park said Grant wanted us all at the hospital—the Stoddards, Ed Green, Park, and me. Part of Grant's treatment was a small glass of whiskey each afternoon. As we drank with him, I think we all realized we were drinking a last toast to him, and I believe Grant knew it, too.

Soon afterward, he lapsed into the coma from which he never recovered. Three days later, when the hospital called to say that Grant was sinking, I could not force myself to go to his bedside. Park Rinard was the only person with him at the end, but Grant would have understood my reaction. When Mother died, he had reacted in the same way.

Grant died just two hours short of his fifty-first birthday. He spoke no last words, and there was only the letter—unopened until that moment. Alone in my room, I opened it with trembling fingers. It was his bequest to me, and I was to administer his estate. In his last few years, Grant had climbed a mountain of debt, and after his death, I found that the debts exceeded the assets by slightly more than $1,000. His life insurance covered that easily, and every cent was paid in full.

Grant had been both brother and father to me. He had seen me through many a crisis, and almost every letter he ever sent to me contained a check. Now, through his insurance, my brother sought to look out for me in death, just as he had in life.

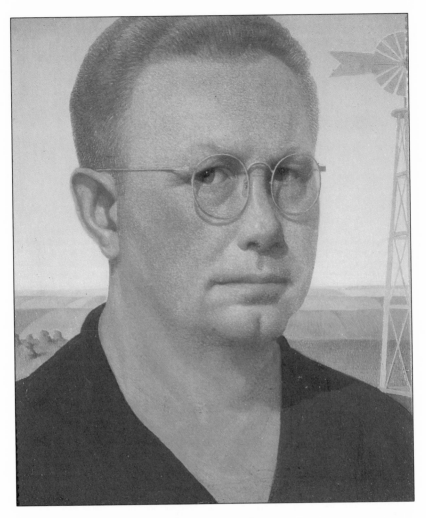

Self Portrait, 1932-1941
Oil on masonite, 14 ³/₄ x 12 ³/₈ in.
Davenport Museum of Art

EPILOGUE
A MAN TO REMEMBER

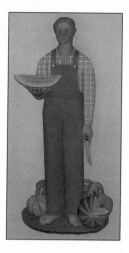

Authorized by Congress, an American Arts Gold Medallion featuring a likeness of Grant Wood on one side and *American Gothic* on the other went on sale in June 1980. The law required the minting of a million ounces of gold in medallion form each year for sale through 1984, each medallion to contain either one ounce or one-half ounce of fine gold.

Artists commemorated were Grant Wood and Marian Anderson in 1980, Mark Twain and Willa Cather in 1981, Louis Armstrong and Frank Lloyd Wright in 1982, Robert Frost and Alexander Calder in 1983, and Helen Hayes and John Steinbeck in 1984.

The honor for these talented Americans is great, and the Grant Wood medallion is especially meaningful to me as a gracious tribute to my brother's memory. As I near the end of my own life, this honor reinforces my feeling that my brother's bitter critics have failed to carry the day, and that his place in American history is one of friendly and lasting appreciation.

I have not always been so sure. Grant's detractors were numerous and noisy, and I often found them confusing. Grant was called just about everything—all-time satirist, liberal, socialist, fascist, communist, isolationist, and, in a derogatory sense, flag-waver.

I always knew in my heart that Grant's detractors were jealous and bitter, trying to build themselves up by tearing him down, but sometimes that heart has not been too strong. Like Grant, I was reared in the gentle tradition. Perhaps I was not prepared or willing to cope with the world of wildly—even

violently—conflicting ideas. Sometimes I have reacted with automatic fury to those I believed were misrepresenting Grant's talent, career, devotion, or life story.

Fortunately, Grant was of stronger stuff. He seemed prepared for fame if it should come to him, prepared for the day when his opinions would be sought and widely circulated, prepared for the controversies that would result. He always sought to answer criticisms of substance with logical statements of his own views. This he did whether the criticisms came from art sophisticates or from dirt farmers and their wives.

Grant never answered personal or vituperative attacks. This was not a calculated non-reaction, in my opinion, nor was it a tactic. It was simply a manifestation of his own self, his own nature.

Grant was once described as a simple man with a very complex intelligence—a paradox. I prefer to say that Grant was forever gentle and soft-spoken. His eyes twinkled, and he usually took a humorous look at life.

His talent was noted in early childhood, and he decided to become an artist at an early age. Then he worked diligently to develop techniques and searched his soul for years to decide what he wanted to paint. He shared his knowledge and his philosophy with all comers and was kindly and helpful to any and all. In boyhood and in manhood, he was totally incapable of hatred.

Looking back, I see the era before his fame as the golden years. Cedar Rapids was alive with interest in the arts, and Grant and Marvin Cone were both beneficiaries and catalysts of this spirit. Community involvement in art, theater, dance, music, and literature was extraordinary—as if the town were supporting its own permanent artists' colony. Work was exhibited in various ways by a happy combination of professionals and amateurs, and continuing intellectual stimulation came from within the community. A multitude of easy social occasions offered relaxation and renewal of spirit. Mother and I sat on the edges of this pleasant world through good times and the Depression, in the era of early movies and radio but long before television.

Much as Grant enjoyed that time, I am sure that if he had to make a choice of an era to relive, he would take the final years—the period of his wide renown. All his early years of work and study were a preparation for the time when his paintings would speak directly to a wider public.

His first meetings with people such as Thomas Hart Benton, John Steuart Curry, Henry Wallace, Carl Sandburg, and John Dewey, to name a few, were beginnings of long acquaintances. They plunged into animated conversations, comparing notes on shared aspirations and outlooks.

Despite the personal trauma of the failed marriage and of finding himself in the hurricane's eye of raging art storms, the late years were a time of fulfillment.

The legacy of Grant Wood to future generations is a series of remarkable paintings and drawings that communicate directly with people, no

matter what language they speak. This unspoken communication derives from the ability to portray the painter right along with the painting. *Woman With Plants* never could have been created by a pugnacious grudge-holder, nor *American Gothic* by a humorless drudge, nor *Parson Weems' Fable* by someone lacking in imagination, nor *Stone City* by someone who looks without seeing beauty. The paintings tell a great deal about Grant.

Grant Wood will be long remembered, and he should be known for the personality that was uniquely his—his style, his manner, his talent, his creations, his thoughts, his opinions, and his plans. To this end these pages have been written by one who knew and loved him well. My brother Grant Wood was a good model, a man to remember.

The End

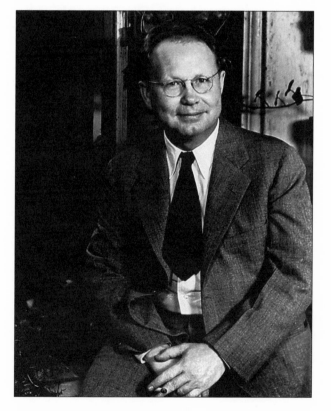

INDEX

Page numbers in boldface type indicate color plates of artwork.